Oct *

To S.t Diane Brantley —

Dopands
Shelly + Celerstreamd

SPEAK
TRUTH
TO
POWER

SPEAK
TRUTH
TO
POWER

HUMAN RIGHTS DEFENDERS WHO ARE CHANGING OUR WORLD

KERRY KENNEDY CUOMO

PHOTOGRAPHS BY EDDIE ADAMS

EDITED BY NAN RICHARDSON

AN UMBRAGE EDITIONS BOOK

CROWN PUBLISHERS / NEW YORK

DEDICATION

For Anonymous
and all the unsung who show us
not how to be saints,
but how to be fully human

For our children—
Cara, Mariah, and Michaela—
and yours.
—Kerry Kennedy Cuomo

To Adelaide Suprano Adams,
ninety-seven years old,
the most beautiful woman
I know and love. Thank you, Mom,
for making me understand
the meaning of life.
—Eddie Adams

The generous support of the following individuals
and foundations made this book and its accompanying exhibition possible:
Daniel Abraham, Elliot Broidy, Peter L. Buttenwieser, Ron and Beth Dozoretz, Matt Gohd,
David and Storrie Hayden, Alexandra, Teddy, and Audrey King, Sidney Kimmel, Cheryl and Hani Masri,
Lynne O'Brien, Mary and Steven Swig, Carrie Trybulec, and Vardis and Marianna Vardinoyannis;
The Arca Fund, The Paul and Phyllis Fireman Fund, Furthermore, the publication program of The J. M. Kaplan Fund,
The Marjorie Kovler Fund, The General Motors Foundation, The Joseph P. Kennedy, Jr. Foundation,
The Robert F. Kennedy Memorial, The Open Society Institute, and The Reebok Foundation;
American Airlines, Arti Transcribers, Edelman Public Relations Worldwide, Four Seasons Hotels,
Marriott Hotels, Northwest Airlines, Starwood Hotels, and United Airlines.

TABLE OF CONTENTS

INTRODUCTION
BY KERRY KENNEDY CUOMO

In a world where there is a common lament that there are no more heroes, too often cynicism and despair are perceived as evidence of the death of moral courage. That perception is wrong. People of great valor and heart, committed to noble purpose, with long records of personal sacrifice, walk among us in every country of the world. I have spent the last two years traveling the globe to interview the fifty-one individuals from nearly forty countries and five continents included in these pages, people whose lives are filled with extraordinary feats of bravery. I've listened to them speak about the quality and nature of courage, and in their stories I found hope and inspiration, a vision of a better world.

The individuals portrayed here include the internationally celebrated, such as Baltasar Garzón of Spain, Vaclav Havel of the Czech Republic, Sister Helen Prejean and Marian Wright Edelman of the United States, and Muhammad Yunus of Bangladesh, as well as Nobel Prize laureates His Holiness the Dalai Lama, Archbishop Desmond Tutu, Elie Wiesel, Oscar Arias Sánchez, Rigoberta Menchú Tum, José Ramos-Horta, and Bobby Muller. But the vast majority of these defenders of human rights are mostly unknown and (as yet) unsung beyond their national boundaries, such as environmental feminist Wangari Maathai of Kenya, former sex slave and leading abolitionist Juliana Dogbadzi of Ghana, domestic violence activist Marina Pisklakova of Russia, mental disability-rights advocate Gabor Gombos of Hungary, leading human rights lawyers Asma Jahangir and her sister Hina Jilani of Pakistan, and over thirty more.

For many of these heroes, their understanding of the abrogation of human rights has been profoundly shaped by their personal experiences: of death threats, imprisonment, and in some cases, bodily harm. However, this is not, by any measure, a compilation of victims. Rather, courage, with its affirmation of possibility and change, is what defines them, singly and together. Each spoke to me

with compelling eloquence of the causes to which they have devoted their lives, and for which they are willing to sacrifice them—from freedom of expression to the rule of law, from environmental defense to eradicating bonded labor, from access to capital to the right to due process, from women's rights to religious liberty. As the Martin Luther Kings of their countries, these leaders hold in common an inspiring record of accomplishment and a profound capacity to ignite change.

Told in the defender's own voices, the interviews in this book provoke fundamental questions for the reader: why do people who face imprisonment, torture, and death, continue to pursue their work when the chance of success is so remote and the personal consequences are so grave? Why did they become involved? What keeps them going? Where do they derive their strength and inspiration? How do they overcome their fear? How do they measure success? Out of the answers emerges a sympathetic and strength-giving portrait of the power of personal resolve and determination in the face of injustice.

These fundamental questions have a special interest for me personally. As a mother of three young girls, I deeply wished to understand if there were steps I could take to encourage my own daughters to develop similar attributes, or if moral courage was something certain people are born with, inherently, while the rest of us (with our own lesser sensibilities) are left to muddle through. If we are capable of less, then are we off the hook? Condemned to be sinners, is there any point in striving to be saints?

With these considerations in mind, then, the criteria for the decisions that went into this narrow selection of individuals were complex. After nineteen years in the human rights field, there were certain individuals with whom I had worked and knew intimately that I wanted to include. There were certain

issues I thought should be represented as well as specific countries with egregious violations to highlight. I called upon friends and colleagues from human rights organizations across the world to suggest women and men dramatically changing the course of events in their respective communities and countries. From the outset, the goal was to show the range of these activities, their omnipresence in every continent, and the number of men and women alike participating in them. The resulting group (though so many other "heroes" are out there, their accomplishments enough fill a veritable encyclopedia) combine a wonderful mixture of absolute self-confidence and disarming humility. And some strong themes in their interviews began to emerge.

Almost all spoke about their faith in a higher power, most referenced a structured religion, a number had ambitions at some point to join a religious order, and at least six actually have (The Dalai Lama, Desmond Tutu, Bishop Wissa, Digna Ochoa, Dianna Ortiz, and Helen Prejean). Many talked more generally about being called to their work by some outside force. Juliana Dogbadzi spoke of "a calling," while Archbishop Desmond Tutu compared such an avocation to the prophets of old, with words burning in their throats. Fauziya Kassindja attributed her salvation to part of a divine plan wherein, "Everything happens for a purpose and whatever happens is destined," concluding, "God made this possible."

Strikingly, most of the defenders expressed an overpowering inner conviction, a driving force that helped sustain their path, in spite of dark moments. Gabor Gambos expressed it succinctly: "I had no alternative [but to] take up this role and find myself, or leave it and be lost forever." Ka Hsaw Wa explained how he overcame his own self-recriminations: watching many of his former classmates return from the United States with money and PhDs, he asked himself, "What am I doing...I don't gain anything for myself and I can't seem to do any-

thing to lessen the suffering....I blame myself for not being able to do enough," by coming to the recognition that, "If I turn my back and walk away, there would be no one to address the issue." Hafez Abu Seada and Zbigniew Bujak echoed that sentiment, speaking of taking on the task in order to help the next generation: "If not us, who else?" Koigi wa Wamere spoke of the long road a human rights defender must walk, and of the difficulty in returning to the struggle once you knew the consequences, but like José Ramos-Horta, remembered, "the spirits of those telling me to fight on," and stayed the course. Some described themselves, existentially enough, as dissidents through accidents of fate, like Vaclav Havel and Rigoberta Menchú Tum. Perhaps Harry Wu put the dilemma of personal sacrifice most clearly when he explained, "Once in exile, why shouldn't I have enjoyed the rest of my life? Why did I need to go back to China? The answer is that I tried to enjoy it, but I felt guilty—especially when people were calling Harry Wu a hero." Selflessness for a greater good was a refrain echoed by his compatriot Wei Jingsheng, who said, "It is impossible to balance personal life and commitment to your country when you face a massive oppressor. Your responsibility has to be with those who suffer. And if you do not fight tyranny, the tyrants will never let you have an ordinary life—so you simply have to give your life to the larger responsibility." All the defenders share a special empathy for others, a quality the Dalai Lama named as compassion, in Tibetan *nying je*: "The less we tolerate seeing others' pain, the more we do to ensure that no action of ours ever causes harm."

This sensitized appreciation for others developed in these remarkable individuals in various ways. Several defenders recalled an early moment or incident that galvanized their social conscience forever. Some told stories of searing childhood encounters with injustice, as when Digna Ochoa spoke of her union-organizing father's abduction and the family's bitter realization that they couldn't afford a

lawyer to help; or when Raji Sourani spoke of watching soldiers beat and shoot classmates in his grade school, and when Patria Jimenez spoke of bigotry in her own family against gays and her own experience of prejudice as a lesbian. Many defenders are members of groups that have endured sustained repression, and so have come to a natural understanding of the issues and desire to overcome the wrongs of the past, notably Marian Wright Edelman, and Juliana Dogbadzi. Others saw injustice in a community they were not a part of and took up the cause, such as Bruce Harris and Sister Helen Prejean. And still others had enjoyed the comforts of being among the elite in their countries, yet risked ostracization—and worse—to right wrongs committed by their peers, notably Natasa Kandic, Kailash Satyarthi, and Mohammad Yunus.

And while the overwhelming number of the individuals here share a past that includes torture, death threats, harassment, detention, and imprisonment, they would mention these experiences only when pressed. The diffidence was understandable on the most basic level, as avoidance of the memory of pain and suffering. As Dianna Ortiz put it, "No one should have to re-enter the torture chamber." But there were other reasons. Raji Sourani explained, "We have to be strong enough to make people feel we can defend them; we have to be strong enough to take care of the real victims."

Among the diversity of voices and causes two common themes emerged that took me by surprise. One was the centrality of maintaining a sense of humor. Vaclav Havel spoke eloquently on the subject, arguing that, "to stay human, it's important that you keep a certain distance...of absurdity," while Asma Jahangir told of gathering her colleagues after particularly terrifying incidents "for a good laugh," and Bruce Harris shared the grim humor of human rights work, relating how after his

Guatemalan office was riddled by machine guns, his New York headquarters sent him a bulletproof vest, "complete with a money-back guarantee." The second theme was the role of righteous anger. When asked about their source of strength to overcome fear, many described a calm at their moment of truth. While in Western European society, women are taught to repress anger, Digna Ochoa's fury and outrage at the cruelty of the perpetrator actually helped her prevail, proving that anger, too, can be harnessed for noble purpose. On the pyramids, constructed by slave labor, ancient graffiti reads, "No one was angry enough to speak out;" yet the defenders show us how to raise up our voices against injustice.

Despite the overwhelming powers arrayed against them, these men and women are, as a whole, an optimistic lot. Archbishop Tutu emphasizes this attitude when he says, "We have a God who doesn't say, 'Ah ... Got you!' No. God says, 'Get up,' and God dusts us off and God says, 'Try again.' " Perhaps the stance should be qualified as less optimistic than hopeful. Overwhelmingly pragmatic and realistic about the prospects for change, all too aware of the challenges they face, nonetheless they continue to roll their boulders back up the hill. Oscar Arias Sánchez points out, "In a world which presents such a dramatic struggle between life and death, the decisions we make about how to conduct our lives, about the kind of people we want to be, have important consequences. In this context, one must stand on the side of life....One works for justice not for the big victories, but simply because engaging in the struggle is itself worth doing."

But those who seek social justice do share a unifying sense of fulfillment. Marian Wright Edelman references Henrik Kierkegaard, who wrote that we must all: "Reach into the envelope that God has placed in our soul to determine why we were placed on this earth." In this group of women and men, one feels immedi-

ately that they have discovered the meaning of their own lives, and accordingly devoted themselves to the tasks for which they were placed among us. Perhaps this accounts for the deep spirituality and sense of peace one feels around so many of the defenders; peace at an essential, deep level, not to be confused with satisfaction. For the defenders have dreams, too. Abubacar Sultan said, "I hope that some day we will have a world in which children can be treated like children again, given all the opportunity they deserve as human beings." That is, in essence, the ambition of all the people in this book. Just as they challenge governments, these individuals challenge each of us to move beyond physical comforts to some higher order of aspirations and to take up the cause of a more just, more decent world. When the Dalai Lama demands that we think of those who destroyed his country and massacred his people, not as murderers and thieves, but as human beings deserving of our compassion, it is this sense of love, not at the policy and statistical level, but at the human one, that shows us how lives can be changed because of our actions—or lost due to our failure to act.

These voices are, most of all, a call to action, much needed because human rights violations often occur by cover of night, in remote and dark places. For many of those who suffer, isolation is their worst enemy, and exposure of the atrocities is their only hope. We must bring the international spotlight to violations and broaden the community of those who know and care about the individuals portrayed. This alone may well stop a disappearance, cancel a torture session, or even, some day, save a life. Included in the book (pages 253-254) is the resource guide of contact information for the defenders and their organizations in the hope that you, the reader, will take action, send a donation, ask for more information, get involved. The more voices are raised in protest, the greater the likelihood of change. That lift to the human spirit is difficult to measure but well worth undertaking.

Abubacar Sultan, who risked his own life again and again to rescue child soldiers in Mozambique, explained why he continues his work: "You are a human being and there are other human beings there; you are in a better position than they are. So you need to sacrifice. It's hard to explain. It is, perhaps, a kind of gift that you have inside yourself."

Just a few weeks after I interviewed Digna Ochoa, two armed, masked gunmen broke into her small apartment, tied her up, interrogated her, and set off a gas canister in her closed kitchen. Miraculously, she survived. She contacted me, and I, in turn, spoke to others about her plight and the need to protect her. Did all those voices on behalf of a nun in Mexico help shield her from further atrocities? We will never absolutely know, but in the human rights world you must act on faith that what you are doing might make a difference, and is therefore worth doing. How you measure success in that context, I'm not sure. But I do know from the reaction of many people who have transcribed tapes and edited these words and read them in their present form for the first time that the experience of the interviews is haunting, transformative. Meeting these heroes will help readers and viewers alike discover that gift inside themselves, and in turn help them transform their own communities, and our shared world.

I grew up in the Judeo-Christian tradition where we painted our prophets on ceilings and sealed our saints in stained glass. They were superhuman, untouchable, and so we were freed from the burden of their challenge. But here on earth, people like these and countless other defenders are living, breathing human beings in our midst. Their determination, valor, and commitment in the face of overwhelming danger challenge each of us to take up the torch for a more decent society. Today we are blessed by the presence of these people. They are teachers, who show us not how to be saints, but how to be fully human.

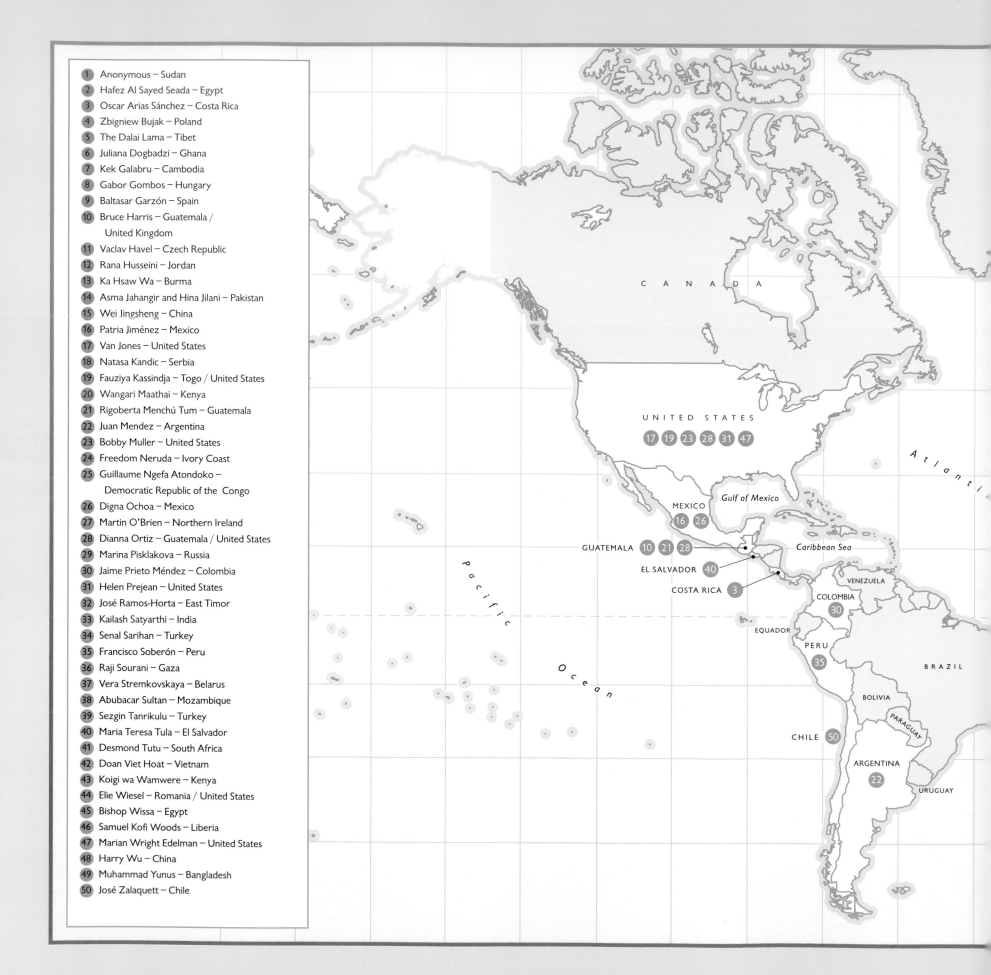

1 Anonymous – Sudan
2 Hafez Al Sayed Seada – Egypt
3 Oscar Arias Sánchez – Costa Rica
4 Zbigniew Bujak – Poland
5 The Dalai Lama – Tibet
6 Juliana Dogbadzi – Ghana
7 Kek Galabru – Cambodia
8 Gabor Gombos – Hungary
9 Baltasar Garzón – Spain
10 Bruce Harris – Guatemala /
 United Kingdom
11 Vaclav Havel – Czech Republic
12 Rana Husseini – Jordan
13 Ka Hsaw Wa – Burma
14 Asma Jahangir and Hina Jilani – Pakistan
15 Wei Jingsheng – China
16 Patria Jiménez – Mexico
17 Van Jones – United States
18 Natasa Kandic – Serbia
19 Fauziya Kassindja – Togo / United States
20 Wangari Maathai – Kenya
21 Rigoberta Menchú Tum – Guatemala
22 Juan Mendez – Argentina
23 Bobby Muller – United States
24 Freedom Neruda – Ivory Coast
25 Guillaume Ngefa Atondoko –
 Democratic Republic of the Congo
26 Digna Ochoa – Mexico
27 Martin O'Brien – Northern Ireland
28 Dianna Ortiz – Guatemala / United States
29 Marina Pisklakova – Russia
30 Jaime Prieto Méndez – Colombia
31 Helen Prejean – United States
32 José Ramos-Horta – East Timor
33 Kailash Satyarthi – India
34 Senal Sarihan – Turkey
35 Francisco Soberón – Peru
36 Raji Sourani – Gaza
37 Vera Stremkovskaya – Belarus
38 Abubacar Sultan – Mozambique
39 Sezgin Tanrikulu – Turkey
40 Maria Teresa Tula – El Salvador
41 Desmond Tutu – South Africa
42 Doan Viet Hoat – Vietnam
43 Koigi wa Wamwere – Kenya
44 Elie Wiesel – Romania / United States
45 Bishop Wissa – Egypt
46 Samuel Kofi Woods – Liberia
47 Marian Wright Edelman – United States
48 Harry Wu – China
49 Muhammad Yunus – Bangladesh
50 José Zalaquett – Chile

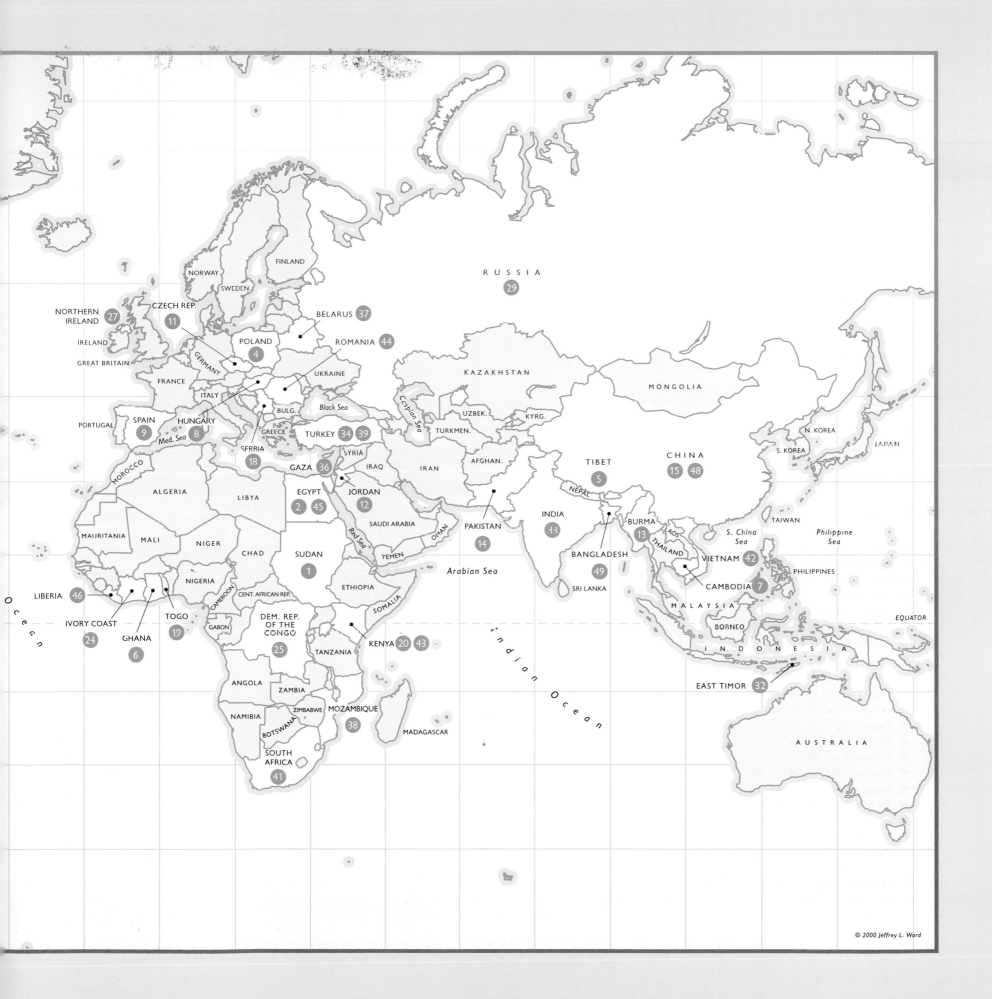

NORTHERN IRELAND 27

CZECH REP. 11

BELARUS 37

RUSSIA 29

FINLAND

NORWAY

SWEDEN

IRELAND

GREAT BRITAIN

POLAND 4

ROMANIA 44

UKRAINE

KAZAKHSTAN

MONGOLIA

FRANCE

GERMANY

ITALY

PORTUGAL

SPAIN 9

HUNGARY 8

Med. Sea

BULG.

Black Sea

GREECE

SERBIA 18

TURKEY 34 39

Caspian Sea

TURKMEN.

UZBEK.

KYRG.

N. KOREA

S. KOREA

JAPAN

SYRIA

TIBET

CHINA 15 48

MOROCCO

GAZA 36

IRAQ

IRAN

AFGHAN.

NEPAL 5

ALGERIA

LIBYA

EGYPT 2 45

JORDAN 12

SAUDI ARABIA

PAKISTAN

INDIA 33

BURMA 13

TAIWAN

MAURITANIA

MALI

NIGER

CHAD

SUDAN 1

Red Sea

YEMEN

OMAN

Arabian Sea

BANGLADESH 49

LAOS

THAILAND

VIETNAM 42

S. China Sea

Philippine Sea

PHILIPPINES

LIBERIA 46

NIGERIA

CENT. AFRICAN REP.

ETHIOPIA

SRI LANKA

CAMBODIA 7

IVORY COAST 24

GHANA 6

TOGO 19

CAMEROON

GABON

DEM. REP. OF THE CONGO 25

SOMALIA

MALAYSIA

BORNEO

EQUATOR

KENYA 20 43

TANZANIA

Indian Ocean

INDONESIA

ANGOLA

ZAMBIA

EAST TIMOR 32

NAMIBIA

BOTSWANA

ZIMBABWE

MOZAMBIQUE 38

MADAGASCAR

AUSTRALIA

SOUTH AFRICA 41

Ocean

© 2000 Jeffrey L. Ward

ABUBACAR SULTAN

MOZAMBIQUE

CHILD SOLDIERS

"The boy's family was shot in front of him and cut to pieces.
He shared with me the worst moments of his young life."

The war in Mozambique (1985–1992) left 250,000 children displaced and 200,000 orphaned, while tens of thousands more were forcibly recruited and put into combat. It was rare that government forces and guerrillas engaged— combat was waged almost exclusively against unarmed civilians. In the midst of the brutality Abubacar Sultan traveled the country across roadless lands and on tiny planes to rescue the children of war—kids, six to thirteen years old, who had been forced to witness and, in some cases, to commit atrocities against family members and neighbors. Sultan trained over five hundred people in community-based therapies and his project reunited over 4,000 children with their families. Sultan put his life at grave risk on a daily basis. Today he continues his work with children, concentrating on community education and children's rights through his initiative Wona Sanaka.

When the war started in Mozambique, I was finishing teacher training at the university. Neighbors, relatives, friends of those who were kidnapped, and people who fled from war zones brought back news of the war and the suffering.

By the end of 1987, UNICEF estimated that 250,000 children had been orphaned or separated from their families. A high percentage was involved in the war as active combatants, forcibly trained and forcibly engaged in fighting. I was shocked by pictures of child soldiers who had been captured by government forces and others who were shot in combat. Something wrong was going on. I couldn't keep going to my classes, teaching students, while all these things were happening in my country. I decided to do something.

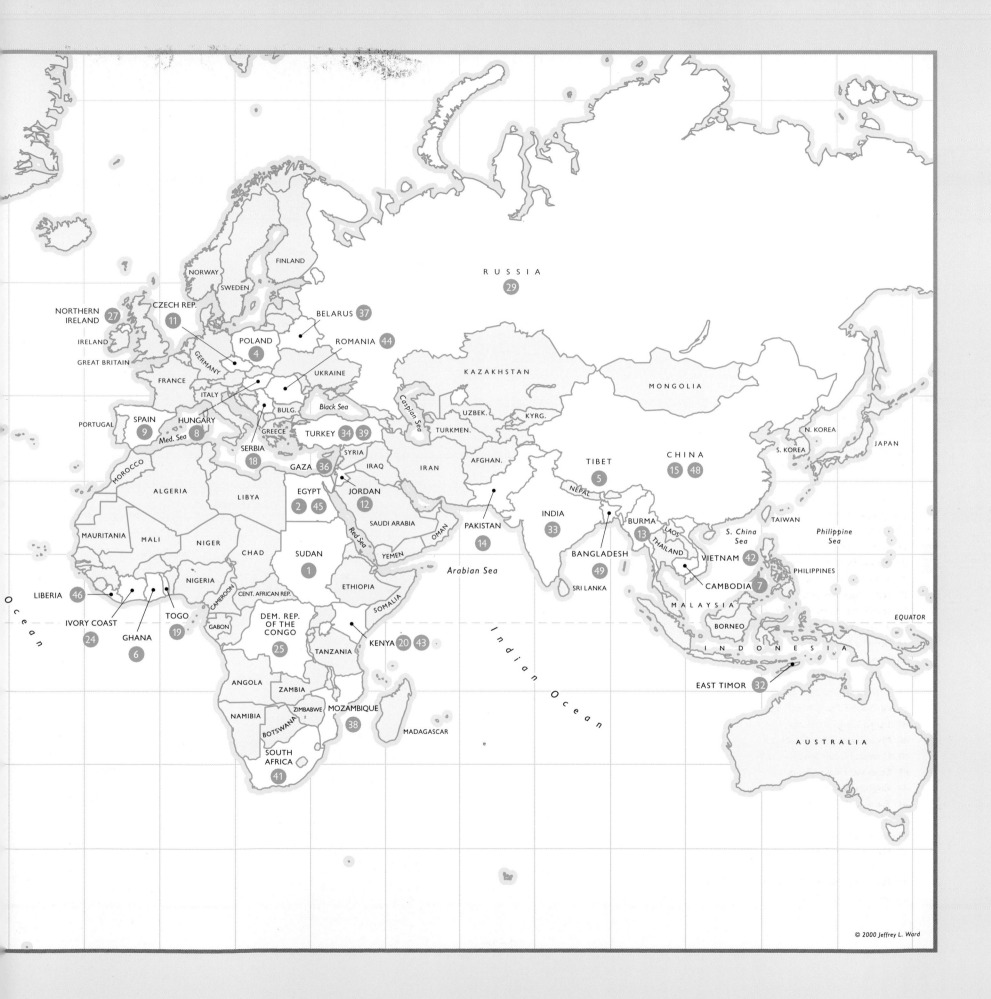

ABUBACAR SULTAN

MOZAMBIQUE

CHILD SOLDIERS

"The boy's family was shot in front of him and cut to pieces.
He shared with me the worst moments of his young life."

*The war in Mozambique (1985–1992) left 250,000 children displaced and
200,000 orphaned, while tens of thousands more were forcibly recruited and
put into combat. It was rare that government forces and guerrillas engaged—
combat was waged almost exclusively against unarmed civilians. In the
midst of the brutality Abubacar Sultan traveled the country across roadless
lands and on tiny planes to rescue the children of war—kids, six to thirteen
years old, who had been forced to witness and, in some cases, to commit
atrocities against family members and neighbors. Sultan trained over five
hundred people in community-based therapies and his project reunited over
4,000 children with their families. Sultan put his life at grave risk on a daily
basis. Today he continues his work with children, concentrating on commu-
nity education and children's rights through his initiative Wona Sanaka.*

When the war started in Mozambique, I was finishing teacher training at the uni-
versity. Neighbors, relatives, friends of those who were kidnapped, and people
who fled from war zones brought back news of the war and the suffering.

By the end of 1987, UNICEF estimated that 250,000 children had been
orphaned or separated from their families. A high percentage was involved in
the war as active combatants, forcibly trained and forcibly engaged in fight-
ing. I was shocked by pictures of child soldiers who had been captured by
government forces and others who were shot in combat. Something wrong
was going on. I couldn't keep going to my classes, teaching students, while all
these things were happening in my country. I decided to do something.

Around that same time, a local orphanage took in thirty-five kids captured in combat. A psychiatrist and a social worker interviewed these children, and what they heard was truly horrifying: entire families kidnapped, taken into the bush, forced to carry heavy loads to military base camps, and subjected to all kinds of abuse. Children were beaten, sexually violated, and compelled to witness killings and beatings, pressed into combat and urged to commit murder. These were common practices. Many of these children had been physically injured, and most of them were traumatized.

One particular seven-year-old boy who had been kidnapped changed my life. When I arrived at this orphanage, he was completely withdrawn from the world. He would be calm one day and cry continuously the next. Finally he started speaking. He said he was living with his family when a group of rebel soldiers woke him up at night, beat him, and forced him to set fire to the hut where his parents were living. And when his family tried to escape from the hut, they were shot in front of him and then cut into pieces. I will never forget his feelings, because I kind of went inside him and he shared with me the worst moments of his life. The images, the bad images I had from my childhood of small things that hurt me, all came alive. And sometimes I tried to put myself into his position and tried to live his experience. His was just one story among many others.

In conjunction with Save the Children (U.S.), we developed a program to gather information about children who had been separated from their families by the war. While the point of this program was to provide the victims with psychological and social help, it soon became obvious that we did not have the necessary resources. We were mostly left with the mission of helping the children leave the war areas and return to their families. We went into the war zones every day, documented as many children as possible, and tried to trace them to communi-

ties of displaced people inside the country, and to refugee camps in neighboring countries. Whenever possible we took children to safer environments.

Most of these kids were on the front so that's where we went. In some cases we didn't have permission from the government to go there, and furthermore, we never had permission from the rebels, since we didn't have any contact with them. Among the most basic needs we wanted to provide for the kids was access to water, food, and to simple medicine in order to fight the spread of malnutrition, malaria, cholera, and other diseases. But if a kid was injured with bullets in his body, or had been maimed by land mines, you had to address that before you could start doing your real work. Our lives were thus in permanent danger, too.

There were no safe roads in the country then, and the only way to reach those areas was by plane. On several occasions, we were almost shot down. We landed on airstrips that had been heavily mined. We had several plane accidents. Whenever we got too frightened, we tried to remember how lucky we were even to be alive.

The conflict in Mozambique was unique in the sense that it targeted only civilian populations. Direct combat between the government and rebel forces was very, very rare. In most cases, they would just go into the villages and into the huts and loot everything and kill everybody, or kidnap people and steal everything. In this process girls and boys were taken and indoctrinated as soldiers. At the end of the war we had evidence that many girls were used as maids and as sexual partners to the soldiers. After a few years of indoctrination, these kids became perfect killing machines. They would do exactly what their perpetrators had done to them: cold-blooded killing.

Everyone who promoted this war was to blame. There was a real psychology of terror. People risked being killed if they dissented from whatever they were forced to do. Either you killed or you were killed. That's what made people do what they did. Even life in the rebel camps was so bad and so difficult that the only people who had access to food or to the basic necessities were the soldiers. Being a soldier, in that context, meant that you would survive. It was as simple as that.

The camps no longer exist today. They were dismantled as part of the peace agreement. But the problem is that many of the kids were left behind as part of the demobilization process. The United Nations provided resettlement to adult soldiers but since the former fighting armies denied they had children in their forces, resettlement was not available to them. We tried to follow up but we were only able to provide support for something like eight hundred kids. We don't know what happened to the majority of them. They just went to a place where they felt safe and often the only place that they considered home was the place where they lived during the war.

Many times I asked myself why I chose this work. I had two kids and until they reached the age of four or five, I didn't spend more than two or three days a month with them. I finally came to realize that I was hurting my own family. They were always worried about my safety. And yet, there was something strong within myself that responded to saying I was a human being and there were other human beings out there in danger. And if those who are close to you are in a better position than those who suffer, you need to sacrifice some of your own privileges. It's hard to explain. It's perhaps a kind of gift that you have inside yourself. Part of the explanation lies in religion (I am a practicing Muslim) and part in education. Yet, there are many other people like myself who never considered doing what I did. Hence, it must be something deeper, something inside.

And though our program succeeded in reuniting about twenty thousand children with their families, when you consider that over a quarter million children were orphaned or lost during the war, our efforts seemed almost insignificant. We had the constant feeling that we were spending too much money to help only a few hundred children, even though I had worked as hard as I could.

Now that the war is over, the country is finally recovering and slowly making its transition into economic development and democracy. It's become clear to me that those who were suffering at the time of the war were the same as those who were most affected when the war was over: the ones who still lack basic resources. They are the ones who continue to be maimed by land mines in the country. The girls in the rural areas are the ones who have limited access to education, and who are still subjected to all kinds of abuse. It also became apparent to me that programs of education and health continue to focus on urban areas, where people are mostly safe, whereas in all those former frontline territories, there is nothing going on. Children continue to die of diseases that in other parts of the country can be easily treated. The struggle is far from over, and despite the end of the war, there is an ongoing war to improve children's rights and welfare.

I hope that some day we will have a world in which children can be treated like children again and in which they can be given all the opportunity they deserve as human beings. I imagine a world in which "humanness" would be the guiding principle behind rules and laws. I hope that someday we will reach this ideal.

You see, once you give people the opportunity to express their potential, many problems can be solved. My country is an example in which people were able to use their own resources in the most extreme and difficult circumstances. People really are resilient, and in countries like mine, that has an important meaning. And in that you must believe.

JULIANA DOGBADZI

GHANA

———

SEX SLAVERY

"I was a kid, seven years old, when my parents took me from our
home to captivity in a shrine where I was a sex slave to a fetish priest."

Juliana Dogbadzi, enslaved in a shrine in her native Ghana as a young child under a custom known as Trokosi, was forced to work without pay, without food or clothing, and to perform sexual services for the holy man. She was able to escape seventeen years later, after several failed attempts, at the age of twenty-three. Trokosi comes from an Ewe word meaning "slave of the gods," and is understood as a religious and cultural practice in which young girls, mostly virgins, are sent into lifelong servitude to atone for the alleged crimes of their relatives. In 1997, it was estimated that approximately five thousand young girls and women were being kept in 345 shrines in the southeastern part of Ghana. Through Juliana Dogbadzi's daring escape and her subsequent efforts to denounce the system, the Trokosi practice was banned in Ghana; however, law enforcement against Trokosi is still lax. Dogbadzi speaks out against Trokosi, traveling the country, meeting with slaves, and trying to win their emancipation; and increasingly, she is not alone in her courageous stance.

I have never been in a classroom. I have never been to school. When I was seven years old, my parents took me from our home and sent me to a shrine where I was a slave to a fetish priest for seventeen years. My grandfather, they said, had stolen two dollars. When he was suspected of the crime and asked to return the money, he defended his innocence. The woman who had accused him of the crime went to the shrine and cursed my grandfather's family, at which point members of my family began to die. In order to stop the deaths, a soothsayer told us that my grandfather would have to report to the Trokosi shrine. The priest told my family that it must bring a young girl to the shrine to appease the gods. A sister was sent to the shrine at Kebenu some six hundred miles away, but she died a few years later. Since I had been born just after my grandfather's death, I became her replacement.

I lived and worked in the priest's fields and kept the compound clean. While doing so, I was raped repeatedly by the priest on torn mats on the cold floor of windowless huts. The other female slaves and I received neither food nor medical care. We had to find time after working on the priest's farm to burn charcoal or to sell firewood in the nearest town in order to make enough money to buy food. There were times we lived on raw peppers or palm kernel nuts to stay alive.

Because I was just a kid, I didn't know what to do. There was an elder woman who was a slave and took care of me. She couldn't help me much because she had so many kids as a consequence of being raped by the priest. She said, "Look, little girl, take care of yourself or you will die." There used to be a hundred women slaves in my shrine, but the priest sent about ninety of them to work on his farms in other villages. Collectively, they had about sixty-five children and would have to work to look after the children.

Twelve of us, four women and eight children, lived in a one-room, thatched-roof house. It was built of mud and lacked both windows and doors. The rain got in. The snakes got in. The room was twenty feet long and twelve feet wide. The ceiling was low, just shy of our heads, and we all slept together on a mat on the floor. This is not everything that I can remember, but saying it brings back pains of old and it's difficult to go back through all those experiences.

You see, in the shrine you have no right to put on shoes or a hat to protect yourself against the hot sun. If it is raining or cold, you have only a small piece of cloth around yourself. A typical day in the shrine was as follows: you wake up at five o'clock in the morning, go to the stream about five kilometers away to get water for the compound, sweep, prepare meals for the priest (not eating any yourself), go to the farm, work until six o'clock, and return to sleep without food or to scrounge for leftovers. At night, the priest would call one of us to his room and would rape us. I was about twelve when I was first raped.

There was favoritism even in slavery. The priest liked girls who would readily give in to his sexual demands and hated those who would always put up a fight. Consequently, these girls were beaten. The ones he liked always said they were being wise because they wanted to avoid being beaten, while some of us maintained that they were foolish and were enjoying sex with a man they didn't love. When I saw people who came to the village to buy food wearing nice dresses, I started to think that I had to do something for myself. I had to get freedom.

I had to do something that would change my life. I escaped several times. The first time I escaped, I went to my parents. I told them I was suffering in the shrine, but they were scared to keep me. They said that if they did, the gods would strike them dead. They brought me back to the priest to suffer the same pain again. I thought, no. This is not going to happen again. I had to find a way to free myself and free the other women, too.

The second time I escaped, I went to a nearby village. A young man fed me and took me to himself. He took advantage of me and made me pregnant. When the priest found out, he sent young men around the village to get me. They beat me endlessly and I had lots of cuts on my body. I collapsed and nearly died. The child's father had wanted to take care of us, but the priest threatened him with death. The young man who was taking care of me was asked to pay some bottles of hard liquor and a fowl and warned to stay away from me or die. I haven't seen him since and he hasn't seen our child.

The third time I escaped, I resolved that I would never again go back to the shrine. By this time, I was three months pregnant as a result of another rape that I had suffered from the priest. I was not feeling very well. For a number of days I had starved. I was pregnant and needed to get some food. Otherwise, I was going to die. I decided to go to a nearby farm owned by the priest to get an ear of corn from the crop which the other slaves in the shrine and I had planted. I was caught stealing the corn and the priest ordered the young men around the village to beat me until I fell unconscious. When I came to, I saw all the bruises and wounds on my body and nearly lost the baby I was carrying. I decided I had to leave or I would be killed. But it was not to be. I was scared and I went back to the shrine again. Yet, that was the turning point. I was about seventeen or eighteen at the time and resolved that I was going to do something to help other people in the shrine.

One day, a man representing a nonprofit organization called International Needs–Ghana came to the shrine to talk to the priest. This was my chance. I don't know where my sudden confidence came from, but all my fear had disappeared. I was no longer afraid of death and was prepared to die for others. Thank God I had that feeling! I did not escape immediately because I was very weak, my pregnancy was well advanced and I could not walk a long distance. Luckily, I had the baby a few weeks later. With the baby strapped to my back and the first child, Wonder, in my hands, I escaped through the bush to the major street where I was given a lift to Adidome and to the site of International Needs–Ghana.

The members of the organization taught me a lot of skills and kept me away from the priest. They trained me in bread baking and other vocations. Nonetheless, I

> "The shrine is a crime against children. The child of a slave shares his mother's plight. When the mother has food to eat, the child eats. If she has no food, the child will starve."

thought, "There are more women who remain in the shrine who need help. No one is going to represent them better than someone who has been in the shrine and who has gone through the pain, someone who can tell the world what happens in the shrine. If no one stops this practice, we will all have to die in pain." Against all odds, I decided to take the responsibility of addressing the issue and have been doing so ever since. I went to the shrines and spoke to the inmates. I told them that they needed to gather courage like I had and to get out.

The shrine claims powers it does not have in order to instill fear in the slaves and to stop them from escaping. The practice is a deliberate attempt by men to subjugate women. A man commits a crime and a woman has to pay for it. That is unacceptable. Likewise, the shrine is a crime against children. The child of a slave shares his mother's plight. When the mother has food to eat, the child eats. If she has no food, the child will starve. If she has clothing, the child will likewise have some. If not, that is it. If she goes to the farm, the child goes along. There are thousands of women *Trokosi* slaves with children who need to be helped. Those who have been liberated also require help in order to recover from the suffering endured in the shrines.

Unlike most of the other girls and women, I got over the fear instilled by the *Trokosi* system. This was my weapon. Now that I have escaped, I help to dimin-

ish the women's fears by telling them my story. I tell them what I am presently doing, that I am still alive, not dead, as they have been made to believe. I try to help the priests to understand the pain that the women have endured. Some do not allow me to enter their shrines any longer. When I am in the city, I educate people about life in the shrines and advocate for an end to the practice.

What I do is dangerous, but I am prepared to die for a good cause. People send threats by letter and others confront me openly. Thank God that those I work with are very strong and give me encouragement. At the moment, eight girls have joined me in my work with the organization. My next step to disbanding *Trokosi* is to ensure enforcement of the law and to get allied organizations in the Republics of Togo and Benin to stop this practice in their respective countries.

I do believe I have a calling because it is strange to be alive and sane and working after going through what I went through. The help that I have received from International Needs and my own confidence have made all the difference. I have totally forgiven my parents because I know that what they did to me was done through ignorance and fear. I don't want them to feel guilty so I avoid telling them about my experiences. I don't, however, see them often. I am glad to say that I am now happily married and have just had my first planned baby with the man I love. My life today is like the life of any other young woman.

BRUCE HARRIS

CHILDREN'S RIGHTS

"Why are the children hungry?
Why are they being abused and murdered?"

BRUCE HARRIS

Throughout Latin America, homeless children are beaten, tortured, raped, and murdered with virtual impunity. Bruce Harris is Central America's foremost advocate for "street kids." Since 1989, Harris has been the director of Casa Alianza, in Guatemala City, which provides food, shelter, medical care, drug rehabilitation, counseling, skill training, legal aid, and other services to forty-four hundred homeless children abandoned to the streets. His investigations have led to 392 criminal prosecutions where children were the victims, and he was the first person in the history of Guatemala to successfully sue police for the murder of a street child. At the request of the attorney general, Harris investigated and exposed a baby-trafficking ring where poor women were tricked into giving up their infants for adoption. Bound for the United States, these infants yielded a hefty twenty-thousand-dollar fee each for unscrupulous middlemen. One alleged perpetrator (married to the president of the Guatemalan Supreme Court) then filed criminal charges against Harris for defamation. In Guatemala, truth is no defense in a defamation suit, and defamation is a criminal offense. Despite the danger of imprisonment (with some of the fifteen law enforcement personnel he helped land in jail), Harris forges ahead.

I'm not fully sure of what my reason for being is, but a lot of it is to protect children who have nobody to protect them. We are the sum of the parts of people who have had an impact on us in our own lives. We all have our heroes. Mine is Nahaman.

Soon after I joined Casa Alianza, I befriended Nahaman, a thirteen-year-old boy. One day, Nahaman's best friend, Francisco, came to the crisis center and shouted through the gate for him to get high, and by midnight seven or eight kids were huddled around with their faces submerged in plastic bags of glue, two blocks from the main police station. When the shift changed, five policemen emerged. One pointed his gun at the kids and told them to freeze. The kids ran and the cops caught a few, grabbed the bags of glue and literally started to pour it over their heads and into their eyes. Why? Because the kids would have to shave their heads to get the glue off and a shaved head indicates that you're a criminal.

Nahaman pushed the policemen's hands away, and they took this as an affront. They grabbed him and threw him to the ground and they kicked the dickens out of him—a thirteen-year-old boy against four grown men. He doubled over, screaming, and they kicked him unconscious. He lost control of his bladder. He had six broken ribs. There was bruising over 60 percent of his body. His liver had burst.

Meanwhile, Francisco was hiding underneath a car watching, and when the cops took off, he called an ambulance. But the ambulance never arrived—they didn't believe the kids. The kids thought Nahaman was dead. And to show you that part of their reality is to accept death as part of life on the street, they just went off to a park and went to sleep for a few hours.

When they woke up, they flagged a police car, who called an ambulance. They thought the boy was just intoxicated, so they put him under observation. By coincidence one of our social workers was in the hospital when Nahaman happened to regain consciousness and he told her what happened. She called the doctor and they found one and a half liters of blood in his abdomen and evidence of brain damage. He went into convulsions, suffered for ten days, and then he died.

Looking back on it, I realize Casa Alianza was in bed with the wrong people. We started out just offering food and shelter—but that was naive. I keep thinking of

a priest in Brazil who said, "When I feed the hungry, they call me a hero; when I ask why the people are hungry, they call me a Communist." It is a noble task to feed the hungry (and quite honestly it would be more comfortable just to feed them!) but as an agency we have matured into asking why the children are hungry and why they are being abused and murdered.

When Francisco said the men who killed Nahaman were policemen, our first reaction was we've got to do something, but then the brain starts to rationalize all the reasons why you shouldn't: it's very dangerous, this is Guatemala, people get killed, there's a certain moral dilemma. But then you see Nahaman laying out there, and the path is so clear. Or is it?

We spoke with ten other children's advocacy groups and decided we should call for a meeting with the police: but only two groups showed up. It was the beginning of the realization that this was going to be a long, lonely road. And while I can understand why people didn't want to raise their voices, it would have made it a damn sight easier if they did. When it's just one organization that's crying out, then you become very vulnerable. We started getting phone calls and death threats. And as we started pushing more and more, the crisis center itself was attacked.

It was mid-morning when a BMW with no license plates and polarized windows came to the crisis center in the middle of Guatemala City. Three men with machine guns went to the gate, asked for me by name, and said, "We've come to kill him." The guard was terrified, and said I wasn't there. They got back in the vehicle, and came back down the street and opened fire with machine guns. Thank God none of the kids was shot. When something like that happens, you call the police—funny in this case. So the police came very quickly and they took away all the bullets. They took away all the evidence. It shows how naive we were. When Covenant House in New York heard about the incident, they sent me a bulletproof jacket. It had a money-back guarantee, if for any reason it didn't work!

One of the greatest favors the perpetrators of this violence did for us was to spray our building with machine-gun fire because it was tangible evidence that we were doing something that affected interests. We were protecting children but there was something more here than met the eye. We were challenging the status quo, the way Guatemala had for decades operated, challenging the assumption that if a man had the gun and the uniform, he could get away with murder—literally.

Street kids aren't easy. When you see a kid who's been beaten or has a black eye or bullet holes in him, and he's not crying, then serious emotional damage has happened to that kid. If you start to show your feelings, you start to show what they perceive to be weakness. But when they assume the risk to love you, that's very personal.

The proof of it is that the most difficult thing for kids when they come into our program is a hug. Often it's the first time there's an honest sign of affection— with nothing expected in return. What we're trying to do is give children back their childhood—if it's not too late.

I truly dream of a world in which children will not have to suffer. We may not reach that between today and tomorrow, but at least there will be fewer kids on the street.

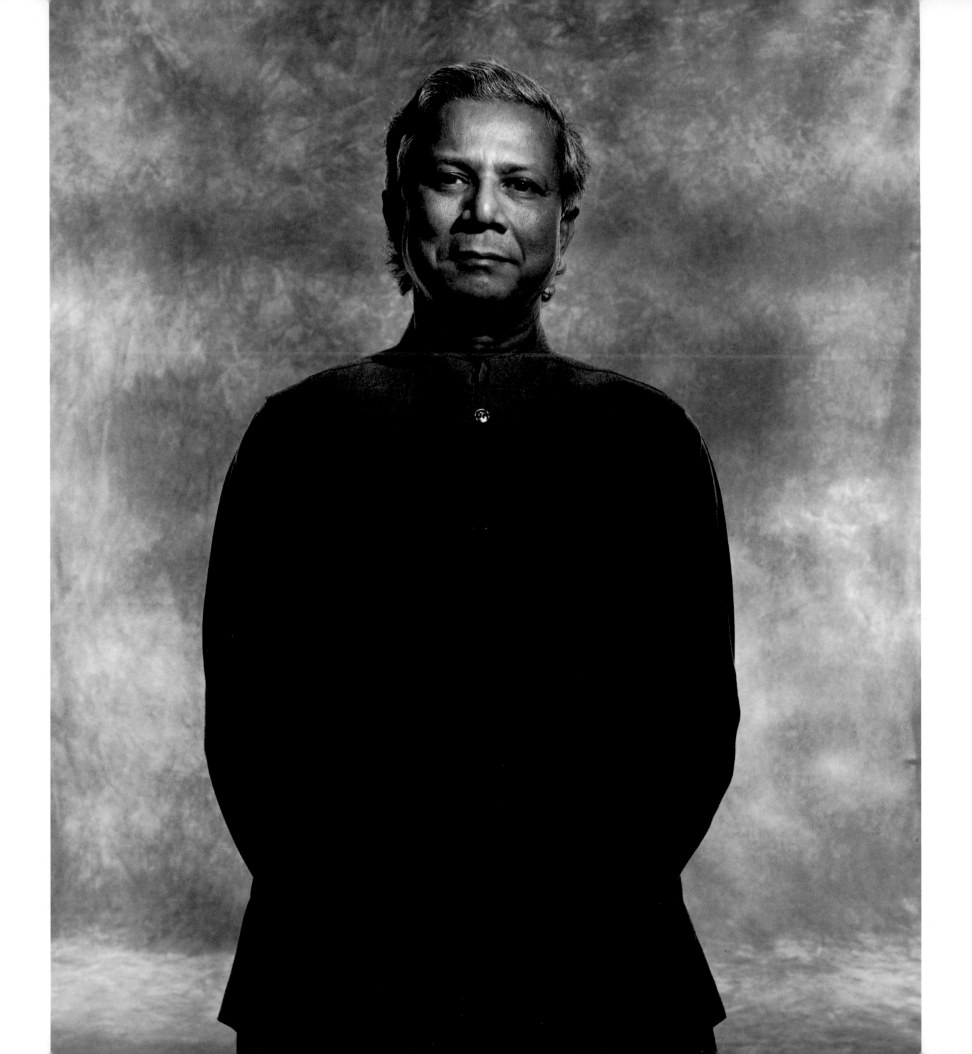

MUHAMMAD YUNUS

BANGLADESH

MICROCREDIT

"And she struggles to pay that first loan and then the second installment due the following week. And when she has paid completely, she can say, 'I did it!' It's not just a monetary transaction that has been completed, it is nothing less than the transformation of that person."

Founder of the Grameen Bank, the world's largest and most successful microcredit institution, Muhammad Yunus was born in one of the poorest places on earth, the country (then part of Pakistan) of Bangladesh. As a professor of economics, he was struck by the discrepancy between the economic theory taught in universities and the abject poverty around him. Recognizing the poor remained poor because they had no access to capital, no collateral for loans, and borrowing requirements so modest that it was not cost-effective for large banks to process their needs, Yunus started experimenting with small collateral-free loans to landless rural peasants and impoverished women. In 1983, he founded the Grameen Bank. Its rules were strict and tough. Clients find four friends to borrow with. If any of the five default, all are held accountable, building commitment and providing community support. Initial loans are as little as ten dollars, and must be repaid with 20 percent interest. Nearly twenty years later, this revolutionary bank is flourishing, with more than 1,050 branches serving 35,000 villages and two million customers, 94 percent of them women. Ninety-eight percent of Grameen's borrowers repay their loans in full, a rate of return far higher than that of the rich and powerful. More importantly, the clients are transforming their lives: from powerless and dependent to self-sufficient, independent, and politically astute. The real trans-

formation will be felt by the next generation: a generation with better food, education, medication, and the firsthand satisfaction of taking control of their lives, thanks to Yunus's vision, creativity, and confidence.

When I started the Grameen program to provide access to credit for the poor, I came upon two major obstacles. First, commercial banks were institutionally biased against women. Secondly, they had absolutely blocked credit to the poor by demanding something no poor person has access to: namely, collateral.

After overcoming the second issue, I addressed the first. I wanted half of the borrowers from banks in my program to be women—a challenge. At first, women were reluctant to accept loans. They said, "No, no, I have never touched money in my life. You must go to my husband. He understands money. Give the money to him." So I would try to explain why a loan would benefit her family. But the more I tried to approach women, the more they ran away from me. My colleagues and I worked hard to come up with a way we could build trust in women so that they would accept loans from men. We slowed down our work just to include more women, since this trust-building took time.

Six years later, proud that half our loans were to women, we began to see something very remarkable. Money that went to families through women helped the families much more than the same amount of money going to men. Unlike men, women were very cautious with money and passed benefits on to their children immediately. They had learned how to manage with scarce resources. And women had a longer vision; they could see a way out of poverty and had the discipline to carry out their plans. Perhaps because women suffer so much more from poverty than men, they are more motivated to escape it.

In contrast, men were looser with money. They wanted to enjoy it right away, not wait for tomorrow. Women were always building up things for the future, for themselves, their children, their families. We saw a number of such differences between men and women.

We decided to make a concerted effort to attract women clients because we got much more mileage out of the same amount of money. So I created incentives for our loan officers because they had such a hard time convincing women to borrow money from the bank. Today, 94 percent of our loans go to women.

It has worked in ways we never anticipated. For instance, women borrowers decided to commit themselves to a set of promises that they called the "sixteen decisions." These are commitments to improve the welfare of the borrowers and their families above and beyond the loans. They agreed to send their chil-

dren to school, they decided to maintain discipline, to create unity, to act with courage, and to work hard in all their endeavors. They agreed to keep their families small, to send their children to school, to plant as many seedlings as possible, even to eat vegetables. These are some of the resolutions created by the women, not imposed by the bank. These aspirations were critical to their lives. Listening to them, you see what a difference women make.

A typical initial loan is something like thirty-five dollars. The night before a woman is going to accept that money from the bank, she will be tossing and turning to decide whether she is really ready for it. She is scared that maybe something terrible will happen to her. And finally in the morning her friends will come over and they will try to persuade her: "Let's go through with it. If you don't go, we can't. We can't always worry. It was not easy coming to this point. Let's go." And finally, with their encouragement, she will come to the bank.

When she holds that money, it is such a huge amount in her hands, it is like holding the hope and treasure that she never dreamt she would achieve. She will tremble, tears will roll down her cheeks, and she won't believe we would trust her with such a large sum. And she promises that she will pay back this money, because the money is the symbol of the trust put in her and she does not want to betray that trust.

And then she struggles to pay that first loan, that first installment, which is due the following week, and the second installment, which is payable the following

"As women become empowered,
they look at themselves, and at what they
can do. They are making economic
progress and alongside that, making
decisions about their personal lives."

week, and this goes on for fifty weeks in sequence, and every time that she repays another installment she is braver! And when she finishes her fiftieth installment, the last one, and she has now paid in full, she can say, "I did it!" She wants to celebrate. It's not just a monetary transaction that has been completed, it is nothing less than a transformation of that person. In the beginning of it all, she was trembling, she was tossing and turning, she felt she was nobody and she really did not exist. Now she is a woman who feels like she is somebody. Now she can almost stand up and challenge the whole world, shouting, "I can do it, I can make it on my own." So it's a process of transformation and finding self-worth, self-esteem. Proving that she can take care of herself.

You see, if you only look at the lending program of Grameen, you have missed most of its impact. Grameen is involved in a process of transformation. The sixteen decisions is an example: we found that Grameen children attend school in record numbers because their mothers really take that commitment seriously. And now many of the children are continuing in colleges, universities, going on to medical schools, and so on. It is really striking to see young boys and girls go on to higher levels of education. The program has been so successful that we now foresee a big wave of students needing loans, so we recently came up with another loan product to finance higher education for all Grameen children in professional schools. Now they don't have to worry about whether their parents will be able to pay for their higher education when tuition is so expensive.

A recent study in Bangladesh showed that children in Grameen families are healthier than non-Grameen children. *Scientific American* did a study of population growth in Bangladesh showing that the average number of children per family twenty years back was seven, but now it has been reduced to three. What happened? Why did it happen? *Scientific American* has spurred controversy by claiming the change is due to our program. As women become empowered, they look at themselves and at what they can do. They are making economic progress and alongside that, making decisions about their personal lives and how many children they choose to have. And of course Article 16, Decision 1, says that we should keep our families small. So this is an important part of the equation. At the population summit in Cairo all the sessions spoke of the Grameen model, because the adoption of family planning practices of women in our program is twice as high as the national average. Now, we are not a population program, but this is a beneficial side effect.

There are other side effects. Starting seven years back we encouraged Grameen borrowers to participate in the political process by voting. Their first reaction was negative. They said, "The candidates are all devils, so why should we vote for them?" It was very depressing that people looked at their electoral process in that way.

So we replied, "Okay, yes, they are all devils, but if you don't go and vote, the worst devil will get elected. So go sit down in your centers, discuss who could

be the worst, what could happen if he gets elected, and if you find this prospect terrible, then you have an opportunity to choose among all the devils, the least evil." People immediately got excited, and we had almost 100 percent participation in that first election.

It was very well organized. All the Grameen families met the morning of the elections, and went to the voting place together, so the politicians would take note of their large numbers, so that they were taken seriously. In the next elections we organized Grameen families to vote themselves and also to bring their friends and neighbors to vote, particularly the women.

The result was that in the 1996 election in Bangladesh voter participation was 73 percent, the highest percentage ever. And what shocked everybody was that across the board more women voted than men. In fact, women waited for hours, because when the voting arrangements were made, the authorities had expected only half the number to show up.

The outcome changed the political landscape. In the previous parliament, the fundamentalist religious party had seventeen seats; in the 1996 election, their number was reduced to three, because women found nothing interesting in the fundamentalist party's program. So that was very empowering, very empowering indeed.

Then, in last year's local elections, we were shocked to see that many Grameen members themselves got elected. So I went around and talked to those people, and asked why they chose to run for office. They said, "You told us to select the least of the devils, and we tried, but it was such an ugly job that we got fed up, and we started looking at each other, thinking, 'Why are we looking for the least devil, when we are good people here? Why don't we run ourselves?" And that started the snowball effect which ended with more than four thousand Grameen members elected into local office. That's amazing. And the way they talk is completely different. I never heard women in Bangladesh talking like this. They are challenging the government. They say, "The government can't tell us how to vote. We made commitments to our electorate." This is the kind of thing that happens. So in health care, in political participation, in the relationship between mother and child and between husband and wife, there are transformations of society.

Now you can open up, you can do things, you can discover your own talent and ability and look at the world in a very different way than you looked at before. Because Grameen offers a chance to become part of an institution, with some financial support to do your own thing. Our customers are in a kind of business relationship, but one that makes such a difference to their lives.

Of course there is resistance. The first resistance came from husbands who felt insulted, humiliated, threatened that their wives were given a loan and they were not. The tension within the family structure sometimes led to violence against the women. So we paused for a while and then came up with an idea. We started meeting with the husbands and explaining the program in a way where they could see it would be beneficial to their family. And we made sure

> "You can open up,
> you can do things,
> you can discover your
> own talent and ability
> and look at the world in
> a very different way."

to meet with husbands and wives together so everyone understood what was expected. So that reduced a lot of initial resistance by the husbands.

Neighborhood men also raised objections, and cloaked the fact that they felt threatened by women's empowerment in religious trappings. We carefully examined whether our program was in some way antireligious. But they were hiding behind religion instead of admitting that they felt bypassed. It was the male ego speaking in religious terms.

Our best counterargument was just to give it time. It soon became clear that our borrowers were still attending to their religious duties, at the same time earning money and becoming confident. Women started confronting the religious people. They said, "You think taking money from Grameen Bank is a bad idea? Okay, we won't take any more—if you give the money yourself. We don't care who gives it to us, but without money we cannot do anything." And of course the religious advocates said, "No, no, we can't give you money." So that was the end of that.

We also received criticism from development professionals who insisted that giving tiny loans to women who do not have knowledge and skill does not bring about structural change in the country or the village and therefore is not true development at all. They said development involves multimillion dollar loans for enormous infrastructure projects. We never expected opposition from the development quarter, but it happened, and became

controversial. Because what we do is not in their book. They cannot categorize us, whether right, left, conservative, or liberal. We talk free market, but at the same time we are pro-poor. They are totally confused.

But if you are in a classroom situation, you wander around your abstract world, and decide microcredit programs are silly because they don't fit into your theoretical universe. But I work with real people in the real world. So whenever academics or professionals try to draw those conclusions, I get upset and go back and work with my borrowers—and then I know who is right.

The biggest smile is from one of those women who has just changed her existence. The excitement she experienced with her children, moving from one class to another, is so touching, so real that you forget what the debate was in the ballroom of the hotel with all the international experts, telling you that this is nothing. So that's how I've got the strength—from people.

Grameen Bank is now all over Bangladesh, with 2.4 million families. Even in hard times, like this year's terrible flood, people are willingly paying and we're getting really good loans. That demonstrated the basic ability of the people to do something that they believe in, no matter what others say. People ask, what is the reason that we succeeded, that we could do it, when everybody said it couldn't be done. I keep saying that I was stubborn. So when you ask if it took courage, I would instead say it took stubbornness. No matter what kind of beautiful explanation you give, that's what it takes to make it happen.

RANA HUSSEINI

JORDAN

HONOR KILLINGS

"The only way to rectify the family's honor
is to have a wife, daughter, sister killed.
'Blood cleanses honor,' the killers say."

Journalist, feminist, and human rights defender, Rana Husseini broke the silence and exposed the shame of Jordan when she unveiled the common but unspoken crime of honor killings there. Honor killings happen when a woman is raped or is said to have participated in illicit sexual activity. Across the globe, women who are beaten, brutalized, and raped can expect police, prosecutors, and judges to humiliate victims, fail to investigate cases, and dismiss charges. Imagine what it means in Jordan, where women who are raped are considered to have compromised their families' honor. Fathers, brothers, and sons see it as their duty to avenge the offense, not by persuing the perpetrators but by murdering the victims; their own daughters, sisters, mothers. Honor killings accounted for one-third of the murders of women in Jordan in 1999. Husseini wrote a series of reports on the killings and launched a campaign to stop them. As a result, she has been threatened and accused of being anti-Islam, antifamily, and anti-Jordan. Yet, Queen Noor took up the cause, and later, the newly ascended King Hassan cited the need for protection of women in his opening address to parliament. The conspiracy of silence has been forever broken thanks to this young journalist who risks her life in the firm faith that exposing the truth about honor killings and other forms of violence against women is the first step to stopping them.

31

I never imagined that I would work on women's issues when, in September 1993, I was assigned as the crime reporter at *The Jordon Times*. In the beginning I wrote about thefts, accidents, fires—all minor cases. Then, after about four or five months on the job, I started coming across crimes of honor. One story really shocked me and compelled me to get more involved.

In the name of honor, a sixteen-year-old girl was killed by her family because she was raped by her brother. He assaulted her several times and then threatened to kill her if she told anyone. When she discovered that she was pregnant she had to tell her family. After the family arranged an abortion, they married her off to a man fifty years her senior. When he divorced her six months later, her family murdered her.

An honor killing occurs when a male relative decides to take the life of a female relative because, in his opinion, she has dishonored her family's reputation by engaging in an "immoral" act. An immoral act could be that she was simply seen with a strange man or that she slept with a man. In many cases, women are killed just because of rumors or unfounded suspicions.

When I went to investigate the crime I met with her two uncles. At first when I questioned them about the murder they got defensive and asked, "Who told you that?" I said it was in the newspaper. They started telling me that she was "not a good girl." So I asked, "Why was it her fault that she has been raped? Why didn't the family punish her brother?" And they both looked at each other and one uncle said to the other, "What do you think? Do you think we killed the wrong person?" The other replied, "No, no. Don't worry. She seduced her brother." I asked them why, with millions of men in the street, would she choose to seduce her own brother? They only repeated that she had tarnished the family image by committing an impure act. Then they started asking me questions: "Why was I dressed like this? Why wasn't I married? Why had I studied in the United States?" They inferred that I, too, was not a good girl.

From then on I went on covering stories about women who were killed in an unjust, inhuman way. Most of them did not commit any immoral, much less illegal, act, and even if they did, they still did not deserve to die. But I want to emphasize two things. One is that all women are not threatened in this way in my country. Any woman who speaks to any man will not be killed. These crimes are isolated and limited, although they do cross class and education boundaries. The other thing is a lot of people assume incorrectly that these crimes are mandated by Islam, but they are not. Islam is very strict about killing, and in the rare instances where killing is counseled, it is when adultery is committed within a married couple. In these cases, there must be four eyewitnesses and the punishment must be carried out by the community, not by the family members involved.

Honor killings are part of a culture, not a religion, and occur in Arab communities in the United States and many countries. One-third of the reported homicides in Jordan are honor killings. The killers are treated with leniency, and families assign the task of honor killing to a minor, because under Jordanian juvenile law, minors who commit crimes are sentenced to a juvenile center where they can learn a profession and continue their education, and then, at eighteen, be released without a criminal record. The average term served for an honor killing is only seven and a half months.

"Honor killings are part of a culture, not a religion. One-third of the reported homicides in Jordan are honor killings."

The reason for these killings is that many families tie their reputation to the women. If she does something wrong, the only way to rectify the family's honor is to have a wife, daughter, sister killed. Blood cleanses honor. The killers say, "Yes, she's my sister and I love her, but it is a duty."

I undertook this issue not just because I am a woman, but because most people fight for human rights in general—political agendas, prison conditions, children's rights—but nobody is taking up this issue. And isn't it important to guarantee the right of a woman simply to live before fighting for any other laws?

Related to this is the practice of protective custody. If a woman becomes pregnant out of wedlock, she will turn herself in to the police, and they'll put her in prison to "protect her life." Anywhere else in the world you would put the person who is threatening someone's life in prison, but in my country and elsewhere in the Arab world, it is the opposite. The victim goes to jail. Most of these women are held there indefinitely. They are not charged, and they cannot make bail. If the family bails them out, it is to kill them. So these women remain, wasting their lives in prison.

Since I started reporting on the honor killings, things have started to change for the better. When King Hussein opened the Thirteenth Parliament, he mentioned women and their rights—the first time a ruler had emphasized women and children. And now King Hassan is following in his father's footsteps, with a new constitution where he put in two new sections, one on women. And he asked the prime minister to amend all the laws that discriminate against women. What was not included was a solution; we could begin with a shelter for women. Instead of putting women who seek haven from their families in prison, the government could have programs to rehabilitate them.

Of course this kind of human rights work has its critics. People have accused me of encouraging adultery and premarital sex. Once I had this man threatening that if I didn't stop writing, he would "visit me" at the newspaper. What upsets me the most is that people want to stay away from the subject by using these excuses. One woman said, "So what if twenty-five women are killed every year; look at how many illegitimate children are born every year?" So sad. People try to divert the main issue by accusing the victim and portraying evil women as the main cause of why adultery takes place. Women are always blamed in my country, and elsewhere in the world. Everywhere in the world, they are blamed. We are talking here about human lives that are being wasted.

It is important to realize that people who commit the killings are also victims. Their families put all the burden and pressure on their back. If you don't kill, you are responsible for the family's dishonor. If you do kill, you will be a hero and everyone will be proud of you.

While I was studying in the United States, I felt that there were good people who were trying to work for other people who were in need of help. I came to believe that if you want to do something or change something, you could do it. But in Jordan many people are passive. They don't care. Many believe that whatever they do will not affect anything in society. But I am convinced this is wrong. Because we can't say, "Okay, I won't do this because nothing will change." If you adopt this attitude, then it's true: nothing *will* ever change. I hope the day will come when I will no longer need to report on these crimes. This will happen when Jordan modernizes, not only materially, but in its awareness of human rights for women. And I am sure that day will come; and it may be closer than we think.

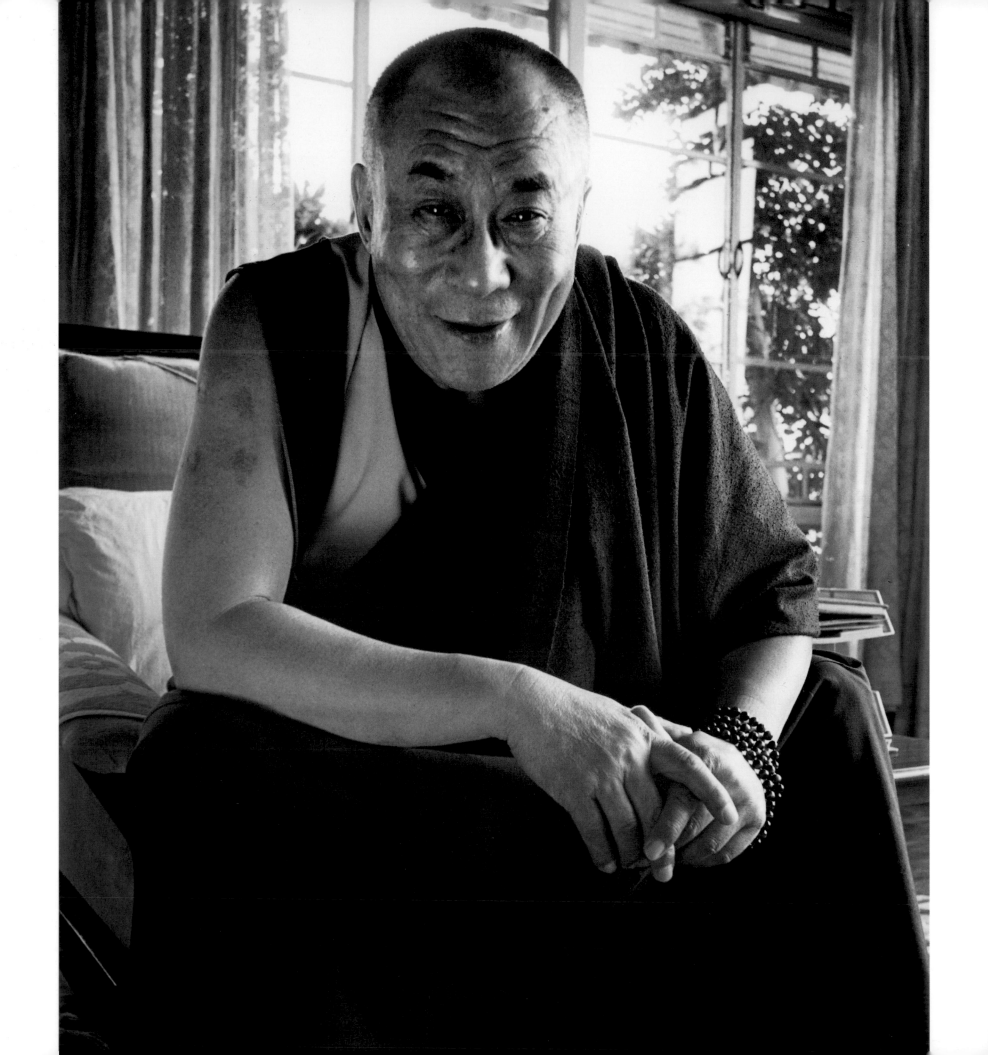

THE DALAI LAMA

RELIGIOUS FREEDOM

"Unless the world community tackles the
Tibetan issue, the human rights violations will continue."

The ninth child born to a farming family in the Chinese border region of Amdo in 1937, two-year-old Lhamo Thondup was recognized by Tibetan monks as the fourteenth reincarnation of the Dalai Lama, considered a manifestation of the Bodhisattva of Compassion. Renamed Tenzin Gyatso, he was brought to Lhasa to begin a sixteen-year education in metaphysical and religious texts to prepare him for his role as spiritual leader. The Chinese invasion of Tibet in 1949, and its aftermath, introduced brutal repressions in which thousands of Tibetans were executed in prisons or starved to death in prison camps, and hundreds of monasteries, temples, and other cultural and historic buildings were pillaged and demolished. In their effort to eradicate Tibetan culture and identity, the Chinese forced Tibetans to dress like Chinese, to profess atheism, to burn books, and to condemn, humiliate, and kill their elders and teachers. His life in jeopardy, the Dalai Lama fled into exile in northern India along with eighty thousand Tibetans in 1959; he has never returned. Meanwhile, new waves of repression erupted in the 1960s and 1980s that continue in the present. To date, the Chinese government has murdered, massacred, tortured, or starved to death over one million Tibetans, one-fifth of the population. In the face of this state oppression, where do Tibetans gather strength to continue the struggle? His Holiness the

Dalai Lama inspires Tibetans to embrace their beliefs and hold fast to their dreams. He has demanded that we think of those who have stolen his land and massacred his people, not as murderers and thieves, but as human beings deserving of forgiveness and compassion.

ON COMPASSION

When I visited the Nazi death camps of Auschwitz, I found myself completely unprepared for the deep revulsion I experienced at the sight of the ovens where hundreds of thousands of human beings were burned. The sheer calculation and detachment to which they bore horrifying witness overcame me. This is what happens, I thought, when societies lose touch with feeling. And while it is necessary to have legislation and international conventions in place to prevent such disasters, these atrocities happen in spite of them. What of Stalin and his pogroms? What of Pol Pot, architect of the Killing Fields? And what of Mao, a man I knew and once admired, and the barbarous insanity of the Cultural Revolution? All three had a vision, a goal, with some social agenda, but nothing could justify the human suffering engendered. So, you see it all starts with the individual, with asking what the consequences are of your actions. An ethical act is a nonharming act. And if we could enhance our sensitivity to others' suffering, the less we would tolerate seeing others' pain, and the more we would do to ensure that no action of ours ever causes harm. In Tibetan we call this *nying je,* translated generally as compassion.

ON SUFFERING

All human beings desire happiness, and genuine happiness is characterized by peace. A sentient being experiences suffering as well. It is that experience that connects us to others and is the basis of our capacity for empathy. Many in Tibet have experienced the suffering of having what we want taken away from us. As

refugees, we have lost our country, and have been forcibly separated from our loved ones. When I hear bad news from Tibet my natural reaction is one of great sadness. By the late seventies and early eighties there was an influx of large numbers of Tibetans who came to see me in India and spoke about how their fathers or their parents or their brothers or sisters were killed and how they themselves had been tortured or suffered. I often wept. Now, after hearing so many cases, my eyes have become dry. It's like the soldier who is scared when he hears the first shot, but after many shots becomes familiar with the sound.

And when the Chinese lost their temper with me, and they took it out on the Panchen Lama, that was very sad, and I accept some responsibility for what happened. Yet, what could I do? When these things occur there is no point in being discouraged and sad. Feelings of helpless anger do nothing but poison the mind, embitter the heart, and enfeeble the will. I take comfort in the words of the ancient Indian master Shantideva's advice, "If there is a way to overcome the suffering, then there is no need to worry. If there is no way to overcome the suffering, then there is no use in worrying." We must place this in context and remind ourselves that the basic human disposition toward freedom, truth, and justice will eventually prevail. It is also worth remembering that the time of greatest difficulty is the time of greatest gain in wisdom and strength. A great Tibetan scholar who spent more than twenty years in prison enduring terrible treatment, including torture, wrote letters during his confinement and smuggled them out—and they were acclaimed by many as containing the most profound teachings on love and compassion ever heard.

ON ETHICS AND ENVIRONMENT

It is no exaggeration to say that the Tibet I grew up in was a wildlife paradise. Animals were rarely hunted. Immense herds of *kyang* (wild asses) and *drong* (wild yak) roamed the plains along with shimmering *gowa* (gazelles), *wa* (fox), and *tsoe* (antelope). The noble eagles soared high over the monasteries and at night the call of the *wookpa* (long-eared owl) could be heard. Now, because of loss of habitat and hunting, the wildlife of my country is gone. In addition,

Tibet's forests have been clear-cut by the Chinese, and Beijing admits that this is at least partly to blame for the catastrophic flooding in western China. Sensitivity to the environment must be part of realizing the universal dimensions of our actions, and restraint in this, as in all, is important.

ON NONVIOLENCE

Chairman Mao once said political power comes from the barrel of a gun. But I believe that while violence may achieve short-term objectives, it cannot obtain long-lasting ends. I am a firm believer that violence begets violence. Some may say that my devotion to nonviolence is praiseworthy, but not really practical. I am convinced people say that because engaging in it seems daunting and it is easy to become discouraged. But where once one only spoke of peace in one's land, now world peace is at stake—the fact of human interdependence is so explicit now. And we must recognize that nonviolence was the principal characteristic of the political revolutions that swept the world during the 1980s. I have advanced the idea that Tibet, among other places, become a Zone of Peace, where countries like India and China, which have been at war for a long time, would benefit enormously from the establishment of a demilitarized area, saving a considerable portion of their income, which is presently wasted in maintaining border troops.

On a personal level, violence can undermine greater motivations. For example, I feel that hunger strikes as a vehicle of protest are problematic. The first time I visited the Tibetan hunger strikers (on April 2, 1988, in New Delhi), they had been without food for two weeks, so their physical condition was not yet too bad. Right from the beginning they asked me not to stop them. Since they undertook the hunger strike for the Tibetan issue, which is also my responsibility, in order to stop them I had to show them an alternative. But sadly there was no alternative. At last, Indian police intervened and took the strikers to the hospital, and I was immensely relieved. Yet the strikers acted with courage and determination, which is remarkable, and fortunately they did not have to die, not because they changed their minds, but because they were forced to live by the

because they changed their minds, but because they were forced to live by the Indian government. The strikers did not consider self-sacrifice to be a form of violence, but I did. Although they realized that our cause was a just one, they should not have felt that death at the hands of the perceived enemy was a reasonable consequence for their actions. This is a distinction and an important one.

ON HUMAN RIGHTS

Human rights violations are symptoms of the larger issue of Tibet, and unless the world community tackles the Tibet issue, the human rights violations will continue. Meanwhile, the Tibetans suffer, the Chinese are embarrassed, and general resentment increases. The Chinese authorities are concerned about unity and stability, but their method of dealing with Tibet creates instability and disunity. It's a contradiction and does not work.

ON THE VALUE OF LIFE

I realize that being the Dalai Lama serves a purpose. If one's life becomes useful and beneficial for others, then its purpose is fulfilled. I have an immense responsibility and an impossible task. But as long as I carry on with sincere motivation, I become almost immune to these immense difficulties. Whatever I can do, I do; even if it is beyond my ability. Of course, I feel I would be more useful being outside government administration. Younger, trained people should do this, while my remaining time and energy should concentrate on the promotion of human value. Ultimately, that is the most important thing. When human value is not respected by those who administer governments or work on economic endeavors, then all sorts of problems, like crime and corruption, increase. The Communist ideology completely fails to promote human value, and corruption is consequently great. The Buddhist culture can help to increase self-discipline, and that will automatically reduce corruption. As soon as we can return to Tibet with a certain degree of freedom, I will hand over all my temporal authority. Then, for the rest of my life, I will focus on the promotion of human values and the promotion of harmony among the different religious traditions. I will continue teaching Buddhism to the Buddhist world.

ON GOALS AND IMPERMANENCE

There are no inherent contradictions between being a political leader and a moral leader, as long as you carry on political activities or goals with sincere motivation and proper goals. Proper goals mean not working for your own name, or for your own fame, or for your own power, but for the benefit of others.

Within another fifty years I, Tenzin Gyatso, will be no more than a memory. Time passes unhindered. The Chinese authorities and the Tibetan people very much want me to continue my work, but I am now over sixty-four years old. That means, in another ten years I will be seventy-four, in another twenty years I will be eighty-four. So, there is little time left for active work. My physicians say that my life span, as revealed by my pulse, is one hundred and three years. In this time, until my last day, I want to, for the benefit of all, maintain close relationships with those who became Tibet's friends during our darkest period. They did it not for money, certainly not for power (because by being our friends they may have had more inconvenience dealing with China), but out of human feeling, out of human concern. I consider these friendships very precious. Here is a short prayer that gave me great inspiration in my quest to benefit others:

May I become at all times both now and forever

A protector for those without protection

A guide for those who have lost their way

A ship for those with oceans to cross

A bridge for those with rivers to cross

A sanctuary for those in danger

A lamp for those without light

A place of rugs for those who lack shelter

And a servant to all in need.

WANGARI MAATHAI

———

WOMEN AND THE ENVIRONMENT

"When you start doing this work, you do it with a very
pure heart, out of compassion.... The clarity of what you ought to
do gives you courage, removes the fear, gives you the courage
to ask. There is so much you do not know. And you need to know."

Throughout Africa (as in much of the world) women hold primary responsibility for tilling the fields, deciding what to plant, nurturing the crops, and harvesting the food. They are the first to become aware of environmental damage that harms agricultural production: if the well goes dry, they are the ones concerned about finding new sources of water and those who must walk long distances to fetch it. As mothers, they notice when the food they feed their family is tainted with pollutants or impurities: they can see it in the tears of their children and hear it in their babies' cries. Wangari Maathai, Kenya's foremost environmentalist and women's rights advocate, founded the Greenbelt Movement on Earth Day, 1977, encouraging the farmers (70 percent of whom are women) to plant "greenbelts" to stop soil erosion, provide shade, and create a source of lumber and firewood. She distributed seedlings to rural women and set up an incentive system for each seedling that survived. To date, the movement has planted over fifteen million trees, produced income for eighty thousand people in Kenya alone, and has expanded its efforts to over thirty African countries, the United States, and Haiti. Maathai won the Africa Prize for her work in preventing hunger, and was heralded by the Kenyan government and controlled press as an exemplary citizen. A few years later, when Maathai denounced President Daniel arap Moi's proposal to erect a sixty-two-story skyscraper in the middle of Nairobi's largest park (graced by a four-story statue of Moi himself), officials warned her to curtail her criticism. When she took her campaign public, she was visited by security forces. When she still refused to be silenced, she was subjected to a harassment campaign and

threats. Members of parliament denounced Maathai, dismissing her organization as "a bunch of divorcees." The government-run newspaper questioned her sexual past, and police detained and interrogated her, without ever pressing charges. Eventually Moi was forced to forego the project, in large measure because of the pressure Maathai successfully generated. Years later, when she returned to the park to lead a rally on behalf of political prisoners, Maathai was hospitalized after pro-government thugs beat her and other women protesters. Following the incident, Moi's ruling party parliamentarians threatened to mutilate her genitals in order to force Maathai to behave "like women should." But Wangari Maathai was more determined than ever, and today continues her work for environmental protection, women's rights, and democratic reform. From one seedling, an organization for empowerment and political participation has grown many strong branches.

The Greenbelt Movement in Kenya started in 1977 when women from rural areas and urban centers, reflecting on their needs at organized forums, spoke about environmental degradation. They did not have firewood. They needed fruits to cure malnutrition in their children. They needed clean drinking water, but the pesticides and herbicides used on farms to grow cash crops polluted the water.

The women talked about how, a long time ago, they did not have to spend so much time going out to collect firewood, that they lived near the forest. They spoke of how, once, they ate food that sustained their health. Now, while the food does not require much energy to grow, it does not sustain them. The women feel their families are now very weak, cannot resist diseases, and that their bodies are impoverished because of an environment that is degraded.

The National Council of Women, a nongovernmental organization, responded by encouraging them to plant trees. In the beginning it was difficult because the women felt that they had neither the knowledge, the technology, nor the capital to do this. But, we quickly showed them that we did not need all of that to plant trees, which made the tree-planting process a wonderful symbol of hope. Tree-planting empowered these women because it was not a complicat-

ed thing. It was something that they could do and see the results of. They could, by their own actions, improve the quality of their lives.

When we said we wanted to plant fifteen million trees, a forester laughed and said we could have as many seedlings as we wanted because he was convinced that we could not plant that many trees. Before too long, he had to withdraw that offer because we were collecting more trees than he could give away free of charge. But we didn't have money. We decided that we could produce the seedlings ourselves. We would go and collect seeds from the trees, come back and plant them the way women did other seeds: beans, corn, and other grains. And so the women actually developed forestry management techniques, using "appropriate technology" to fit their needs. Here is the basic method: take a pot, put in the soil, and put in the seeds. Put the pot in an elevated position so that the chickens and the goats don't come and eat the seedlings.

This method worked! Some day we will record all the inventive techniques that the women developed. For example, sometimes trees produce seeds carried by the wind. These germinate in the fields with the first rain. It was very interesting to see a woman cultivating a field with a small container of water. But, she was cultivating weeds! She had learned that among these weeds were also tree seedlings, and that she could pick the seedlings and put them in a container. In the evening, she went home with several hundred seedling trees! These techniques developed by the women became extremely helpful. We planted more than twenty million trees in Kenya alone. In other African countries, we have not kept records.

Trees are alive, so we react to them in very different ways. Quite often, we get attached to a tree, because it gives us food and fodder for our fires. It is such a friendly thing. When you plant a tree and you see it grow, something happens to you. You want to protect it, and you value it. I have seen people really change and look at trees very differently from the way they would in the past. The other thing is that a lot of people do not see that there are no trees until they open their eyes, and realize that the land is naked. They begin to see that while rain can be a blessing, it can also be a curse, because when it comes and you have not protected your soil, it carries the soil away with it! And this is the rich soil in which you should be growing your food. They see the immediate relationship between a person and the environment. It is wonderful to see that transformation, and that is what sustains the movement!

We have started programs in about twenty countries. The main focus is how ordinary people can be mobilized to do something for the environment. It is mainly an education program, and implicit in the action of planting trees is a civic education, a strategy to empower people and to give them a sense of taking their destiny into their own hands, removing their fear, so that they can stand up for themselves and for their environmental rights. The strategy we use is a strategy that we call the "wrong bus syndrome," a simple analogy to help people conceive what is going on. People come to see us with a lot of problems: they have no food, they are hungry, their water is dirty, their infrastructure has broken down, they do not have water for their animals, they cannot take their children to school. The highest number of problems I have recorded at a sitting of about a hundred people is one hundred and fifty. They really think we are going to solve their problems. I just write them down, but I am not going to do anything about them. I just write them down in order to give the people a feeling of relief and a forum where they can express their problems.

After we list these problems, we ask, "Where do you think these problems come from?" Some people blame the government, fingering the governor or the president or his ministers. Blame is placed on the side that has the power. The people do not think that they, themselves, may be contributing to the problem. So, we use the bus symbol (because it is a very common method of transportation in the country). If you go onto the wrong bus, you end up at the wrong destination. You may be very hungry because you do not have any money. You may, of course, be saved by the person you were going to visit, but you may also be arrested by the police for hanging around and looking like you

"Women who start to plant trees
on their farms influence their neighbors.
The neighbors eventually become involved.
Now, we see the government reacting."

are lost! You may be mugged—anything can happen to you! We ask the people, "What could possibly make you get on the wrong bus? How can you walk into a bus station and instead of taking the right bus, take the wrong one?" Now, this is a very ordinary experience. The most common reason for people to be on the wrong bus is that they do not know how to read and write. If you are afraid, you can get onto the wrong bus. If you are arrogant, if you think you know it all, you can easily make a mistake and get onto the wrong bus. If you are not mentally alert, not focused. There are many reasons.

After we go through this exercise, we ask them to look at all the problems that they have listed. Why are we hungry? Why are we harassed by the police? We cannot hold meetings without a license. When we look at all of this, we realize that we are in the wrong bus. We have been misinformed for too long. The history of Kenya in the last forty years explains why.

During the Cold War period, our government became very dictatorial. There was only one radio station that gave out controlled information and our country was misinformed. Because the government was so oppressive, fear was instilled in us, and we very easily got onto the wrong bus. We made mistakes and created all of these problems for ourselves. We did not look at the environment and decide to plant trees, so our land was washed away by the rain! The beautiful topsoil was lost. Then, we had made the mistake. Maybe we were not fully focused, suffered from alcoholism, or were not working, but our personal problems had nothing to do with government. We got on the wrong bus and a lot of bad things happened. What we needed to do was to decide to get out, only to make the best of the situation you find yourself in.

You need to take action. You have to inform yourself. And you are willing to inquire; you are willing to learn. That is why you came to the seminar. You want to plant, you want to empower yourself. You have every right to read what you want to read. You want to meet—without asking permission. To get off the bus means to control the direction of your own life.

We say to go ahead and start to plant trees. Grow and produce enough food for your family. Get in the food security project, making sure that you plant a lot of indigenous food crops so that we do not lose local biodiversity. We are working in the tropics so the trees grow very fast. In five years, or less, you can have fruit trees, like banana trees. You can go and teach others what you have learned here so that you will have educational outreach in the village. We will support you, so that you can encourage others to get off the bus. You can get a small group of people to protect a park or a forest or an open space near you. Environmental protection is not just about talking. It is also about taking action.

People who live near the forest are among the first to see that the forest is being destroyed. People who live near water resources are the ones who notice that these springs are being interfered with. People who are farmers recognize that the soil is being exposed and carried away by the rains. These are the people who should be the ones to draw attention to these problems at the local and national levels.

And this is the process I have seen with the Greenbelt Movement. Women who start to plant trees on their farms influence their neighbors. The neighbors eventually become involved. At the national level, we have been able to draw the attention of the parliament, and even the president, to the need to protect the environment! And now, we see the government reacting to what the environmentalists are saying: that the remaining forest not be degraded, that open spaces not be privatized, and that the forest not be interfered with or privatized. This pressure is coming from ordinary people. We started by empowering women. Then the men joined in because they saw that the women were doing some very positive work.

A lot of men participate in the planting, though not in the nurturing of the seedlings at the nursery as the women do (and do very well). The men see trees as an economic investment. They look thirty years into the future and see that they will have huge trees to sell. Well, nevertheless, it means that the

Greenbelt Movement enjoys the participation of men, women, and children, which is important. You could very easily have the women planting trees and the men cutting the trees down! Everyone needs to work together and to protect the environment together.

When you start doing this work, you do it with a very pure heart, out of compassion. Listen to the statement from our pamphlet: "The main objective of this organization is to raise the consciousness of our people to the level which moves them to do the right things for the environment because their hearts have been touched and their minds convinced to do the right things, because it is the only logical thing to do."

The clarity of what you ought to do gives you courage, removes the fear, gives you the courage to ask. There is so much you do not know. And you need to know. And it helps you get your mind focused. Now, you are out of the bus and moving to the right direction. They will see you move with passion, conviction, and persistence. You are very focused. Quite often you threaten people, either people who are on the wrong bus or people who are driving others, because you know they are driving people in the wrong direction and you are asking them not to follow. And now you feel free to tell people, "Believe me, you are all moving in the wrong direction, your leader as well." Now, of course, a leader does not want to be told this. He certainly does not want to hear the people he is driving being told they need to get out of the bus. This is where the conflict comes in. The leader accuses you of misleading his people, misrepresenting his vision, misrepresenting what he's trying to do, misrepresenting him.

This is what happened between me and President Moi. In 1989, the president wanted to take over Uhuru Park, the only park left in Nairobi. He was going to build the highest building in Africa, sixty-two stories. Next to the skyscraper he was going to put a four-story statue of himself (so you could pat his head from the fourth floor). All of downtown Nairobi would have had to be restructured.

That building would have been so intimidating, that even if some land in the small park remained, no one would have dared come near it. Very intimidating. So it was completely wrong. It also would have been an economic disaster, as was borrowing money to do it, putting us in greater debt. It was truly a white elephant. But he wanted it because it was a personal aggrandizement.

And so we raised objections, and said this was the only park that we had in the city where people who have no money could come. Not even a policeman could ask you to move; it was an open space. A lot of people joined in and agreed, even those people who were going to invest, who then decided that it was probably not a very good idea.

We staged a protest in the park and were beaten by the police. We were only a small group of women, because, at that time, in 1989, there was a lot of fear. I had taken the matter to court, arguing that this park belonged to the people and that it could not be privatized. The president was only a public trustee, so for him to now go and take what had been entrusted to him, to take it, and privatize it, was criminal. We lost the case, which in the court meant that we had no business raising the issue and complaining about the park. But we won in the end because those who were providing the money withdrew due to the outcry from the public. And members of parliament actually suspended business to discuss the Greenbelt Movement and myself, recommending that the Greenbelt Movement should be banned as a subversive organization. They did a lot of dirty campaigning to discredit us, including dismissing us as, "a bunch of divorcées and irresponsible women."

Well, I gave them a piece of my mind that people kept talking about for the rest of the time. "Whatever else you may think about the women who run the Greenbelt Movement," I said, "we are dealing here with privatizing or not privatizing a public park. We are dealing with the rights of the public and the rights of the people. These are the kind of issues that require the anatomy of whatever lies above the neck." The press loved it. Parliament was just being mean, chauvinistic, and downright dirty. Fortunately, my skin is thick, like an

elephant's. The more they abused and ridiculed me, the more they hardened me. I know I was right, and they were wrong.

A few years later, in 1992, with about ten women whose sons had been detained for demanding more democratic rights for the people, I went back to the same park and declared it "freedom corner." We stayed there for four days. By the fifth day the government brought in policemen; some of us were very badly beaten. But I will always remember the power of those women. After we were disrupted by the police, I ended up in the hospital, so I didn't even know what was going on. The other women were herded into cars and forced to go back to where they had come. But the following day, those women came back to Nairobi and tried to locate the others. They knew some were in the hospital, and sent a message that they were waiting for us. They would not go home. Instead, they went to the Anglican provost of All Saint's Cathedral who told them they could go to the crypt and wait for the other women. Though the provost thought this would be a two-night stay, it lasted for one year. They stayed in that crypt, waiting for Moi to release their sons. The authorities tried everything to get the women to leave. They tried to bribe some of them; intimidated them; even sent some of their sons to persuade their mothers to leave. Several times we were surrounded by armed policemen, who threatened to break the doors of the church and to haul us out. Fortunately they never did, because some of these soldiers were Christians, and we could hear them say they just could not break into the church.

And we won again! It was a great ceremony to see those young men come out of jail and also to celebrate the powers of their mothers. It was really wonderful. I was amazed that they were so strong. It goes to show that you can have a very oppressive government, but even in very dark times in our nation, there were people who stood up to protect the rights of others.

There was another time when the pro-democracy movement pushed the president very far. Rumors started circulating that he was going to turn the government over to the army. And so we issued a statement saying that if he felt there was a need for change in the government (which we were demanding), what we wanted was a general election, but not to turn over power to the army, because this was not democratic.

Instead of responding, he arrested us for inciting people to violence. I went into my house and locked myself in because I was so convinced that no one could get me out—it had been so reinforced for security. Unless I became hungry, I had enough to last me for a month. They surrounded the house with guns and it was very, very scary. I was one woman alone. After three days, they broke into the house, literally cutting the windows so that they could reach me, and they hauled me to jail. That was 1993, when we were really breaking loose from a very strong dictatorship.

Courage. I guess that the nearest it means is not having fear. Fear is the biggest enemy you have. I think you can overcome your fear when you no longer see the consequences. When I do what I do, when I am writing letters to the president, accusing him of every crime on this earth, of being a violator of every right I know of, especially violating environmental rights and then of violence to women, I must have courage.

You know, when they attack me, I say this is violence against women. When they threaten me with female genital mutilation, this is violence against women. When they attack me, I attack them back. A lot of people say, "They could kill you." And I say, "Yes, they could, but if you focus on the damage they could do, you cannot function. Don't visualize the danger you can get in. Your mind must be blank as far as danger is concerned." This helps you to go on. You look very courageous to people—and maybe you are courageous. But it is partly because you cannot see the fear they see. You are not projecting that you could be killed, that you could die. You are not projecting that they could cut your leg. If you do that, you stop. It's not like I see danger coming, and I feel danger. At this particular moment, I am only seeing one thing—that I am moving in the right direction.

OSCAR ARIAS SÁNCHEZ

DISARMAMENT

"War, and the preparation for war,
are the two greatest obstacles to human progress.
The poor of the world are crying out for
schools and doctors, not guns and generals."

War raged throughout Central America. The Sandinistas ruled Nicaragua with Soviet backing, and right-wing military governments fought guerrilla insurgencies in El Salvador and Guatemala, while tensions in Honduras were fueled by millions in military aid from the United States and the USSR. Oscar Arias dared to advocate for peace against these powerful Cold War interests and to broker the Arias Peace Plan, which brought a cessation of fighting to his neighbors and prosperity to his own peaceful country of Costa Rica. Born in 1940, Arias studied law and economics at the University of Costa Rica and received a doctoral degree at the University of Essex, England. Appointed minister of planning and economic policy in Costa Rica in 1972, he was elected to congress in 1978 and to the presidency in 1986. On the day he was inaugurated, Arias called for an alliance for democracy and social and economic liberty throughout Latin America. In 1987, he drafted the peace plan, which led to the Esquipulus II accords, signed by all the Central American presidents on August 7. He was awarded the Nobel Peace Prize for his role in ending conflict in the region. Since then, Arias has used his considerable moral authority to embark on a worldwide campaign for human development, democracy, and demilitarization, applying the lessons from the Central American peace process to conflicts across the globe.

Three billion people live in tragic poverty, and forty thousand children die each day from diseases that could be prevented. In a world that presents such a dramatic struggle between life and death, the decisions we make about how to conduct our lives, about the kind of people we want to be, have important consequences. In this context, I think it is clear that one must stand on the side of life. The fact that working for human security is difficult, or that we might face occasional setbacks, in no way affects this existential decision. One works for justice not for the big victories, but simply because engaging in the struggle is itself worth doing. Globalization is a Janus-faced

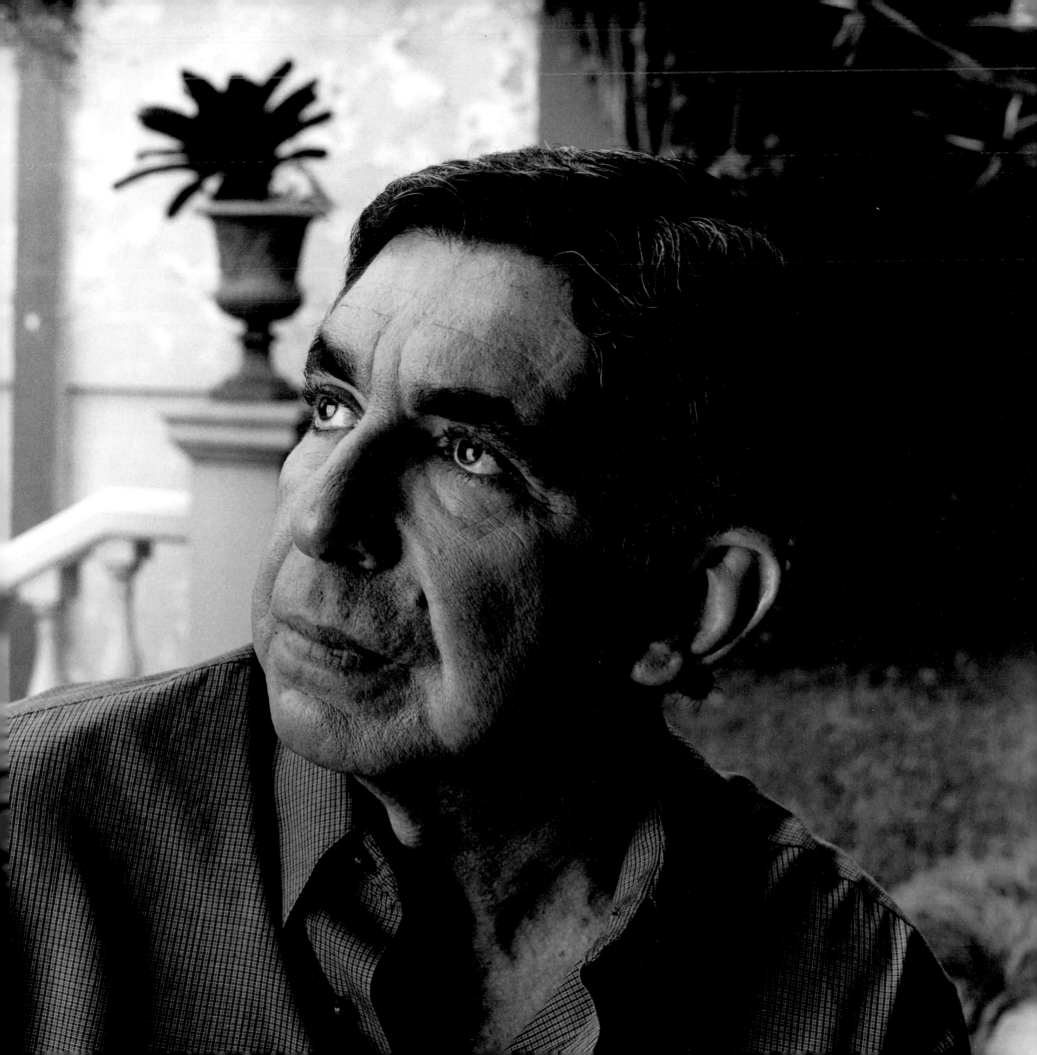

beast, offering unimaginable prosperity to the most well educated and well born, while doling out only misery and despair to the world's poor. For some, the new economic system means minimizing labor costs and maximizing profits; for many others, it means facing the end of job security, and at the same time witnessing the reappearance of "sweatshops." The most vulnerable and economically insecure populations bear the miserable brunt of the impact of an economic system based on greed and speculation, rather than on human need. While the world as a whole consumes twenty-four trillion dollars worth of goods and services each year, the planet holds 1.3 billion people who live on incomes of less than one dollar a day. The three richest countries in the world have assets that exceed the combined gross domestic product of the poorest forty-eight countries.

The question is not whether you will be involved in the ethical challenges of globalization, but what your contribution will be. Will you, in your apathy, be complicit in the injustices I have described? Or will you, with your action and your example, bolster the ranks of those fighting for human security? Today we must accept the fact that the evils of environmental destruction and human deprivation, of disease and malnutrition, of conspicuous consumption and military buildup, are global problems—problems that affect us all.

Military spending is not merely a consumer excess; instead, it represents a huge perversion in the priorities of our civilization. We're talking about enormous sums of money that could be spent on human development. But also, we're talking about vast investment in instruments of death, in guns and fighters designed to kill people. The creation and proliferation of arms bolsters the power of the military, impedes the process of democratization, destroys economic advances, perpetuates ethnic and territorial conflicts, and creates situations in which even the most basic human rights are endangered. Moreover, we increasingly find that women and children are forced to endure a disproportionate share of the hardships of armed conflict and the poverty it worsens.

Since the end of the Cold War, many industrialized nations have reduced their defense budgets. As a result, those countries' arms merchants have turned to new clients in the developing world, where the majority of today's conflicts take place. The United States stands out as an extreme case. Currently, the United States is responsible for 44 percent of all weapons sales in the world. And, in the past four years, 85 percent of U.S. arms sales have gone to nondemocratic governments in the developing world.

At the end of 1997, weapons manufactured in the United States were being used in thirty-nine of the world's forty-two ethnic and territorial conflicts. It is unconscionable for a country that believes in democracy and justice to continue allowing arms merchants to reap profits stained in blood. But ironically, vast amounts of taxpayer money goes to support this immoral trade. In 1995 the arms industry received 7.6 billion dollars in federal subsidies—this amounts to a huge welfare payment to wealthy profiteers.

War, and the preparation for war, are the two greatest obstacles to human progress, fostering a vicious cycle of arms buildups, violence, and poverty. In order to understand the true human cost of militarism, as well as the true impact of unregulated arms sales in the world today, we must understand that war is not just an evil act of destruction, it is a missed opportunity for humanitarian investment. It is a crime against every child who calls out for food rather than for guns, and against every mother who demands simple vaccinations rather than million-dollar fighters. Without a doubt, military spending represents the single most significant perversion of global priorities known today, claiming 780 billion dollars in 1997. If we channeled just 5 percent of that figure over the next ten years into antipoverty programs, all of the world's population would enjoy basic social services. Another 5 percent, or forty billion dollars, over ten years would provide all people on this planet with an income above the poverty line for their country.

Military officials simply try to marginalize and downplay disarmament proposals as much as possible. They call these ideas "impractical" and "idealistic." They use backroom political tricks to impede disarmament legislation. And they have a whole array of arguments to rationalize the production and sale of arms. I have worked to advocate an International Code of Conduct on Arms Transfers, a comprehensive international effort to regulate and monitor weapons sales. This agreement demands that any decision to export arms should take into account several characteristics pertaining to the country of final destination. The recipient country must endorse democracy, defined in terms of free and fair elections, the

rule of law, and civilian control over the military and security forces. Its government must not engage in gross violations of internationally recognized human rights. The International Code of Conduct would not permit arms sales to any country engaged in armed aggression in violation of international law.

Many say that such a code is impractical—impractical because it puts concern for human life before a free-market drive for profits; impractical because it listens to the poor who are crying out for schools and doctors, rather than the dictators who demand guns and fighters. Yes, in an age of cynicism and greed, all just ideas are considered impractical. You are discouraged if you say that we can live in peace. You are mocked for insisting that we can be more humane. I often question the relationship between the International Code of Conduct on Arms Transfers and the free-market concept of supply and demand. If a country's leaders want arms, some might ask, who are we to say that they shouldn't have them?

This question merits two responses. First, since the end of the Cold War, arms manufacturers have been aggressively promoting sales to the developing world, in order to compensate for the drastic reduction in arms purchases by most industrialized countries. Furthermore, when we assert that a "nation" desires arms, to whom exactly are we referring? Is the single mother in Indonesia or the street orphan in Egypt pressuring government leaders to buy tanks and missiles? Or is it a dictator—who sees arms purchases as the only way to maintain power? The poor of the world are crying out for schools and doctors, not guns and generals. Another argument to justify the sale of arms is that if one country does not sell arms to a nation that wishes to buy them, someone else will. That is precisely why all arms-selling nations must agree to certain common restrictions. We can no longer say business is business and turn a blind eye to the poverty and oppression caused by arms transfers. Just like slavery and the drug trade, the arms trade reaps profits tainted with blood.

Demilitarization is the goal—and it has proven to be an attainable one. Truly the progress made in Panama and Haiti, to name two countries, give us much reason to hope. The U.S. invasion of Panama in 1989 dissolved that country's armed forces. Subsequently, the Arias Foundation for Peace and Human Progress pushed for the constitutional abolition of Panama's military. We com-

missioned an opinion poll to gauge the Panamanian people's support for a demobilization process; not surprisingly, the poll found substantial support for such a measure. We also began a public education campaign to promote the value of demilitarization. These efforts, and the resolve of the millions of Panamanians who stood for disarmament, came to fruition in October 1994 when Panama's legislature amended the Constitution to abolish their armed forces.

Similarly, the army of Haiti was in considerable disarray following the U.S.-led interventions in 1994. At this time I encouraged President Aristide to consider demobilizing his armed forces. Meanwhile, many civil society groups held meetings to promote demobilization. The Arias Foundation launched a public opinion poll campaign akin to that of Panama's and documented similar support among the Haitian public for the abolition of their armed forces. In April 1995, Aristide publicly announced his intention to seek the elimination and constitutional abolition of Haiti's armed forces. Then in February 1996, the Haitian Senate presented a resolution stating their intent to pursue the constitutional abolition of Haiti's armed forces.

Courage begins with one voice—look at all the people who have come forward, as individuals and groups, to support the Code of Conduct. Clearly, much work remains to be done. People must continue to organize, so that their voices will be heard. Political leaders must be convinced that demilitarization is a practical and desirable goal. And if they cannot be convinced, then people must elect new representatives. Conviction itself is only talk, but it is important talk, because it motivates action. So while I recognize the hard work of bringing people together in democratic movements, of policy formation, and of diplomacy, I think it is important to affirm that change in consciousness is a crucial first step in making social change—the step from which action grows.

Courage means standing with your values, principles, convictions, and ideals under all circumstances—no matter what. If you stick to your principles, you will often have to confront powerful interests. Having courage means doing this without fear. It means having the courage to change things. I often say that Costa Rica is not now an economic power, but that we want to be some day. Costa Rica is not a military power, and we do not ever want to be. But Costa Rica is already a moral power. This is why we must always be sure to have the courage to do what is right.

DIANNA ORTIZ

GUATEMALA / UNITED STATES

TORTURE

"To this day, I can smell the decomposing of bodies, disposed
of in an open pit. I can hear the piercing screams of other people being
tortured. I can see the blood gushing out of the woman's body."

Dianna Ortiz is an Ursuline nun from New Mexico who journeyed to Guatemala in the early 1980s as a missionary, teaching Mayan children in the highlands. After months of receiving threats, Ortiz was abducted and brutally raped by armed men in November 1989. One of the men overseeing the torture appeared to be American. The Inter-American Commission on Human Rights concluded that: "Sister Ortiz was placed under surveillance and threatened, then kidnapped and tortured, and that agents of the government of Guatemala were responsible for these crimes...including violating Dianna Ortiz's rights to 'humane treatment, personal liberty, a fair trial, privacy, freedom of conscience and of religion, freedom of association and judicial protection.'" Ortiz's ordeal did not end with her escape. Her torment continued as she sought answers from the U.S. government about the identity of her torturers in her unrelenting quest for justice. Ortiz's raw honesty and capacity to articulate the agony she suffered compelled the United States to declassify long-secret files on Guatemala, and shed light on some of the darkest moments of Guatemalan history and American foreign policy.

I want to be free of these memories. I want to be as trusting, confident, adventurous, and carefree as I was in 1987 when I went to the western highlands of Guatemala to teach young indigenous children to read and write in Spanish and in their native language and to understand the Bible in their culture. But on November 2, 1989, the Dianna I just described ceased to exist. I tell you this story only because it reflects the suffering of hundreds of thousands of people in Guatemala, a country ravaged by a civil war that began in 1960 and lasted thirty-six years. Most of the victims, like me, were civilians targeted by government security forces.

As I sat reading in the garden of a convent, where I had retreated to think about my options after receiving increasingly violent death threats, I heard a man's deep voice behind me: "Hello, my love," he said in Spanish. "We have some things to discuss." I turned to see the morning sunlight glinting off a gun held by a man who had threatened me once before on the street. He and his partner forced me onto a bus, then into a police car where they blindfolded me. We came to a building and they led me down some stairs. They left me in a dark

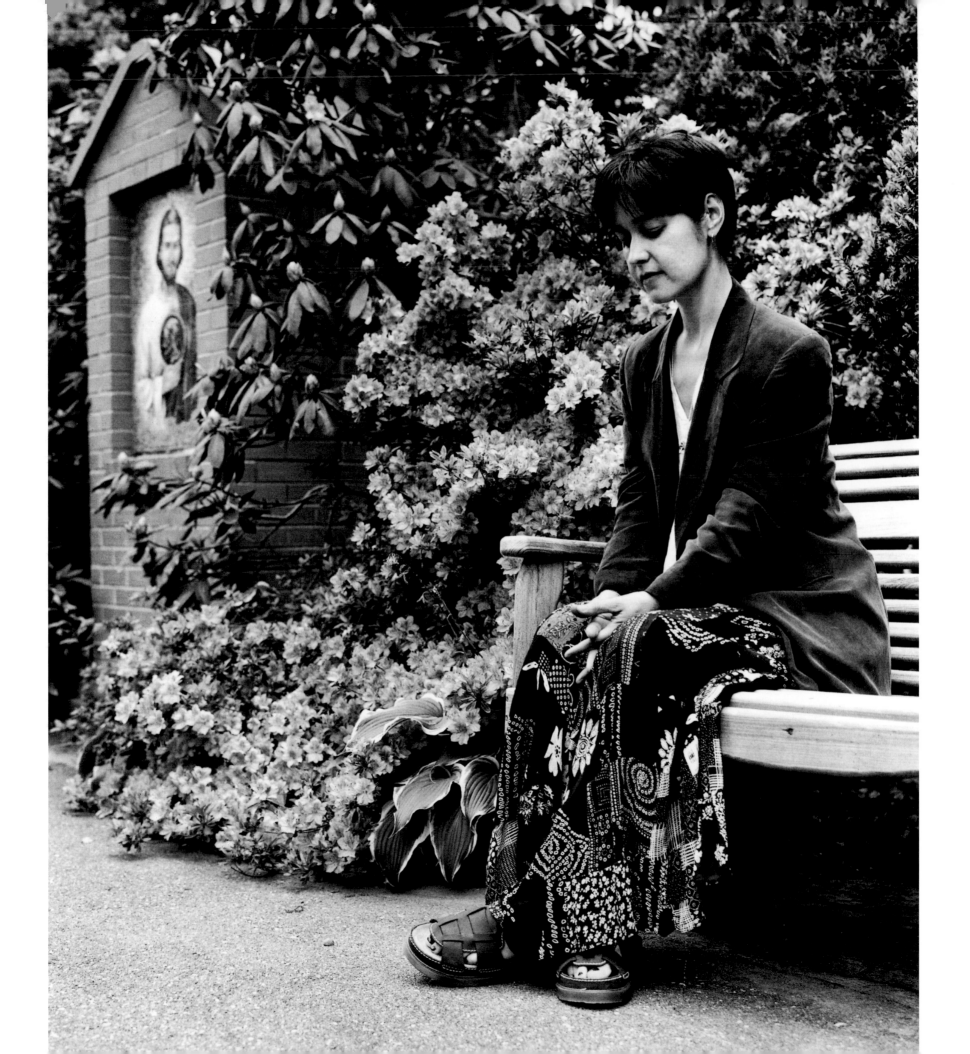

cell, where I listened to the cries of a man and woman being tortured. When the men returned, they accused me of being a guerrilla and began interrogating me. For every answer I gave them, they burned my back or my chest with cigarettes. Afterwards, they gang-raped me repeatedly.

Then they transferred me to another room and left me alone with another woman prisoner. We exchanged names, cried, and held onto each other. "Dianna," she said in Spanish, "they will try to break you. Be strong." When the men returned, they had a video camera and a still camera. The policeman put a machete into my hands. Thinking it would be used against me, and at that point in my torture wanting to die, I did not resist. But the policeman put his hands onto the handle, on top of mine, and forced me to stab the woman again and again. What I remember is blood gushing—spurting like a water fountain—droplets of blood splattering everywhere—and my cries lost in the cries of the woman.

The policeman asked me if I was now ready to talk, and one of the other torturers, the man who had threatened me on the street, mentioned that they had just filmed and photographed me stabbing the woman. If I refused to cooperate, their boss, Alejandro, would have no choice but to turn the videotapes and the photographs over to the press, and everyone would know about the crime I'd committed. This was the first I had heard of Alejandro, the torturers' boss. But soon I would meet him.

I was taken into a courtyard and interrogated again. The policeman wanted me to admit that I was Veronica Ortiz Hernandez. Earlier he had shown me a photograph of a long-haired, indigenous woman. "That's you," he'd said. "You are Veronica Ortiz Hernandez." She looked nothing like me. He was still insisting on this, and asking me the name of a man in another photograph he had shown me.

The policeman raped me again. Then I was lowered into a pit full of bodies—bodies of children, men, and women, some decapitated, all caked with blood. A few were still alive. I could hear them moaning. Someone was weeping. I didn't know if it was me or somebody else. A stench of decay rose from the pit. Rats swarmed over the bodies and were dropped onto me as I hung suspended over the pit by the wrists. I passed out and when I came to I was lying on the ground beside the pit, rats all over me.

The nightmare I lived was nothing out of the ordinary. In 1989, under Guatemala's first civilian president in years, nearly two hundred people were abducted. Unlike me, they were "disappeared, gone forever." The only uncommon element of my ordeal was that I survived, probably because I was a U.S. citizen, and phone calls poured into Congress when I was reported missing. As a U.S. citizen, I had another advantage: I could, in relative safety, reveal afterwards the details of what happened to me in those twenty-four hours. One of those details: an American was in charge of my torturers.

I remember the moment he removed my blindfold. I asked him, "Are you an American?" In poor Spanish and with a heavy American accent, he answered me with a question: "Why do you want to know?" Moments before, after the torturers had blindfolded me again and were getting ready to rape me again, they had called out in Spanish: "Hey, Alejandro, come and have some fun!"

And a voice had responded "Shit!" in perfect American English with no trace of an accent. It was the voice of the tall, fair-skinned man beside me. After swearing, he'd switched to a halting Spanish. "Idiots!" he said. "She's a North American nun." He added that my disappearance had been made public, and he ran them out of the room.

"I know what few U.S. citizens know:
what it is to be an innocent civilian, and to be
accused, interrogated, and tortured,
to have my own government eschew my
claims for justice and actively destroy
my character because my case causes political
problems for them."

Now he was helping me on with my clothes. "*Vamos*," he said, and he led me out of the building. He kept telling me he was sorry. The torturers had made a mistake. We came to a parking garage, where he put me into a gray Suzuki jeep and told me he was taking me to a friend of his at the U.S. embassy who would help me leave the country.

For the duration of the trip, I spoke to him in English, which he understood perfectly. He said he was concerned about the people of Guatemala and consequently was working to liberate them from Communism. Alejandro told me to forgive my torturers because they had confused me with Veronica Ortiz Hernandez. It was an honest mistake.

I asked him how they could have mistaken me for a woman who did not resemble me in any way. And why were the threatening letters I had received addressed to Madre Dianna and not to Veronica Ortiz Hernandez? He avoided my questions and insinuated that I was to blame for my torture because I had not heeded the threats that were sent to me. I asked him what would happen to the other people I had heard screaming and saw tortured before my eyes. He told me not to concern myself with them and to forget what had happened.

In English again, he made it clear that if I didn't "forgive" my torturers, I would face consequences. "We have the videotapes and the photographs," he said. Soon the jeep stopped in traffic. We were near an intersection and up ahead was a red light. I took advantage of the opportunity, jumped out of the jeep, and ran.

I thought that was the end of my torture. It was only the beginning. Because I didn't "forget" about the other people being tortured, because I filed suit against the Guatemalan security forces instead of forgiving my torturers, and because I revealed

that they were supervised by an American, I faced consequences. The Guatemalan president claimed that the abduction had never occurred, simultaneously claiming that it had been carried out by nongovernmental elements and therefore was not a human rights abuse. Only one week after my abduction, before any true investigation had been conducted, the U.S. ambassador suggested that I was a political strategist and had staged my own kidnapping to secure a cutoff of U.S. military aid to Guatemala.

Two months later, after a U.S. doctor had counted 111 cigarette burns on my back alone, the story changed. In January 1990, the Guatemalan defense minister publicly announced that I was a lesbian and had staged my abduction to cover up a tryst. The minister of the interior echoed this statement and then said he had heard it first from the U.S. embassy. According to a congressional aide, the political affairs officer at the U.S. embassy, Lew Anselem, was indeed spreading the same rumor.

In the presence of Ambassador Thomas Stroock, this same human rights officer told a delegation of religious men and women concerned about my case that he was "tired of these lesbian nuns coming down to Guatemala." The story would undergo other permutations. According to the Guatemalan press, the ambassador came up with another version: he told the Guatemalan defense minister that I was not abducted and tortured but simply "had problems with [my] nerves."

During this time, the United States was working arm in arm with the Guatemalan army to achieve a secret foreign policy objective—defeating the Guatemalan guerrillas. And my case was bad publicity for the army. Because I had mentioned the American boss, it was also bad publicity for the U.S. government, whose overt foreign policy objectives in Guatemala were promoting democracy, stability, and respect for human rights. In the ambassador's words, my case could "damage U.S. interests." In a letter urging State Department officials not to meet with me to take my tes-

timony, the ambassador put it this way: "If the Department meets with her…pressure from all sorts of people and groups will build on the Department to act on the information she provides…I'm afraid we're going to get cooked on this one…."

The Organization of American States, after completing a four-year investigation of my case, found in 1997 that I indeed was abducted and tortured by agents of the Guatemalan government, that the details of my testimony were credible, and that the Guatemalan government had "engaged in repeated unwarranted attacks on [my] honor and reputation."

The Guatemalan justice system was not so forthcoming. I made three trips to Guatemala to testify against the government, something no torture survivor had ever been able to do. Again, my passport opened up possibilities for me that Guatemalans would never have. Pressing charges would mean certain death for a Guatemalan who managed to survive torture. I identified the place where I was detained and tortured, and participated in a reenactment of my abduction.

On my return to the United States, I received intimidating phone calls and anonymous packages. One contained a dead mouse wrapped in a Guatemalan flag. I suspect that Guatemalan military intelligence agents or members of a U.S. intelligence agency were behind these attempts to intimidate me.

The intimidation did not end with anonymous threats, but carried over into the courtroom. As I sought justice, I was cast as the criminal, much as women who file charges of rape are presumed guilty until proven innocent. The lawyers' accusations against me and their aggressive interrogations triggered flashbacks. The case languished in the Guatemalan court system. No suspects were ever identified.

In 1996, I held a five-week vigil before the White House, asking for the declassification of all U.S. government documents related to human rights abuses in Guatemala since 1954, including documents on my own case. A few days into my vigil, I was granted a meeting with First Lady Hillary Clinton. Mrs. Clinton admitted what no other U.S. government official had dared to concede during my seven-year search for the truth behind my abduction and torture in Guatemala: she said it was possible that the American in charge of my Guatemalan torturers was a "past or present employee of a U.S. agency."

I ended my vigil and fast when the State Department declassified thousands of documents. But the documents contain no information about the American boss, and they do not identify my Guatemalan torturers. They do contain several interesting points of information. For example, Americans employed by various government agencies were in fact working within the Guatemalan security forces at the time of my abduction; and the U.S. ambassador at the time of my abduction admitted that the embassy had contact with members of a death squad.

Documents also show that the Guatemalan defense minister in office at the time of my torture studied counterinsurgency tactics at an army school in Georgia. Course manuals advocated the torture and execution of civilians ("terrorists operating within the democratic system") whose "political, social, and economic activities" could cause "discontent." The manuals urged internal intelligence agencies to "obtain information on the substance of [these] nonviolent attacks." It is no surprise that the Guatemalan army targeted me, as all civilians trying to help the poor were considered potential subversives.

> "My torturers were never brought to justice. It is possible that, individually, they will never be identified or apprehended. But I cannot resign myself to this fact and move on."

After escaping from my torturers, I returned home to New Mexico, so traumatized that I recognized no one, not even my parents. I had virtually no memory of my life before my abduction; the only piece of my identity that remained was that I was a woman who was raped and forced to torture and murder another human being. I still have little memory of my life before my abduction at thirty-one. Instead I have memories of the torture. You may think this strange, but even at this moment, I can sense the presence of my torturers. I can smell them. I can feel their monstrous hands on my body, I can hear them hissing in my ear that I am the one who killed the woman. I want to be free of these memories. I want freedom for myself and all the people of Guatemala. The key is the truth. I want to know who Alejandro was. Was he a CIA agent? Why is the U.S. government protecting him? How many other Alejandros are there out there, supervising torture?

Efforts to obtain information through U.S. government investigations also led nowhere. The Department of Justice interviewed me for more than forty hours, during which time their attorneys accused me of lying. They interrogated my friends and family members and generally made it clear that I was the culprit, I was the one being investigated, not the government officials who acted wrongly in my case. During the interview, I reentered that clandestine military prison and relived my torture it in all its horror. After I had given the majority of my testimony, I felt compelled to withdraw from direct participation in the Justice Department investigation. The investigators had the sketches I had made with the help of a professional forensic artist, delineating the characteristics of each torturer, including Alejandro, and the investigators had my testimony, in detail. The responsibility for finding answers lay with them. The Department of Justice came up with a two-hundred-page report to protect sources and methods and, ostensibly, to protect my own privacy.

In an attempt to get the report declassified, I then had to violate my own privacy. Afraid that the Department of Justice investigators might leak information I had given them if I pressured for the release of the report, I went public with that secret information myself: I got pregnant as a result of the multiple gang rapes. Unable to carry within me what the torturers had engendered, what I could only view as a monster, the product of the men who had raped me, I turned to someone for assistance and I destroyed that life.

Am I proud of that decision? No. But if I had to make the decision again, I believe I would decide as I did then. I felt I had no choice. If I had had to grow within me what the torturers left me I would have died. In 1998, after going public with this information, I filed a Freedom of Information Act request to obtain the Department of Justice report. My request was denied in full.

But to this day, I cannot forget those who suffered with me and died in that clandestine prison. In spite of the humiliation that demanding answers has entailed, I stand with the Guatemalan people. I demand the right to a future built on truth and justice. My torturers were never brought to justice. It is possible that, individually, they will never be identified or apprehended. But I cannot resign myself to this fact and move on. I have a responsibility to the people of Guatemala and to the people of the world to insist on accountability where it is possible. I know what few U.S. citizens know: what it is to be an innocent civilian, and to be accused, interrogated, and tortured, to have my own government eschew my claims for justice and actively destroy my character because my case causes political problems for them. I know what it is to wait in the dark for torture, and what it is to wait in the dark for the truth. I am still waiting.

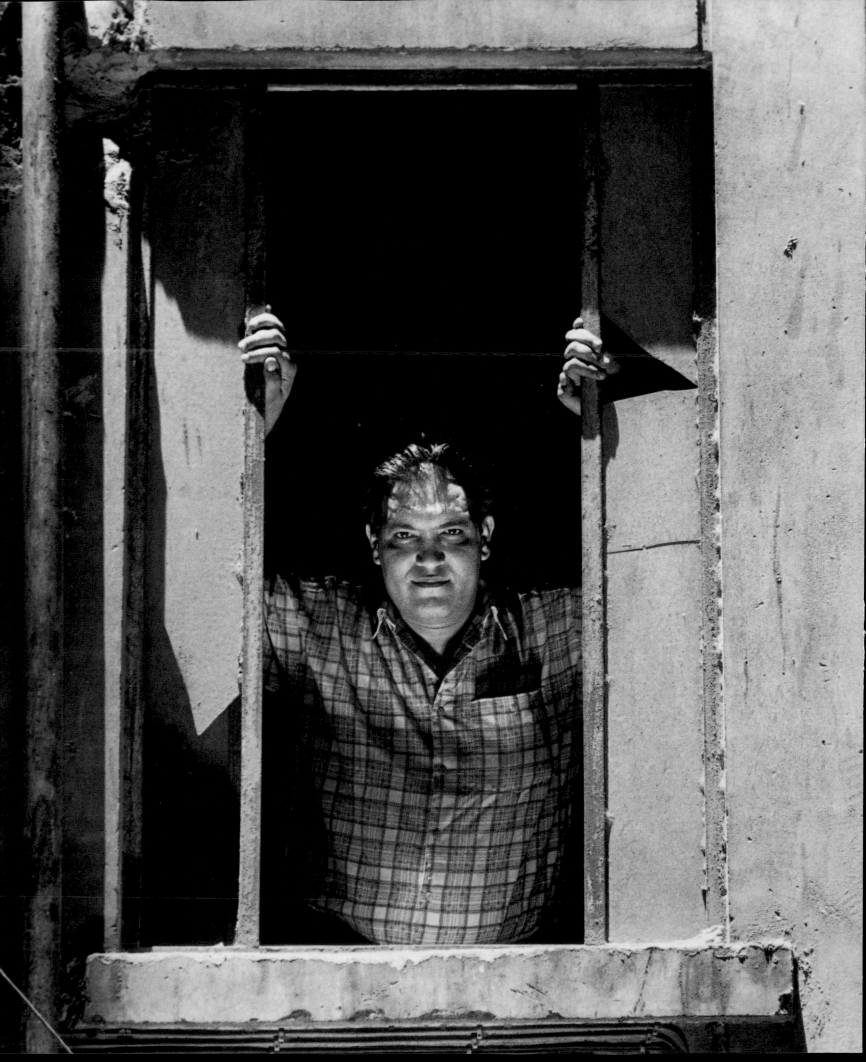

HAFEZ AL SAYED SEADA

POLITICAL RIGHTS

"The government didn't accept our report documenting
the abuses so they targeted our organization. But what I wrote are
facts. Hundreds of the people were arrested. Hundreds were
tortured in the police stations."

*Established in 1985, under Hafez Al Sayed Seada's leadership, the Egyptian
Organization for Human Rights investigates, monitors, and reports on viola-
tions of the Universal Declaration of Human Rights. Seada defends victims;
strives to create understanding of, and popular support for, the defense of
human rights; and works to change laws and government practices that vio-
late international instruments. He has launched numerous campaigns
against specific violations, including torture, female genital mutilation, inhu-
mane prison conditions, and religious persecution. Due process in Egypt is
hampered by emergency decrees, military and state security courts where
due process rights are suspended, a judiciary beholden to the executive, the
routine use of torture by security agents, and the deep divisions and suspi-
cions among the many religious and ethnic minorities in the country.
Although there are many news outlets, press self-censorship is common, and
dissent from the official party line is dangerous. Sexual discrimination is
rampant, and women are at a severe disadvantage in family law and access
to legal literacy. Seada's early life as a student activist landed him in prison,
where he was mistreated and thrown through a window in an effort to deter
him. Instead the experience transformed a university demonstrator into a
man with a lifelong commitment to protection of human rights. Today EOHR
is Egypt's foremost human rights organization.*

The police first arrested me in 1979, at university, because I participated in a demonstration against the government to uphold the rights of students to free association and to work on political issues. They beat me, gave me electric shocks, and tortured me for one month. They kept telling me to reveal who was supporting me, what country or leader was backing me. These scars across my face are from when they pushed me through a window. I was hurt so badly they had to take me to a hospital where I was operated on and remained for nineteen days. That was the end of the torture, but they kept me in jail for another four months.

A decade later, I decided to work as a human rights lawyer. I joined the Egyptian Organization for Human Rights, working without pay, from 1990 until 1993, documenting cases of abuse throughout Egypt and helping to build the organization. In 1997 the board appointed me director general. My country had been suffering since the Emergency Law had been declared in 1981. The Emergency Law annuls all constitutional rights—any rights—under international conventions. The press is restricted, independent newspapers and television are banned, and all the other newspapers are owned by the government. The police, security, and intelligence forces enforce this by regularly employing all kinds of torture. We had a very narrow space in which to operate. You can't even talk about corruption. You can't talk about the transition to democracy in Egypt or the rigging of elections: not in a place where the government chooses not only the candidates running from the state party, but those of the opposition party as well!

There are now twenty thousand detainees in prison. They have had no trial, and no charges have been pressed. Recurrent detention is widely resorted to. The emergency law gives the authorities (upon the approval of the minister of the interior) the right to detain someone without charge or trial for thirty days. But this often extends to six months or more, because the authorities have the right to reject the appeal of the detained person twice. Then, when the duration is over, another ministerial order is issued, keeping the detainee as long as the authorities wish. It amounts to endless detention.

Even when trials do take place, civilians are often referred to the military courts (and you can imagine the military courts). The latest case, involving over one hundred people from Albania, included four thousand pages of documents, and the defense was given only one week to prepare for the hearing. In most cases the outcome is predetermined. Military trials continue to be a source of serious concern for the Egyptian Organization for Human Rights due to the absence of any constitutional or international guarantees for a fair and a just trial. These trials demonstrate the lack of independence of the judiciary system in Egypt. There is another issue that represents an enormous challenge: securing respect for women's rights. Fewer than 2 percent of parliamentarians are women, and those are appointed by the state. Our group works with the UN Commission for Human Rights, which condemns the abuses in Egypt. Their support helps, though we know that we will have to pay the cost of this struggle. Look at what happened to me: I went to prison for writing about the torture of the Copts. The government didn't accept our report documenting the abuses so they targeted our organization. But what I wrote are facts. Hundreds of people were arrested. Hundreds were tortured in the police stations. We couldn't remain silent and call ourselves human rights defenders. So we published this report and then the government accused me of spying for a foreign country, Britain. They accused me of receiving money from the

British Embassy to make the report. This indictment is still pending—I am out on five hundred dollars bail.

When I was under investigation, they asked me if I was responsible for managing everything here at the Human Rights Organization. I told them I was. The investigators didn't believe me, saying, "No, the president shares responsibility with you." I told them publishing the report was my decision alone. I was responsible for everything. I wrote the report, I read it, I reviewed it, and I decided to publish it and issue it in a newspaper—to uphold human rights. I personally sent it to all the news agents. Sure, if I had told the investigators that I was not responsible, they might not have arrested me. But this is not my moral code. I felt I should take my responsibility and bear the consequences.

It may never come to trial but they have made it clear that if I write any more reports, they will restart the investigation and prosecute. But this is our job, as human rights advocates, to point the finger at government errors. If we don't do this, who will? These are our rights; we should fight for them. No government recognizes rights without a struggle. Look at America's Civil War and the agony of Europe's battles for democracy. We, too, must demand our rights. Winning democracy will involve sacrifice. So far we haven't paid heavily, or sacrificed ultimately. But we know that at some point, we'll either pay or be forced to accept this corrupt regime. If we are not willing to sacrifice, then we cannot complain when we are thrown in jail without reason, without any charge, and without any due process. We can expect no better. Because the fact is that this government doesn't respect the UN Conventions on Human Rights. They don't respect the democratic system. They want only to continue retaining sole political power.

I am not frightened. I think of the future, of my son. I face this challenge for him, for all our children, and for all their future. If we don't start now, the next generation will inherit our failure to bring about change.

My father and my mother always said, "Look at the facts and then make things right." When my father came to visit me in jail, he said: "Good or bad, your destiny is in the hands of God. God has planned whether you stay in prison or are released back to us. No one can change that." This encouraged me to always confront what I knew was wrong.

I know that the future will see an Egypt becoming more democratic, with respect for human rights. But this is the future only if the people demand their rights and they struggle. With mass communications, satellite dishes, and the internet, people cannot be kept in the dark any longer. And with the prosecution of Pinochet in Spain and Milosevic in Serbia before the International Criminal Court, those in power now know they will, someday, be held accountable for their wrongdoing. Things are in a state of change—there is no looking back.

My country has tremendous potential. It is rich in resources. We have the infrastructure of industrialization and a vast host of Egyptians abroad who work in the field of technology. If my countrymen believe that Egypt now respects human rights and that corruption is limited, they will invest. If we create systems for transparency, for democratization, for accountability, and for tolerance, this will protect our country from any threat, fundamentalist or terrorist, domestic or foreign. I believe in our future—and I know it will be better than now.

DESMOND TUTU

RECONCILIATION

"We have a God who doesn't say, 'Ah...Got you!' No. God says, 'Get up.'
And God dusts us off and God says, 'Try again.'"

Archbishop Desmond Tutu's work confronting the bigotry and violence of South Africa's apartheid system won him the Nobel Peace Prize in 1984. Born in 1931 in Klerksdorf, he graduated from the University of South Africa in 1954 and was ordained as a priest in 1960. He studied and taught in England and South Africa, and in 1975 he was appointed dean of St. Mary's Cathedral in Johannesburg, the first black South African to hold that position. In 1978 he became the first black general secretary of the South African Council of Churches. Outspoken against the evils of apartheid, he was vilified by friend and foe, press and politicians, yet through his extraordinary patriotism and commitment to humanity, his vision, and ultimately, his faith, he persevered. After South Africa's first democratic, nonracial elections in 1994, effectively ending eighty years of white minority rule, the new parliament created the Truth and Reconciliation Commission, appointing Tutu as its head to lead his country in an agonizing and unwavering confrontation of the brutality of the past. His faith in the Almighty is exemplified by his belief in the Word made flesh; that the battle for the triumph of good will be won or lost, not by prayers alone, but by actions taken to confront evil here on earth.

There's a high level of unemployment in South Africa that helps fuel a serious level of crime. These things feed off one another because the crime then tends to make foreign investors nervous. And there aren't enough investors to make a significant impact on the economy so the ghastly legacies of apartheid—deficits in housing, in education, and health—can be truly addressed.

If you were to put it picturesquely, you would say this man and this woman lived in a shack before April 1994. And now, four years down the line, the same man and woman still live in a shack. One could say that democracy has not made a difference in material existence, but that's being superficial.

There are changes of many kinds. Things have changed significantly for the government, despite the restrictions on resources. The miracle of 1994 still exists and continues despite all of these limiting factors that contribute to instability. They are providing free health care for children up to the age of six and for expectant mothers. They are providing free school meals and education through elementary school. But the most important change is something that people who have never lived under repression can never quite understand—what it means to be free. I am free. How do I describe that to you who have always been free? I can now walk tall with straight shoulders, and have this sense of pride because my dignity, which had been trodden underfoot for so long, has been restored. I have a president I love—who is admired by the whole world. I now live in a country whose representatives do not have to skulk around the international community. We are accepted internationally, in sports, etcetera. So some things have changed very dramatically, and other things have not changed.

When I became archbishop in 1986, it was an offense for me to go and live in Bishopscourt, the official residence of the Anglican archbishop of Cape Town. Now we live in a village that used to be white, and nobody turns a head. It's as if this is something we have done all our lives. Schools used to be segregated rigidly, according to race. Now the schools are mixed. Yes, whites tend to be able to afford private schools. But government schools, which in the past were segregated, have been desegregated. Now you see a school population reflecting the demography of our country.

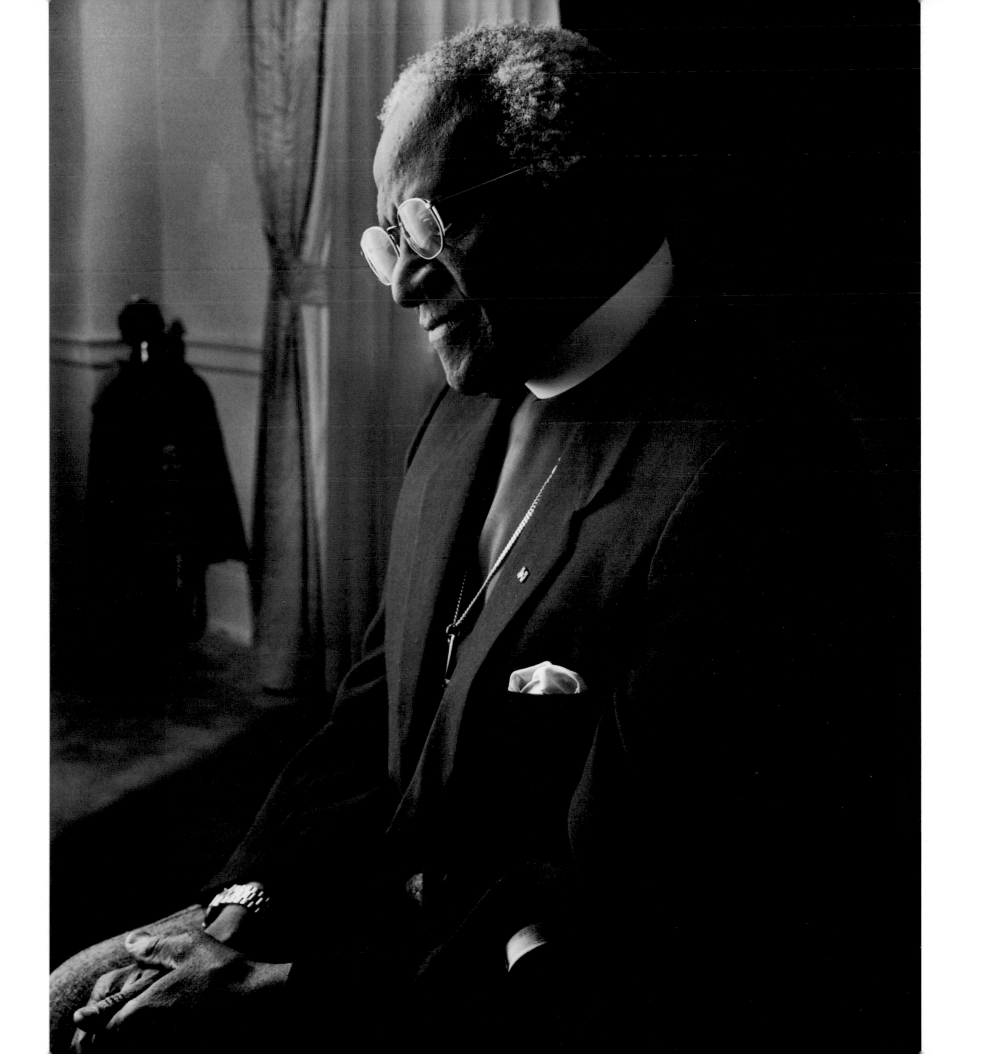

I was an advocate for sanctions and as a result, most of the white community regarded me as the man they most loved to hate. They would say, "Sanctions are going to hurt blacks." Yet South Africa was prosperous largely on the basis of cheap labor, using the iniquitous migratory labor system, where black men lived in single-sex hostels for eleven months of the year. Even my constituents were ambivalent about me. And so you had graffiti like: "I was an Anglican until I put Tu and Tu together." Some were really quite funny, like "God loves Tutu" adding, "The gods must be crazy." If looks could kill, they murdered me many times over. When I got on a plane in Johannesburg, or a train in Cape Town, the looks that I got were enough to curdle milk.

I received death threats, but that was not unexpected. If you choose to be in the struggle, you are likely to be a target. There are casualties in a struggle. Of course, it isn't nice to have threats and things of that sort. But it is par for the course.

When they threatened my children, that really upset me, that really got my goat. If somebody is intent on threatening me, that's okay. But they didn't have a modicum of decency. They could hear it wasn't me, it wasn't my wife, it was only a child on the telephone. They could have either dropped the telephone, or said, "Can you call your father, or call your mother?" But they didn't.

One threat came from a group called the "White Commando." They said that either I left the country by a certain date, or they were going to dispense with me. We told the police, who showed a sense of humor. One said, "Archbishop, why don't you do us a favor and stay in bed that day?"

I think my family would have felt that they were disloyal if they pressured me to change. I asked Leah, my wife, once, "Would you like me to keep quiet?" I have never been more wonderfully affirmed than when she said, "We would much rather be unhappy with you on Robben Island (the South African island prison where black political prisoners were jailed), than have you unhappy thinking you were free (in the sense that I had been disloyal to what I believed was God's calling to me)." Anything else would have tasted like ashes. It would have been living a lie. There is no reason to live like that. I suppose I could have been maybe part of a struggle in a less prominent position. But God took me, as they say, "by the scruff of the neck," like Jeremiah, who for me is a very attractive character because he complained: "God, you cheated me. You said I was going to be a prophet. And all you made me do is speak words of doom and judgment and criticism against the people I love very much. And yet if I try not to speak the words that you want me to speak, they are like a fire in my breast, and I can't hold them in."

Now you can't believe it's the same country. The pleasures of conforming are very, very great. Now it's almost the opposite. I mean on the street, they stop to shake hands and talk. When we found out that I had cancer, I was getting cards from the most unlikely quarters. At least on one occasion a white woman wanted to carry my bags and her family gave up their seats for me. It's a change, yes, it's almost like we are in a different country.

Our country knew that it had very limited options. We could not have gone the way of the Nuremberg trial option because we didn't have clear winners and losers. We could have gone the route of the blanket amnesty and say wipe the slate clean. We didn't go either way. We didn't go the way of revenge, but we went the way of individual amnesty, giving freedom for truth, with people applying for forgiveness in an open session, so that the world and those most closely involved would know what had happened. We were looking particularly to the fact that the process of transition is a very fragile, brittle one. We were saying we want stability, but it must be based on truth, to bring about closure as quickly as possible.

"We should not be scared with being confrontational, of facing people with the wrong that they have done. Forgiving doesn't mean turning yourself into a doormat for people to wipe their boots on."

We should not be scared with being confrontational, of facing people with the wrong that they have done. Forgiving doesn't mean turning yourself into a doormat for people to wipe their boots on. Our Lord was very forgiving. But he faced up to those he thought were self-righteous, who were behaving in a ghastly fashion, and called them "a generation of vipers."

Forgiveness doesn't mean pretending things aren't as they really are. Forgiveness is the recognition that a ghastliness has happened. And forgiveness doesn't mean trying to paper over the cracks, which is what people do when they say, "Let bygones be bygones." Because they will not. They have an incredible capacity for always returning to haunt you. Forgiveness means that the wronged and the culprits of those wrongs acknowledge that something happened. And there is necessarily a measure of confrontation. People sometimes think that you shouldn't be abrasive. But sometimes you have to be to make someone acknowledge that they have done something wrong. Then once the culprit says, "I am sorry," the wronged person is under obligation, certainly if he or she is a Christian, to forgive. And forgiving means actually giving the opportunity of a new beginning.

It's like someone sitting in a dank room. It's musty. The windows are closed. The curtains are drawn. But outside the sun is shining. There is fresh air. Forgiveness is like opening the curtains, opening the window, letting the light and the air into the person's life that was like that dank room, and giving them the chance to make this new beginning. You and I as Christians have such a wonderful faith, because it is a faith of ever-new beginnings. We have a God who doesn't say, "Ah…Got you!" No, God says, "Get up." And God dusts us off and God says, "Try again."

In one instance, I was preaching in a posh church of some of the elite in the white Afrikaner community, a Dutch Reformed church, and I was probably the first black person to have done so. I spoke about some of the things we had uncovered in the Truth and Reconciliation Commission. For instance, the previous government had had a chemical and a biological warfare program which was not just defensive, and had been looking for germs that would target only black people. They wanted to poison Nelson Mandela so that he didn't survive too long after he was released from prison. One of the ministers in the church came and joined me in the pulpit, and broke down, saying he had been a military chaplain for thirty years and didn't know these things. He hoped he'd be forgiven and I embraced him. There are others who have been less than forthright, but generally you have had people say, "We are sorry." Most of our people are ready to forgive.

There are those who are not ready to forgive, like the family of Steve Biko. That demonstrates that we are dealing with something that is not facile. It is not cheap. It is not easy. To be reconciled is not easy. And they make us so very aware of that.

One of the extraordinary things is how many of those who have suffered most grievously have been ready to forgive—people who you thought might be consumed by bitterness, by a lust for revenge. A massacre occurred in which soldiers had opened fire on a demonstration by the ANC (African National Congress), and about twenty people were killed and many wounded. We had a hearing chock-a-block full with people who had lost loved ones, or been injured. Four officers came up, one white and three black. The white said: "We gave the orders for the soldiers to open fire"—in this room, where the tension could be cut with a knife, it was so palpable. Then he turned to the audience and said, "Please, forgive us. And please receive these, my colleagues, back into the community." And that very angry audience broke out into quite deafening applause. It was an incredible moment. I said, "Let's keep quiet, because we are in the presence of something holy."

SENAL SARIHAN

TURKEY

POLITICAL RIGHTS

"When prisoners told me of the tortures that they were suffering, I could barely stand it. The prison was far from the city, and when I returned every day from it, I felt like I was going to another life. I felt that I didn't have the right to hug my husband after hearing all these things that were happening. I had become a mother, but by then I didn't think I even had the right to hug my children."

Mother, lawyer, feminist, wife, playwright, director, teacher, union organizer, editor, advocate, leader, Senal Sarihan has challenged the status quo her entire life. As a member of the teachers union's cultural unit, she wrote and directed plays. She joined the Executive Committee of the newly founded Turkish Teachers Association in 1967, where she wrote pro-union articles for their monthly newspaper. Those articles led to her imprisonment in 1971 when the military regime sentenced Sarihan to twenty-two years for her writings. When the newly elected government released her in 1974, Sarihan studied for her law degree and in 1976 began defending intellectuals, union leaders, and human rights defenders. In 1980 she was again arrested and held for thirty-five days for her articles "espousing antistate views." She founded the Contemporary Lawyers Association in 1986 and served as its president, advocating legal reform and the defense of human rights. As the editor of the CLA's monthly magazine, she has became the most influential critic of Turkey's antiterrorism law and violations of the rights of free expression. Sarihan is known for her dogged defense of prisoners, women, and children. In the course of her work, fundamentalists and supporters of the status quo alike have threatened her life. In spite of ever-present danger, Sarihan marches on. Forming an alliance of women's groups called the Contemporary Women's Association she organized thirty-five thousand women to rally for their rights in 1996, the largest such demonstration in the history of Turkey. The dispossessed are well represented by Senal Sarihan.

I began as a teacher in the 1970s, working in a very poor section of Istanbul. There was a cholera epidemic and a lot of my students died and around the same time we had our first military coup. They started to imprison a lot of intellectuals, and I thought I would be imprisoned as well. I was expecting it, actually. At that point I was helping a professor who had been tortured in the prison. They released her, and I was helping her to recover. The government claimed that she was in league with an organization (she was not) and I really didn't have anything to do with any illegal organization. But nevertheless I was detained and tortured for forty days.

Obviously I didn't know anything. They thought I was being silent. They used electrical shock on my ears, tongue, and sexual organs. At the time I was very thin, with long hair separated in the middle, and I had pimples. I learned that they were looking for a woman who was the daughter of a colonel and I looked very much like her. That's why they imprisoned me and tortured me—mistaken identity.

I always heard about violence and torture in the prisons but never dreamed it would be so bad. They transferred me from Istanbul to Ankara—ten hours of transport. And said in Istanbul that I was lost, that I was killed, that I was dead. My parents didn't have any information—I simply disappeared for three months. Then another prisoner who had just been transferred from Istanbul to Ankara saw me

as she was led in, and was shocked because everybody thought that I was dead. That's how people finally learned I was alive.

On October 3, 1971, I was put on trial with a group of intellectuals. I had never seen these people before, but officials claimed that we were part of underground organizations. We decided together that we weren't going to say anything during this trial, to protest that they were not prosecuting the people who tortured us. The court then said this was "a movement decision," proving we were in league with each other, and gave me twenty years of imprisonment, claiming I was the leader of the group. Today I'm laughing, but at the time I was dumbfounded—I really had nothing to do with that group.

I was twenty-three and had been a leader in student organizations. Just before I was seized I had taken the exams for law school, though I was more inclined towards studying sociology. But after prison, I decided that I actually needed to be a lawyer, to be prepared to defend other people's rights so they didn't have to go through what I did. In 1974 the new government passed an amnesty law and all of us in the Ankara jails were freed three years after. It was a lucky period. The government and all society accepted that what they'd done to us was unfair, so we were able to go back to our professions. I became a teacher again and got married. I decided to get married really fast because I was trying to get out of the house. Even though my father was very democratic, after all that had happened he started to be very careful about me. But I knew that I wanted to get married with somebody who would understand, who had the same point of view as I had. I met my husband in prison; he was also a teacher and the head of a student organization.

While in prison, my students went on a series of strikes to call attention to my situation. That was really important and very moving for me—they were putting themselves in danger and could have been imprisoned as well. So I wanted to return to work as a teacher to support them as they had me. After my husband and I got married we were both sent by the government to teach in a small village by the Black Sea. The day after we arrived, the government decided to send my husband to another city, hundreds of miles away. Our life became work. There were many ultranationalist, almost fascist groups spread throughout Turkey who made a point of finding out where people like me (who had been imprisoned) were, and leading propaganda campaigns against us. In the village where I was teaching, I started to receive death threats. We were publishing a magazine on education and teaching and I was continuing to do plays, folkloric dances, and discussion sessions with the parents of the students. We had excellent relations with teachers, students, and parents, but nevertheless the fascist groups did everything

"I was put on trial with a group of intellectuals. I had never seen these people before, but officials claimed that we were part of underground organizations. The court gave me twenty years of imprisonment, claiming I was the leader of the group. Today I'm laughing, but at the time I was dumbfounded—I really had nothing to do with that group."

they could to destroy this. Finally I couldn't take it anymore. I contacted my husband and said that we just had to go to the same city and live together. We found a way; but again they didn't leave us alone. They said I only had a special amnesty and therefore had to go to a city called Tocat to teach, but would be under detention there. After that the police officers were after me all the time—I couldn't work. So I decided to come to Ankara and sue them in court—and I won. Meanwhile I had finished law school. One of the cities nearby where I was trying to do an internship wouldn't accept me, saying I was a Communist. My husband and I moved again to Ankara, working as teachers while I applied to an Ankara law office for my internship; this time I was accepted, although at that time there were very few lawyers who were interested in cases involving freedom of expression.

But the lawyer that I was working with was famous, and always helping intellectuals and ordinary people. He was a great teacher and a big influence. The year after I started, another military regime seized the government. So there were more and more political cases and I became a lawyer in the courts where once I was a prisoner. I could actually feel the problems that these prisoners were having, in my body, could feel their emotion because I knew that they were also tortured, and they shouldn't have been. So even though it was hard, I started to fight back against the torturers. We simply had to put them on trial. That was

1980. A year later, another coup. This time, all the workers' advocates and teachers unions groups were closed by the government, and the number of lawyers dealing with political cases decreased significantly. There were maybe seven or eight lawyers total in Ankara—that's it, because they were scared. In that period Turkey had a lot of problems: thousands were killed in prison, torture was common. (And of course people say anything under torture.) For up to two years many others remained in prison awaiting trial—even though they weren't guilty. They had to perform hard labor there, could barely see their families. I started to work to improve the situation and was the first to bring a case against the prisons.

Personally, it was very hard. When prisoners told me of the tortures that they were suffering, I could barely stand it. The prison was far from the city, and when I returned every day from it, I felt like I was going to another life. I felt that I didn't have the right to hug my husband after hearing all these things that were happening. I had become a mother, but by then I didn't think I even had the right to hug my children. I gave birth and then forty days later went to work immediately. One judge knew that I had to nurse my baby so he would wait until midnight to start my cases, to help me. I wanted to take flowers from the garden and give them to the children who were in

detention. I wanted to make them feel close to nature. While we waited for our trials—long hours—I would write stories about what was happening to these children. And at that point I started to work with mothers to create a human rights organization. There was a lot going on in these prisons we couldn't do anything about. But we always tried to help. In 1990 we recreated the Contemporary Lawyers Association, which was closed down since 1980 along with all the groups that had been banned then.

All these years of struggle made me well known in the public eye—the press and the media covered me constantly. I was known as a human rights lawyer, not as part of a militant group. I wasn't afraid of being in prison or any other reprisals, but whereas as an underground group leader I was circumscribed, as a lawyer I knew that I could do a lot. Even though I was in danger most of the time, struggling gave me a lot of strength, and made me stronger. The act itself creates a mechanism to allow you to defend yourself even better. In 1985 I had my second child; in 1986 I was in prison again. This time the charge was that eleven years ago (when I was in that little village by the Black Sea) I had been engaging in Communist propaganda by publishing those education magazines. The statute of limitations is normally five years in Turkey, so this certainly had no legal basis, but my activism bothered them to such an extent that they were trying to find any way possible to put me in prison

again. My baby was ten months old then and the fact that I couldn't give him milk was very, very hard for me. Since it was very obvious that what they were doing was illegal, a lot of people supported me, which was really nice. And after thirty-five days we were released.

But I want to make clear that the struggle that I am living today is also my struggle, not just something I do for others. There were elections in our lawyers association recently, and my lawyer friends cautioned me that I was getting too involved with work and not giving enough attention to my children and family (my son had been depressed at this time). And I said to them, "My son is also your son. Anybody's child could have been sick. I am struggling so that all of our children will benefit."

The work that we're doing in the Contemporary Lawyers Association has had absolutely good, extremely positive results. There is now solidarity among lawyers and we have grown in numbers. We've tried to deal with the legal aspects of all the organizations that are trying to democratize Turkey and the intellectual organizations who are trying to help them. We did significant work to end torture and to improve the conditions in the prisons, to improve freedom of expression. But at the same time, bad things still happened in the nineties. There were fewer cases of torture, but many

> "But I want to make clear
> that the struggle that I am living
> today is also my struggle,
> not just something I do for others."

people were killed by extrajudicial executions, or disappeared. In 1991 they passed another amnesty law, but failed to free people who were imprisoned because of the Kurdish situation—all those intellectuals were still in prison, definitely a double standard. This was part of the antiterrorism statute that we were also against, which allowed the government to fight terror by terror. There were a lot of disappearances at this time of Kurdish lawyers. I am Turkish, and have a Turkish ethnic background, but for years we Turks lived as brothers and sisters with Kurdish people. The Kurdish situation became really incendiary because Ocalan (the leader of the Kurdish terrorist group KPLA) started to get support from outside countries, like Iraq, and then the government blamed terrorist activities in the southeast on civilians living there. Since then there have been a lot of human rights violations against the Kurds and we have fought that. For instance, during a meeting of the Kurdish political party someone lowered the Turkish flag, so they decided to arrest and detain all the deputies for that. But only one stupid person did that—the rest had nothing to do with it—and I wasn't scared of defending them because I knew that they weren't against Turkey, the nation, as such. Now they are free.

In 1993 there was a meeting of thirty-five intellectuals in the town of Sirvas and the fundamentalists set the hotel on fire and killed all of them. I repre-sented their families and because of that received a lot of death threats. During that time in Diyarbakir where Sezgin Tanrikulu was living, there was a disappearance of a man called Sherif Afszhar. The family found the person who took him—the first time anyone had. But no lawyer was able to accept the case because they were scared, so they asked me. I went back and forth to Diyarbakir in really difficult conditions. Somebody put a gun to my head and they told me that if I came back again they were going to break my legs. I knew that the secret police were planning to capture me—they told me. Next day I went to the judge and made a complaint. The judge just said that the threat could be from a private underground organization or the funda-mentalists—how could he know? He could do nothing.

Courage is a way of life. Working and struggling is how you become happy. When you look back on your life, you should have changed the world some-how. Of course humans are scared; being scared is a very human feeling. But you can't live being scared. You have to overcome. And you know that those who are against you are really scared of you. You are not doing this because of courage, you're not ever thinking about courage. It has simply become your way of life. Sometimes I am really scared—for my children. But how nice it will be if they have a mother that they can be proud of. So I struggle, until the end, so that they can be proud of me.

VAN JONES

UNITED STATES

POLICE BRUTALITY

"This guy is beaten, he's kicked, he's stomped, he's pepper-sprayed,
gagged (because they didn't want him bleeding on them),
and then left in a cell. Well, that's the sort of stuff you expect in
Guatemala, but it happened just fifteen or twenty minutes from here."

Van Jones is the founder and executive director of Bay Area Police Watch, an organization committed to stopping police misconduct and protecting victims of abuse. Police Watch takes a multifaceted approach, combining advocacy with public education and community organizing. Jones works directly with individuals who have suffered from police harassment, intimidation, and brutality. His efforts to establish civilian oversight, and to require transparency and accountability within disciplinary proceedings, has yielded results. Jones's efforts to ban the use of pepper-spray, routinely used by police in subduing suspects, has helped launch a nationwide campaign against the chemical weapon. The Police Watch Hotline documents callers' complaints and refers victims to lawyers who are, in turn, trained by Police Watch in handling misconduct cases. Police Watch then helps victims and lawyers through legal proceedings, organizes community support, and advocates on behalf of victims to public officials and the media. Jones's efforts have offered a corrective lesson that egregious abuses of human rights still take place even within the vaunted protection offered by the democratic laws of the United States.

The Center for Human Rights is a strategy center for documenting and exposing human rights violations in the United States—particularly those perpetuated by law enforcement. We have a hotline that we opened in 1995 here in the San Francisco Bay area and in 1998 in New York City where people can call and report abuses. We designed a computer database, the first of its kind in the country, that allows us to track problem officers, problem precincts, problem prac-

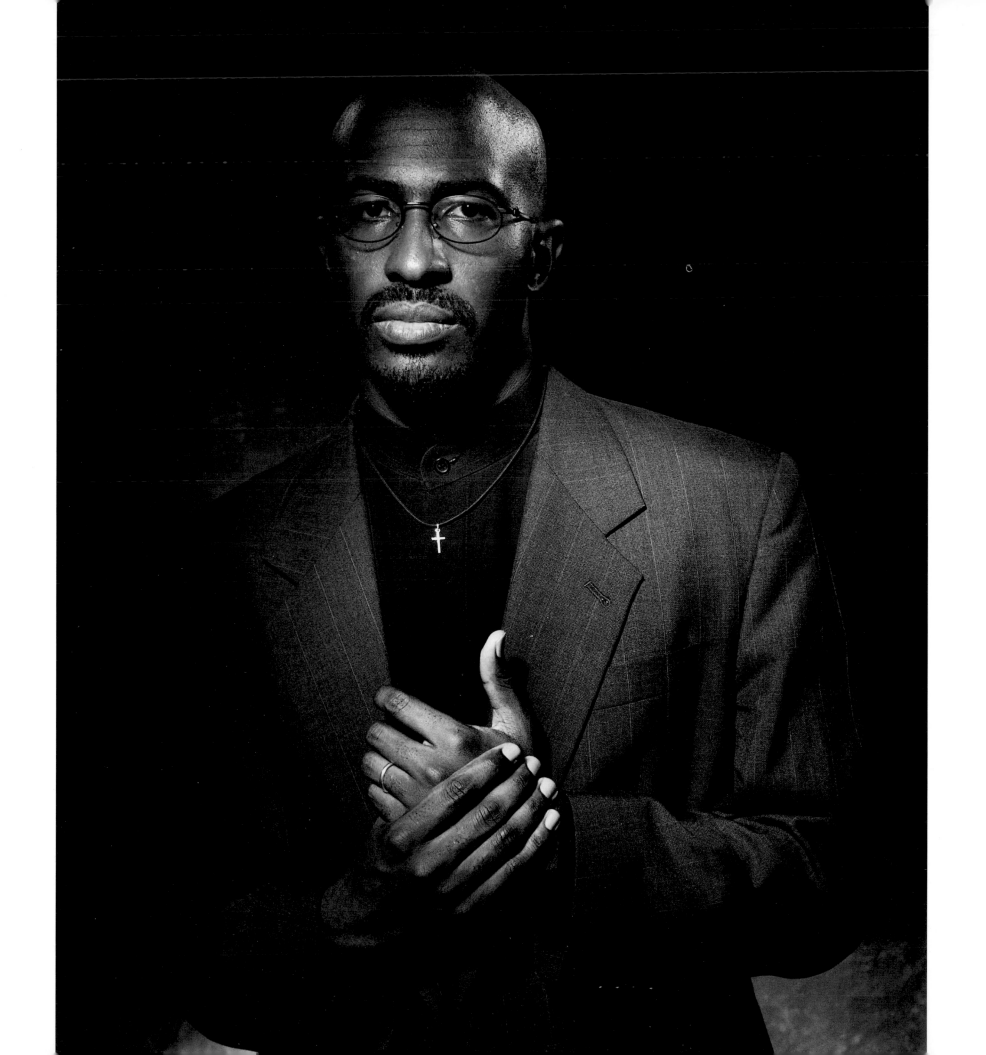

tices, so at the click of a mouse we can now identify trouble spots and trouble-makers. This has given us a tremendous advantage in trying to understand the scope and scale of the problem. Now, obviously, just because somebody calls and says, "Officer so-and-so did something to me," doesn't mean it actually happened, but if you get two, four, six phone calls about the same officer, then you begin to see a pattern. It gives you a chance to try and take affirmative steps.

We also try to expose abuse by doing a lot of public education. This is something we've really pioneered. Sometimes when people who suffered abuse at the hands of the police tried to engage the mainstream media, they would do it in a way that made them seem shrill, alarmist, or racially divisive. Instead, we thought it was important to interact intelligently with the media in a way that let them know that we were credible and interested in moving this issue forward in a responsible way.

Look, we get ten phone calls a day here from survivors of police misconduct and violence. Some of it is, "Officer so-and-so called me a boogerhead," or something minor like that, but it also goes as far as wrongful death. We see the full gamut here. We try to spend half an hour to an hour with every person who calls. We have people who call because their children have come home with a broken arm or broken jaw or their teeth shattered or because the child has been held in jail for four or five days with no charges. What we do when

people call is that we let them tell their story and then we write the story into the computer. We don't try to rush them.

Then we tell them about their rights and their remedies. We tell them if you want to file a complaint with this officer in this municipality, here's the number you call, here's how to get the form to fill out, here's the process. We tell them if you want to bring a lawsuit or file a claim of some sort for money damages, here's what that process looks like.

If a caller has evidence of police brutality, then we have a couple dozen cooperating attorneys that we refer those cases to. Those attorneys rely on us to screen to a certain extent—to ask enough questions about the incidents so that if somebody calls and says, "Police Watch told me to call," then they can be relatively confident that there's at least something to work with here.

We started out in January 1995 at the Lawyers' Committee for Civil Rights. Even though police issues were not a part of their docket (they usually focus on employment, discrimination, and other issues), they saw a need.

That need became clear, after we had been doing this project for a while, in the Aaron Williams case. This was the African-American man who died in police custody. We had a really close relationship to the process. Sometimes you have

"This case became a
question of not letting the
authorities get away with
this level of wholesale disrespect
and disregard for human life
and for the rule of law."

to have a certain amount of professional distance, but this case was not like that at all. Here the family and Police Watch volunteers merged efforts and spent those two years literally arm-in-arm. We went through three separate disciplinary hearings for the same officer on the same case within eight months, and we lost the first two times and we finally won in 1997. I'll never forget the look on the officer's face. It had gone beyond Aaron. This case became a question of not letting the authorities get away with this level of wholesale disrespect and disregard for human life and for the rule of law. Community witnesses, several dozen of them, all said that after Aaron was down on the ground and hand-cuffed, the policeman was kicking him in the head with cowboy boots, and that he was identifiable because he was the only officer in plainclothes.

Aaron had been sprayed in the face with pepper-spray, which is not a gas, like mace—it's a resin. The resin sticks to your skin and it burns and it continues to burn until it's washed off. The police never washed the resin off Aaron. And so this guy is beaten, he's kicked, he's stomped, he's pepper-sprayed, gagged (because they didn't want him bleeding on them), and then left in a cell. Well, that's the sort of stuff you expect in Guatemala, but it happened just fifteen or twenty minutes from here.

All of this was illegal and inhumane and yet it was going to be sloughed under the rug. This case was definitely a turning point in my life. I knew what kind of

officer this was; I knew what the family was going through and I just made a commitment inside myself that I was not going to walk away. Win or lose, this family was not going to fight by itself. Every resource that I had, every bit of creativity that I had, all of the training in criminal law and community organizing that I had, I was going to put to work until we got justice.

As a result, I began to get threats. "Who do you think is protecting you?" or if something were to happen to you, talking about "People like you don't deserve to live"; "People like you don't deserve to be in this city." It just went on and on.

But 99 percent of the cases don't end as dramatically as Williams's. We have this one African-American father who bought a sports car for his son. On the boy's sixteenth birthday, he was driving him home in this new sports car and the police pulled him over—two black guys in a sports car. Now they put them on the hood of the car, they frisked them, they went all through the car. There was no physical violence but the guy wound up with a severe emotional and nervous breakdown. Small business went under. He just couldn't recover from it because he was so humiliated in front of his son.

My point is that this sort of stuff just shouldn't be happening. It doesn't make our world any safer, doesn't make law enforcement's job any easier. It increases the level of resentment against law enforcement. And it's plain just wrong.

MULTINATIONAL CORPORATE RESPONSIBILITY

"Sometimes, the military walks across the path just in front of us,
so close we can touch them. We have to be very careful."

Ka Hsaw Wa is the founder of EarthRights International, a nongovernmental organization that filed a precedent-setting lawsuit against a U.S. corporation for torture committed by its agents overseas. The suit charges that Burmese government agents hired by Unocal, a U.S.-based oil company, to provide security, transportation, and infrastructure support for an oil pipeline, committed extortion, torture, rape, forced labor, and extrajudicial killings against the local indigenous population. Ka Hsaw Wa knows about the abuses committed by the military regime firsthand. He has spent years walking thousands of miles through the forests of Burma, interviewing witnesses and recording testimonies of victims of human rights abuses. He has taught hundreds of people to investigate, document, and expose violations of international human rights. As a student leader in the 1980s, Ka Hsaw Wa organized pro-democracy demonstrations in Rangoon. He was seized and tortured by agents of the Burmese military regime, in power since 1962 (and renamed SLORC (State Law and Order Restoration Council) in late 1988). When police opened fire on peaceful demonstrators, one of Ka Hsaw Wa's best friends died in his arms. Ka Hsaw Wa fled into exile along the Thai border. To protect family members he took a new name, Ka Hsaw Wa, which means "white elephant." Ka Hsaw Wa's meticulously compiled documentation of systemic rape and forced labor is relied upon and cited by Amnesty International, Human Rights Watch, and other international organizations. He has collaborated on several books about the abuses, including School for Rape *(1988): "Take over 300,000 men, many of them under the age of seventeen and largely uneducated. Force some of them to enlist at gunpoint and promise all of them a salary they never receive entirely. Give them guns and bombs. Train them to shoot, to crawl through the jungle at night, to ambush. Convince them that their enemies are ethnic minorities, students, women, anyone who disagrees with the government, and that these millions of people are traitors or infidels. Starve them. Withhold their mail and don't allow them to send any letters. Forbid them from visiting their families. Force them to beat each other for punishment. Abandon some of them if they are too sick to walk. Abuse them verbally and physically every day. Allow them plenty of alcohol and drugs. You have just created the army of Burma's ruling military regime." Ka Hsaw Wa's work, at tremendous personal risk, continues in the jungles of Burma.*

I've been doing this for eleven years. Most of the time I coordinate fieldwork, collect information, conduct fact-finding missions, and train my staff to do the same, specifically in the pipeline area of the U.S. oil company Unocal. We currently have a lawsuit pending against Unocal. The crux of the case is that a U.S. company is using human rights abuses to further their profit margins.

We interview people inside Burma and ask questions about human rights violations perpetrated by the military government. We hear cases of torture and forced labor, forced portering and rape, and extrajudicial killings. Sometimes I collect information outside of Burma along the Thai border and at other times I collect it in the refugee camps.

The villagers who support us keep in touch secretly or by code. We use radios and GPS (Global Positioning Systems) to find our way through the jungle. It is extremely dangerous. There are a lot of military bases. We listen to the radio in order to track the military's movements and to avoid being caught. I wear black clothes and carry a backpack. We travel with a maximum of three people at a time. Sometimes, the military walks across the path just in front of us, so close we can touch them. We have to be very careful. I have been shot at twice.

We make our decisions based on the movement of the troops. Normally, we don't go into the villages because it's so dangerous. Instead, we ask the people to come secretly to the jungle because we don't want to expose ourselves to them and also because we might put them in jeopardy. Among the villagers, there are spies for SLORC, the local military organization. Therefore, we must be very, very careful.

There are many human rights violations directly connected to the Unocal pipeline. The most common is forced labor and portering. The latter occurs when soldiers force villagers to carry their ammunition, their supplies, and food. The porters are not paid for their labor and, at times, they try to escape and to report these crimes to the authorities. If they are caught, the porters may be tortured, imprisoned, or possibly killed by members of SLORC. This happened recently to a close friend of mine. He and a group of villagers had been collecting information for me in order to help themselves and to raise public awareness of local human rights violations. SLORC suspected him of these activities and killed him.

Likewise, in the last four or five years, I have heard of twelve to fifteen rapes against local women by SLORC soldiers providing security for the pipeline. Two of these rape victims are plaintiffs in our lawsuit. The whole area is crawling with soldiers and these women were raped while walking between their village and a nearby farm.

In response to abuses like these, I organized a group of students in 1988 to protest against SLORC and to demonstrate for democracy. Though I was living in Rangoon, each student in my group organized a demonstration in the towns outside Rangoon. Eventually, there were protests all over Burma to educate people about democracy and to resist SLORC. During one demonstration in Rangoon, two of my friends were shot. One died there with me; the other was shot through the mouth and jaw. I carried him to the hospital but, in order to escape, I had to abandon him.

I didn't want to leave Burma and my elderly parents, so I decided to go to an area outside of Rangoon. At that time, I stayed in the jungle and observed the terrible lives of the villagers. In the morning, the villagers took hoes and baskets and were forced to build things for the military. One day the owner of the house that I was living in said, "Tomorrow I have to go and work for the dogs again." "What are you talking about?" I asked. "The villagers refer to the soldiers as dogs because they hate them," he replied. "We don't have time to do anything we need to do because we always have to work for them. We don't get any pay." Then, I got a letter from my mum saying, "Son, it's too dangerous. Wait for me and I will come to see you." My mother came and I said goodbye to her.

I walked through the jungle for five days to the Karen area with another student and a villager. As we neared the village, I saw a sight that I will never forget. I saw a dead woman with a large tree branch in her vagina. I walked to the village and I asked about her. The villagers told me that she was a nurse and that a group of soldiers had taken her to cure one of their comrades who had contracted malaria. Instead, they raped and killed her. It was so sad.

I stayed around the village for quite a while. This totally changed my life. Since no one was doing interviews at the time, I decided to do some. I talked to everyone. I talked to one mother whose son had committed suicide because a group of soldiers had forced him to have sex with her. The soldiers then clapped their hands and called the boy a motherfucker. The son later killed himself out of shame. The mother was heartbroken. It was then that I made the decision to work for these people.

In the beginning, I had neither a pen nor paper to work with. I went to the Karen National Union (KNU) resistance authority and was dismissed as just another young student. The union told me that this kind of incident happened all the time and that no one cared. They told me not to bother, but to take arms and to fight the soldiers. I didn't know how to go about the work I wanted to do without the necessary resources or support. I kept approaching the KNU and asked them to buy me a tape recorder, paper, and a pen with which to write down and pass along important information to the concerned people. They simply told me not to fool myself.

I made a decision to continue working on the testimonies. All that I could do was to talk with the people and to absorb their stories as best that I could. We were living in the middle of the jungle, so I decided to go to a town to get some paper and a pen. I used these resources to write messages to people, but no one listened and no one even cared. "What am I doing?" I thought. I was so frustrated.

Finally, in the beginning of 1992, I met a man by the name of Kevin Heppner. He was a Canadian and together we started doing human rights documentation. I translated the testimonies to English, he typed them, and we sent them to anyone who might be interested. Kevin primarily sent the information to human rights groups like Amnesty International because I didn't have papers to

cross into Thailand. I got arrested four or five times in Thailand because I was illegal there. They'd put me in jail for seven days and then release me. It was extremely difficult. In the beginning, we were very poor. Finally we met a woman from France who gave us money for paper and mailing. I was so happy that we could finally do something.

In Burma, I was arrested before the student uprising and tortured as well. A friend of mine had had a fight with one of the authorities' children and then had disappeared. Although I didn't know where he had gone, the authorities tortured me and insisted that I tell them of his whereabouts.

The torture began with something referred to as the "motorcycle ride," in which I was forced to assume a specific position and to utter the sounds vroom, vroom, vroom. Once I was exhausted, my shins were beaten with a special tool with a tough outside and pure metal core. Next, I was subjected to "the railway." I had to pretend to ride a railway and to call out the name of each stop. If I didn't know the name or if I pronounced it incorrectly, I was beaten. They would beat me continuously and let me break, asking me the same question repeatedly. Finally, I couldn't say anything more and they didn't believe me. Before I passed out, I was tortured once more. There was a cement floor with a pile of sharp rocks in one corner. These rocks were typically used for roads and construction. I was forced to swing myself across them until I would talk. "I can't say anything," I said. They continued to torture me until the pain was unbearable. They stepped on my back and asked me whether I was going to talk. Again, I responded that I didn't have anything more to say and they kicked me. Two of the soldiers, their faces covered, held me and proceeded to punch and kick me. I was so angry but all I could do was to look at them. I finally started to throw up blood and passed out. Although the entire ordeal lasted for about three days, I've seen worse. Some of my friends have been shot and killed.

A lot of my former classmates now have their Ph.D.'s in the United States. They are educated and come here with money. I think to myself, "What am I doing?" I don't gain anything for myself and I can't seem to do anything to lessen the suffering of the villagers. I see the situation worsening and I blame myself for not being able to do enough. At the same time, I can't quit. If I turn my back and walk away, there would be no one to address the issue.

In 1994, one of my friends died and I wanted to give up. I decided that I had to do something for myself. I needed an income to be able to give money to the people. "If I turn my back," I thought, "who is going to do this work?" The suffering would never end. Although it was a hard decision to make, I decided not to stop working for the people. I committed myself to poverty, living in the jungle with very little available food. There was a time when I wanted to shoot myself when there wasn't any water and we had to eat raw rice. We couldn't cook for fear that the soldiers might see the fire. One of us contracted malaria and we didn't have any medicine. It was very cold in the hills and all we had was a sheet of plastic and blanket to cover ourselves. Some people felt sorry for us and gave us a hammock. In the rainy season, life was very tough. Although we hung our hammocks to avoid the leeches on the ground, in the morning we realized the leeches had fallen from the trees and sucked our blood.

We knew the difficulty of the situation, but if we wanted to help the people, we had to make big sacrifices. At times we felt dumbfounded because we had committed a great deal of time without seeing significant results. At one point, I saw the documentation in the trash that we'd been working so hard on. It had been scrunched up and thrown away. I felt heartbroken, though I understood that the issue they were working on was different than ours. I had to be open-minded and to understand the situation. It was so difficult for us to get that piece of paper mailed and to document the suffering that the people had endured. We have an ideal goal: we just want people to be treated like human beings.

I don't know if courage comes from power or from pain. I remember a time that I listened to someone's testimony and my whole body began to shake. It was the most horrible thing I had ever heard. The wife of a revolutionary had been arrested in an attempt to get to her husband. The soldiers killed their baby and burned it, then forced the mother to eat it because the father didn't come back. Tales like this repulse me and simultaneously give me courage. The suffering that I have endured is nothing compared to theirs. These peoples' needs are greater than my own.

JUAN MÉNDEZ

ARGENTINA

HUMAN RIGHTS AND RECONCILIATION

"Is it morally defensible, after twenty years of searching, that individuals still cannot find their relatives, when there are people walking around who know the location of the bodies?"

From the time that he worked as a lawyer in Argentina in the early 1970s help-ing to build the modern human rights movement, Juan Méndez created a road map for others to follow in defending political cases. When he was detained by the brutal Argentine security forces, his family moved quickly to demand his whereabouts, and when his captors realized they had a limited period of time to "elicit" the information they sought, Méndez was subjected to partic-ularly harsh torture. Méndez became one of Amnesty International's first Prisoners of Conscience in Argentina, and advocates and diplomats alike pres-sured the junta, forcing Argentina to release him in 1977. In exile, Méndez con-tinued his human rights work, pioneering advocacy tools that are the bases of much international human rights work today. Méndez spent fifteen years at Human Rights Watch, heading its Latin American division, and later becom-ing Human Rights Watch's general counsel. He has recently left the advoca-cy arena to become executive director of the Inter-American Institute for Human Rights and now runs the human rights program at the University of Notre Dame. He is currently second vice president of the Inter-American Commission on Human Rights of the Organization of the American States.

In the late 1960s, I was a university student in Argentina. It was a time of upheaval and student activism throughout the world: in Prague, in Paris, and in Latin America. At the time, we were under a military regime that exploited the schism between the poor and the wealthy. Many of us got involved politically;

some took up arms, some joined organizations, and others, like me, tried to use their legal skills to defend political prisoners, to fight against cases of torture, and to protect human rights. I thought of that as my contribution to the struggle.

The first time I was detained was in 1974, before General Juan Perón's death, in my hometown, in front of the law school I had attended, where I was teach-ing at the time. They let me go in two or three days. But that signaled to me that I was being watched, that I had enemies. So, my family and I moved to Buenos Aires where nobody knew me. Little by little, I went back to teaching, to prac-ticing law, and to political activism in shanty towns and poor neighborhoods. A while later, in August 1975, I was arrested again. At the time, Isabel Perón, who had succeeded her husband after his death, was in power and her regime con-ducted many political murders.

Terror was everywhere. A lot of people were caught painting political graffiti and the next day they would appear dead and tortured. And there were oth-ers, followed and picked up in their houses or their offices and killed. Like me, a lot of people were thrown in jail and, if they weren't charged with something, they were placed under administrative detention.

The most repressive military dictatorship in our history started in March 1976. I was in prison at the time and though I was about to be allowed to go into exile, the military held me for another year, still without charges. An Amnesty International mission came to Argentina in November 1976, met my family, and reviewed my case. It was clear that the state didn't have any evidence against me, except that I was defending political prisoners. I qualified neatly under the cate-gory of Prisoner of Conscience for Amnesty, one of the first to be adopted in Argentina. Three months after, I was allowed to leave. There were maybe eight thousand people in similar situations, who spent an average of four years in administrative detention, whereas I was lucky to get out after a year and a half.

In Argentina they had no mercy. Those eight thousand were the "legal" pris-oners. Ninety percent were tortured, and tortured heavily with electric shocks,

beatings, near drownings, and mock executions. It was very mechanized, very routine, and very brutal because they wanted to get a lot of information out of you, and even if that information was of no value in court, they didn't care. They just wanted intelligence. After the 1976 coup d'état, it all became worse, because they knew they didn't have to worry about producing you alive. In the early seventies, they had only a few days to get information out of you. One, because your friends immediately protected themselves and moved, in case you were forced to say where they lived; and two, because sooner or later they would have to arraign you before a judge. If you were in really bad physical shape then the judge would probably be on their case. And because they worked very fast, they were also very brutal. They would take you to the edge of killing you in torture, and then, if they couldn't get any more information out of you, might leave you alone. A lot of my friends spent a week in torture sessions. In my case, it was only three days. I was fortunate that my family mobilized very fast to get a writ of habeas corpus and talk to judges. My torturers knew that they had even less time than normal with me. So, instead of two, I had five torture sessions in two days. Pretty brutal, but at least it was short.

After my second arrest, I spent eighteen months in prison. Eventually, I was expelled. I wasn't even allowed to go back to my family and my house in Argentina. I was, literally, put on a plane and sent into exile. Once my family had rejoined me and we established ourselves in the United States, I had to decide whether I wanted to go back illegally. Many of my friends in exile returned clandestinely to Argentina and, while I admired them for it, I thought it was suicidal, quite frankly, because in the end they couldn't do much. At this point I decided to stay in exile and I began to work from the outside with NGOs and local groups.

It wasn't so dangerous when I started. You didn't know whether the repression was going to be transitory and maybe next month it would be all right, or at least a little better. You always have hope that, even if it's dangerous for a lot of people, it's not that dangerous for you, because you're not that well known. So you live. It's not that you're incredibly courageous, you just think that maybe it's not going to be as bad as it looks. In fact, I think we only realized the tragedy of Argentina when we went into exile and observed it from the outside looking in. When you're in the middle of it, obviously, you have a sense of duty. You know you have this prisoner that you have to file a brief for, or there's this friend who's just been caught and his mother is asking you to do something about it. There's a sense of being needed, and also a feeling that this will pass and, hopefully, we sail through it. Unfortunately for many of my friends, that optimism was a serious mistake.

The front line of lawyering can be done very effectively as long as you have a halfway independent press. For example, if we would go to court and the judge wasn't inclined to do anything about it, one way of putting pressure on him was to go simultaneously to the press with a copy of the habeas corpus writ. If, in the morning, there was a little article that said that a habeas corpus on behalf of so-and-so had been filed with Judge so-and-so, then the judge knew that he must do something within the week. If not, there was going to be another article saying, "He didn't do anything." Unless you have all those things in place, the system breaks down. In the present period in Latin America, even under constitutional rule, those conditions are not always met. We can't call it democratic quite yet. There are many other things that must be done, more on the preventive side of things such as human rights education, or building independent, impartial, courageous, and professional press organs, or making sure that human rights activists are better known through the media. We learned hard lessons from the dictatorial past and, even when democracy isn't what we hoped it would be, at least we're building the fences against the future breakdowns of the rule of law.

What passes for reconciliation in Latin America is really another word for impunity. It's not so much because of how I feel about the people who did

wrong to me. I don't really care any more if I could identify them, or send them to prison. But taking the position of the communities affected, I feel very strongly that reconciliation has to happen through a process. It cannot be imposed by public policy. How do we get from here to there? Not with state-imposed amnesties that pretend that reconciliation has happened by fiat. In fact, all they're doing is letting the torturers and the murderers go free. Some say, "Peace and justice are not the same thing and to have peace you can't have justice." I don't deny that one priority in places like Sierra Leone today or El Salvador in the early nineties is to silence the guns; but you cannot raise that to the level of good policy. When you say let bygones be bygones you actually give an incentive to murderers and torturers to come back and to do it again. Or worse. Now democracy has taken hold, but you still don't have military elites or police bodies that are accountable. They have not had to account for anything and, although they don't torture political enemies anymore, instead they torture suspected common crime offenders. What kind of democracy is that? If there is one great thing about the detention of Pinochet, it is that it has forced this issue in Chile. And it has forced it in a good way because there is no risk of a coup d'état. People in Chile, Argentina, and other countries with similar episodes are frankly asking, "Is this reconciliation fair?" Is it morally defensible, after twenty years of searching, that individuals still cannot find their relatives, when there are people walking around who know the location of the bodies? The victim has a right to know. And he or she has a right to have the state tell him or her. And if the violation was serious enough, the state also has the obligation to restore justice by prosecuting those responsible.

Moral leaders have to lead the way by clarifying roles, by calling on the military to disclose the information that they have, and by asking that the government not pass spurious amnesty laws. Likewise, moral leaders must tell the people that once they have been shown in good faith that the new democratic government

has done everything possible, they must reconcile. It is important to ask for reconciliation between warring factions when people go to war over political differences, to say that we are still members of the same national community, who should look to the future and forget the past. But it's a different thing to ask the victim of human rights abuse to reconcile with his or her torturer or the killer of his or her child. Especially when the torturers and the killers don't want to offer anything in return, they don't want it discussed, and they don't want any information revealed. They pretend that they should be given some kind of medal for what they've done. The military is quiet now, but it doesn't accept that it did anything wrong and fights tooth and nail any effort to disclose the truth or to hold itself accountable. In those terms, there is no reconciliation possible.

I feel very privileged that I have been able to work in this field for a long time and to have seen the front lines in Argentina, to work from the international advocacy perspective at Human Rights Watch, and now from the academic perspective at the IIHR (Inter-American Institute of Human Rights), and the University of Notre Dame. This has given me a sense of the place and the purpose of each of these different types of organization in the overall human rights movement. All of them are effective in their own way. Domestic human rights groups are essential because they are in the front line. But without the possibility to go to international organizations and, eventually, in appropriate cases, to intergovernmental organizations (like the Inter-American Commission, the Inter-American Court, or the European Court on Human Rights), their ability to change things on the ground is limited. By the same token, without academic organizations that can train and professionalize activists in different parts of the world, the movement cannot continue to grow and improve, bringing in new generations of people doing the work as effectively as they can. All that is knowledge. And knowledge has to be transmitted. We have much to teach and much to learn.

JAIME PRIETO MENDEZ

COLOMBIA

POLITICAL RIGHTS

"For victims knocking at our door, awaiting a response,
we need to convert our moments of despair and impotence into
a creative capacity to always find at least some space,
then we should stretch our arms and open up that space."

Jaime Prieto Mendez is one of the leading figures in the Colombian human rights movement, serving from 1990 to 1998 as executive director of the Committee in Solidarity with Political Prisoners, the most effective advocates in the country for those imprisoned for political beliefs. For most of the past fifty years, Colombia has been under a state of crisis in which civil rights have been suspended and thousands imprisoned after military proceedings where due process rights are largely ignored. The committee has defended hundreds of clients; denounced arbitrary arrests, torture, and disappearances committed by state security agents; and sought the release of detainees. Because of their work, committee staff have been harassed, threatened, forced into exile, and murdered. Prior to joining the committee in 1976, Prieto worked as an educator in an impoverished neighborhood of Bogotá, and later, in a rural community. Prieto recognized that the conditions of poverty, exacerbated by people's lack of knowledge about their rights, made people vulnerable to abuse, so he established a human rights education program. In retaliation for his work, Prieto was threatened and imprisoned by local authorities. After joining the Committee in Solidarity with Political Prisoners, Prieto continued his human rights literacy work in impoverished communities. He focused on using legal mechanisms to protect and defend human rights. Prieto took the initiative to establish a dialogue between human rights groups and government entities, which sought to bring government practices into line with international law. Prieto recently stepped down as director of the Committee. He teaches at a university in Bogotá, and is internationally regarded as a founder of the modern Colombian human rights movement.

For me, it all began when one day the police entered the national university campus in Bogotá during a student protest. By the end of the day one student was assassinated, and many others were arrested. A campaign of solidarity was organized for the students who were detained, I joined in, and we won their release. After that first success, the Committee in Solidarity with Political Prisoners asked that we collaborate with them. That was 1976—and I have been working in human rights ever since.

In the early seventies, I spent four years in the eastern plains regions with Catholic youth groups, doing literacy work. We accompanied peasants in their struggle for land and against economic depression, sometimes helping create unions among the workers. Perfectly legal and normal, but still the local authorities accused us of being Communists. We were merely teaching the workers their rights as set out in the law, but, as you know, lawful rights are not always allowed to be disseminated. The existing laws make it appear that we have a democratic state, while exercising those rights is something else entirely. My perception of the Catholic Church during those four years was that they were turning their backs on the poorest of the poor; this ended up distancing me from religion, though it was this spiritual foundation that had originally animated my activism.

Initially our work at the Committee focused on national mechanisms for protecting and promoting human rights. By the 1980s, the discussion also embraced international law, in an effort to increase our effectiveness. We thought it was important that those communities most hard-hit by violations knew the mandates of the different authorities and how they could protect their own rights. At the same time, we acted when people were detained. We tried to learn why they were detained, what the conditions of the detention were, and we attempted to prevent any torture and to facilitate legal counsel. We did this from the time I came into the Committee and continue to do so today. In the early 1990s, when political changes were taking place in Colombia, we also opened a dialogue with the authorities about the violations.

JAIME PRIETO MENDEZ

But the pressure against human rights defenders today makes you wonder whether there is enough political space to continue this defense work. People I have been very close to have disappeared and been assassinated. We had to get people from our organization out of the country. And that gives rise to pressure, causes grave concern within a family over personal security. You see, many people who have been assassinated did not have prior threats against them. So when I say I haven't been threatened I am not saying there isn't any risk. Yet I obviously feel much more at ease when the perceived risk is not that high.

I stepped down from the leadership of the committee for a variety of reasons. Over the past ten years it has involved carrying a tremendous amount of responsibility, and, in one way or another, this was impeding other leaders from rising. I also wanted to contribute to the defense of human rights from another perspective. Now I am a professor at the National University. I teach a course on human rights, a course on political economy, and one on international humanitarian law. In addition, I have been trying to write a memoir about the work we have done. I certainly have not stopped working to defend human rights; I have only put aside a specific responsibility.

While I am ready to struggle for the cause of human rights in every way necessary, I am not willing to risk my life irresponsibly. It is often possible to gauge a risk

and know when to step aside, to choose to remove oneself in order to be able to continue one's work. I can accept the latent risk on the front line, but it is a risk I have never pushed the limits of. This is my way of being responsible to myself, to my family, and to the cause itself. There are some circumstances where people need to offer their life, but basically it is no good to foster the idea of a heroic defense that doesn't allow for the possibility of hiding, leaving the country, lowering your profile—because we are much more useful alive than dead.

Combining human rights work with my responsibility as a father or husband has more to do with the risk or transformations of daily life. Serious violations of human rights by the state might make you forget that human rights are also experienced in a day-to-day way. This needs to be reiterated because while the state has a tremendous responsibility to regard and respect a citizen's rights, it is necessary that everyone respects those rights. My children have taught me this. They pointed out that I can't be authoritarian in the home, telling me, "You're a human rights defender and now you are acting like some jefe in the house." Let's just say that they are a good point of reference, and credibility begins in the home, no?

That said, it is possible that the work of "frontline" human rights defenders is overestimated. What work we have done is important, but others have also done vital work. Many people, including some actually within the government,

> "Serious violations of human rights by the state might make you forget that human rights are also experienced in a day-to-day way."

have made a tremendous contribution and helped prevent death or avoid torture. Others have made a tremendous contribution to disseminating the general spirit of human rights. The right to life, the right to personal integrity, the right to liberty are where we concentrated our efforts under difficult circumstances marked by violent attacks. But we must not lose perspective on the overall economic, social, cultural, or environmental rights or on the rights of certain sectors of the population, such as women and children. We must look beyond those affected by violence, and those suffering from discrimination within a patriarchal society or from a society that doesn't even recognize children's rights. Without those considerations, the notion one might have of human rights would be limited. We at the committee have carried out a very particular function. It is necessary, but very limited, perhaps somewhat overestimated. Instead, now, we need to lift up the work of others.

We need to create trust in civil society. People need to believe that even under the most difficult circumstances we can succeed. Seeing the international community becoming increasingly interested in our situation is a source of strength. We don't have a right to lose hope. For victims knocking at our door, awaiting a response, we need to convert our moments of despair and impotence into a creative capacity to always find at least some space. Then we should stretch our arms and open up that space.

Tremendous emphasis needs to be placed on amplifying the voices of the victims until the authorities begin to hear you, and once they begin to hear you, to ensure that the victims' voices, their words, actually become a reality. We need to actually create forums of interlocution that make it possible to accelerate the social force, to create greater legitimacy in public opinion, since this is how the authorities recognize changes must be made. Despite all of our efforts in these adverse circumstances we have succeeded in opening up some political room. Even today a necessary interaction to change the will of the authorities to stop the array of abuses must take place. Though there are still many accusations against human rights defenders, high-level government officials have had to sit down and talk with us. Even though the media for a long time tried to silence our voice, today they take our positions into account. It depends a great deal on having earned credibility, and making sure our information is true and just, on collecting that information carefully and procedurally, on working closely with the victims so that we can argue their petitions with authority. We cannot simply brandish our status as human rights defenders or as victims suffering from aggression by the state as an excuse for arguing our cause. We have a duty to be serious, rigorous, and extremely creative in coming up with formulas that make it possible to overcome human rights problems, wherever we find them. This is the challenge before us.

VERA STREMKOVSKAYA

BELARUS

LAW AND DEMOCRATIC CHANGE

"I requested that the defendant go free on bail
because he was very old and quite sick. In response, the court claimed
that my appeal was making the man nervous—that this
was the reason for his deteriorating health. Then, they censured me."

Belarus was formed in 1988 after the fall of the USSR. As a founding member and former president of the Center for Human Rights in Belarus, Vera Stremkovskaya is one of that country's most respected legal practitioners, known for her willingness to take up the defense of politically unpopular clients. In retaliation, she has been harassed, threatened, and charged with libel. In March 1999, the Collegium of Advocates (the government-controlled bar association) issued a "stern reprimand" to Stremkovskaya because of her outspoken advocacy for human rights, threatening disbarment if she continued her work. The Soviet-style regime maintains strict control over the media, restricts circulation of the independent press (when it is not banned altogether), and controls all broadcast media. Street demonstrators can expect mass arbitrary arrests, beatings, and long prison terms, while plainclothes state security agents carry out threats and kidnappings in the street with total impunity. In the Belarus police state, this courageous woman seeks justice for the few who dare speak out against injustice—Vera Stremkovskaya's bravery and courage are exemplary.

The Belarussian authorities started a wave of harassment against me. Upon my return from the United States, where I had spoken to different audiences about the human rights situation in Belarus, the authorities tried to revoke my license to practice law. I was told to appear before the chairman of the Supreme Court of Belarus and the deputy minister of justice. I was also told to present myself before the Minsk Regional Committee of Advocates, a professional organization. They argued that criminal defense work and human rights activities were entirely separate and told me to choose between being a lawyer or being a human rights activist. At every meeting, they threatened to revoke my license to practice law, citing my speeches, meetings in the United States, and human rights activities as inappropriate to the profession. Strong reaction in my defense from foreign countries, notably the U.S. and German embassies, saved my license to practice law. However, the Belarussian authorities still issued a censure.

I received a second censure after an appeal to change a pretrial detention order. After my request that the defendant go free on bail while on trial because he was very old and quite sick, in response, the court actually claimed that my appeal was making the man nervous—that this was the reason for his deteriorating health. Then, they censured me.

The case was against a fellow by the name of Starovoitov. He had transformed a Soviet type of agricultural institution into a new, market-oriented company in which workers were given shares. President Lukashenko rejected these changes and, in order to squelch his activities, falsely charged the man with embezzlement.

When they threatened to revoke my license, I was very upset. If I were to lose my license, I would lose my job and the opportunity to earn a living for myself and my family. This was my profession and I loved it. I was shocked and it was a terrible time

for me, but I wanted to continue to defend human rights. Belarussian law implies that the lawyer be a professional human rights defender. Only Belarussian authorities could come up with the idea that these are two separate roles.

In fact, most of my clients are people charged in political cases. They are prisoners of conscience and feel apologetic for causing me to suffer from the threats and suppression of the government. The most moving moment took place after the trial of Starovoitov. I went to see this old, skinny, gray-haired man and he fell on my shoulder. He put his head against me, cried, and said, "I am so sorry that I have caused so many troubles for you." Other clients went to meetings with me and would defend me in front of the officials. Their support, along with my own moral convictions, kept me going. Had I decided to forego my obligations, necessary changes in Belarus would not have been possible. Likewise, I understood that I had a personal cross to bear. I felt very strongly that I had been destined to practice law and, therefore, should continue to do so.

In another sense, I see the world as a consistent creation of which I am a part. I know the history of our country well and the developments of different civilizations throughout time. This has been precious, important, and useful knowledge in shaping my view of the world. I am a poet and I love poetry. People who write poetry perceive the world a little bit differently. My view of the world is sensitive and emotional.

I feel an obligation as a member of society. I turn to the Bible and to Jesus Christ and question why he did what he did for human beings, even those who didn't believe in him. There is a line from a Russian poem, "Go alone and help the blind to face at the moment the repression, the indifference of the crowd and the sarcasm of the crowd." In my opinion, this is everyone's obligation. This is the meaning of life for me.

I am a single mother. My parents died and I am bringing up my child alone. We are a family unit. We feel and think the same way and view life in a similar manner. Since I have a lot of friends and my home is a meetinghouse, my son is always meeting creative people. At the same time, he sees how tired I am when I come home from work. He realizes what I am doing, and, more and more often, asks me very particular questions about my cases.

Life for me is one process. I cannot be one person with my kids and another at work. These worlds overlap. My clients often become my friends. They visit my house and my son meets them and sees who they are. He is attracted to this type of person. I think that I am happier than those who work from nine to five and pretend to do something important, when in fact they just exist.

In my opinion, courage comes from doing something despite the difficulty of the circumstances. You do it because you feel it is right, because you should. The feeling of inner strength is like a metal cord inside of you that helps you to go forward. It originates from a vision of the future, from the belief in God, from a consciousness of destiny, and from knowledge of history. Likewise, it comes from the people who surround you, like my friends and my son. In the United States and other countries, people understand and support me. This gives me a great deal of strength.

People in Belarus are no longer afraid. The fear that once gripped them has begun to dissipate and they have become creative in their protests. These protests may be local and small but are a sign of resistance. One inmate organized a protest against the rats in his cell. Although a prisoner, he defended his dignity and protection of his rights. In another incident, he hung his underwear and dirty clothes out the window so that the people working on the streets could see it. In doing so, he hoped to pressure the warden for more sanitary conditions.

At times these protests are quite funny. An artist by the name of Pushkin put a pile of manure in front of the presidential palace. In it, he placed President Lukashenko's campaign slogans, along with a sign reading, "Results of your presidency."

There is also a newly formed presidential youth organization called the Belarussian Patriotic Youth Union. Once, on AIDS Prevention Day, the Democratic Youth Movement formally presented the pro-Lukashenko Presidential Youth Organization activists with dozens of condoms on which the analogous message was written, "So that there will be no more like you." The idea was to stop the group from spreading.

I am sure that the democratic process in Belarus will prevail. I am sure of it. We don't have any other choice. Belarus is a European country in the very center of Europe. Just as changes have taken place elsewhere, so they will happen in Belarus. I see our history as part of the development that is happening throughout the world. The history of the world proves that humanity is the whole union of people. We are united in moving toward democracy, toward justice, and toward a more open society. I believe that these democratic changes will take place in Belarus because there is a plethora of smart, industrious people who devote themselves to this cause on a daily basis. With particular regard to elections, there is additional support from the international community. The United States reacted strongly to the elections and Amnesty International continues to condemn the Lukashenko regime for detaining prisoners of conscience. This has helped Belarus to envision itself as a part of the international community. In fact, I had the opportunity to speak to President Clinton in Atlanta at the American Bar Association ceremony for international human rights lawyers where I was given an award. On behalf of the Belarussian people, I expressed my gratitude to the United States and our continued hope for democratic change.

BOBBY MULLER

UNITED STATES

THE INTERNATIONAL BAN ON LAND MINES

"There is an organization for just about every conceivable issue you can come up with. What makes a difference is getting political leadership behind you. And we got a powerful senator who went nuts."

In 1969, Lieutenant Bobby Muller led an assault up a hill in Vietnam until a bullet hit his back and severed his spinal cord. Miraculously, Muller survived. But the real misery didn't begin until Muller returned to the United States and was confined to a decrepit veteran's hospital. During his first year, eight people on his ward committed suicide. His experiences there led him to become a leading advocate for veterans' rights. Years later, as head of the Vietnam Veterans of America Foundation, Muller traveled to Cambodia where he witnessed the devastating impact of land mines on the local population. He launched himself into this new cause with characteristic energy and determination and in 1997, his efforts, along with cofounders at the Campaign to Ban Land Mines, won the Nobel Peace Prize. Despite his success, Muller is the first to point out that the most daunting task, still to be accomplished, is removing the land mines already planted. Antipersonnel land mines kill or wound twenty-six thousand women, men, and children each year, often years after the conflict has ended and combatants have gone home. Today, Muller continues to focus worldwide attention on war's impact on civilians.

We have an extraordinary capacity to deny our reality. Each and every one of us knows we are going to die. But it probably would be too terrifying for most people to live their lives with the daily awareness of the fact that this could be it. So we deny that. When I was twenty-three I got shot and was conscious long enough to recognize what had happened—to feel the life ebbing out of my body. I was losing consciousness and saying, "I don't believe it, I'm going to die. On this shitty piece of ground, I'm going to die." When I woke up, I was on a hospital ship, in intensive care. I had so many tubes sticking out of me that I couldn't believe that I hadn't died. They wrote in my medical record that had I arrived a minute later I would have—the bullet had gone through my lungs and both had collapsed. I was lucky—the ship right off the coast was the farthest north it ever went up and it was turning around to go back south, back toward Danang. So I had this miraculous series of things happen. When you really face your mortality the way I did, it changes you. My reaction was joy to be given a second chance. And I'll never forget when the doctor came and said, "We've got good news and bad news. We're pretty confident that you're gonna live—but you're gonna be paralyzed." And I just absolutely remember saying, "Don't worry about that. That's okay. I'm here. I'm here."

BOBBY MULLER

I had been an officer with the marines, infantry. I was God: I would decide who went on point, who was first out, this, that, and so on. And to go from being God to a piece of shit—it was kind of overwhelming. The first time I ever cried was when I got to the veteran's hospital. It was a dilapidated facility—over-crowded, understaffed, stinking—it had been an orphanage in the late 1800s.

In these kinds of situations you ultimately get to critical matters. You either say no and push back or you get overwhelmed and crushed. Everybody handles it differently. A lot of vets got injured in ways that were never a question of their life. It was just a question of their loss. Eight on my ward committed suicide. If you are eighteen years old and you have never expected to do anything except manual labor in some capacity, a disability denies you that future. You give up or you get pissed and you start to fight. Once you cross that line and you start to be an activist, you don't get easily intimidated. When people start to push back at you, well, you continue to march and you lean into it a little bit more.

I am amazed at where I started. I kept waiting for somebody to make things right for Vietnam vets and nobody was doing it. So in 1978, nine years after I returned from Vietnam, I said, "I'll go tell the story." I believed that if somebody could get the story out and focus attention on the injustice, the government would make it right. I still naively believed that if you simply got the story out, a caring and values-based society would respond. That's when I learned that things don't happen simply because of arguments that are based on equity and justice. You need more than that. You need political engagement. That was an important lesson. But then you also learn that in the democracy that we have, you still do have opportunity

and the mechanisms are still there. It's like with the land mines campaign. Once I came to understand land mines, I recognized how truly devastating the conse-quences of this weapon were, not just for the lives of the victims, but for the countries they were used in, a major destabilizing factor. Then I really had no doubt that we could ultimately get this weapon banned internationally, put on the list with poison gas, dumb-dumb bullets, the weapons the world community says no to. But it was a difficult process to get the U.S. to say no.

We reached out to the retired military leadership and got Schwartzkopf, the former chairman of the Joint Chiefs, General Jones, and General Galvin to sign an open letter to the president—a full-page ad in *The New York Times*. You don't necessarily have to have grassroots to move mountains. That's a lesson I learned from the early days. So when we came back in '92 we said, we're going to make something happen here on land mines. We went to the most powerful member of Congress that we knew, Senator Patrick Leahy of Vermont. He was the chairman of the appropriations committee on foreign operations, and Leahy single-handedly ensured that the United States out-lawed traffic in land mines. Leahy was even able to use his influence with the president so that Clinton addressed the UN General Assembly and said, "We've got to outlaw these weapons."

This illustrates the importance of political leadership. We can put out a moral call. But you know, there are a lot of moral calls, there are a lot of injustices out there, and there is an organization for just about every conceivable issue you can come up with. What makes a difference is getting political leadership

behind you. And we got a powerful senator who went nuts. I knew a lot of guys in the Senate who said, "Look, Bobby, I only signed that goddamn bill to get Leahy off my back; he wasn't leaving me alone." These guys don't give a shit about antipersonal land mines—it was Leahy's persistence that made them say, "All right already, I'll sign the bill."

One of the things that really pissed me off when we were awarded the Nobel Peace Prize was there was such a romanticized treatment in the media, to make people feel good—inspired. It was horseshit. People think because of Princess Diana, the fact that there was an international treaty, a Nobel Peace Prize, that it's done, the job's over. We need to wait a second—we have not universalized this treaty.

Land mines have totally fallen off the screen for everybody. We still need the United States to sign the treaty because all these other countries that need to be on board are not going to get on board ahead of the United States: China, Russia, India, Pakistan.

Courage for me means swimming against the tide. To go on in the face of adversity. To be willing to expose yourself to failure and ridicule. You have to be conscious of the fact that you're at risk and aware of what you can lose—to then go forward is a courageous act. To just act blindly, that's not courageous. Loss is not only reputation and money, it's security and possibly your life. And if you go in and face those risks and threats I think that's greatness. You're doing it not because you're gonna get applauded at some point down the road or rewarded, but because it's right.

My dream for the future is to make a real contribution in containing conflict. I am not a pacifist. I have killed people and I would do it again if it was necessary. But there's a difference between engaging an enemy soldier and killing civilians. Conflict has fundamentally transformed. Now it is the vulnerable, the innocent, that are the target of violence, instead of the military. That is absolutely unacceptable. If we can't ultimately get people to be outraged over the slaughter of the innocent that's going on, then chances of getting people to engage the concept of conflict is even more remote. Because with most people, conflict is still defined more along the terms of *Saving Private Ryan*. It's a bitch, but it's still military on military. This is the fiftieth anniversary of the Geneva Convention following the Second World War. Those aren't laws of war—they're suggestions. Laws require punishment for those who violate them. There has to be accountability. Antipersonal land mines, since 80 percent of their victims are innocent victims, serve as a good way to illustrate what conflict has become—violence that cannot discriminate between soldiers and civilians.

Look, we live our lives largely insulated from the depth of despair of pain and anguish and everything else that is going on out there. That's why I feel so strongly in going after laws and making them real—the belief that you cannot allow the genocides, the Cambodias, the Rwandas of the world to play out. Allowing innocent people to be slaughtered on the scale that we're witnessing around the world is just degrading the basic level of human conduct that we need to have. The world community has to say that conduct won't be tolerated. Because if we do allow it, then it's a breeding ground and sows the seeds of destruction. One day, that degree of madness is going to walk up the block and come into your neighborhood.

RAJI SOURANI

GAZA

———

HUMAN RIGHTS AND SELF-DETERMINATION

"The world may think that peace is on the way here,
but the reality on the ground is very different…never before has
the overall human rights situation deteriorated as dramatically."

*Raji Sourani is Gaza's foremost human rights lawyer, and the founder and direc-
tor of the Palestinian Center for Human Rights and former director of the Gaza
Center for Rights and Law. In the 1980s, Sourani was widely recognized for his
effective defense of Palestinians before the Israeli military courts. In connection
with his defense work, Sourani was four times held in detention by the Israelis,
beaten and subjected to mental and physical abuse. Sourani has represented
Palestinians facing deportation and closely monitored detention and prison con-
ditions. Reaching out to Israeli human rights organizations, he formed links
regarded with suspicion by fellow Palestinians but which proved to be effective in
the pursuit of human rights. He was detained by the Palestinian Authority in 1995,
following statements critical of their establishment of a state security court. Since
the signing of the Declaration of Principles by the Government of Israel and the
PLO, and the establishment of limited Palestinian self-rule, Sourani has advocat-
ed strict adherence to international standards for the Israeli government and the
Palestinian Authority. And despite the danger of repercussions, he is an outspo-
ken critic of human rights violations committed by both sides. In his bold and prin-
cipled stance, Sourani has won wide respect, and has been recognized by numer-
ous international organizations for his courageous work.*

We Palestinians are living in a highly complicated situation, which is unprecedented in modern history. Six years after the signing of the Oslo Accords, what we are experiencing in the occupied territories is a system of de facto apartheid, developed under the auspices of peace. We are nearly a forgotten people, consigned to a second-class existence. We are far from practicing our right of self-determination and independence.

After fifty years of conflict, and thirty years of occupation in the Palestinian Territories, the Oslo Accords were signed nearly seven years ago by the government of Israel and the PLO. These accords were intended to provide a transitional interim arrangement for a period of five years as a means of moving towards a final resolution of the conflict. The basic philosophy behind the accords was that they were designed to serve two main purposes. The first was to develop a setting in which trust could be built between the two sides; the second was to develop a framework in which to resolve the final status negotiations within five years. It is clear that trust between the two sides has not improved, and in fact, in some areas are at an all-time low. Furthermore, the final status negotiations did not even begin within the five-year interim period, which ended on May 4, 1999.

Policies since the signing of the Oslo Accords include aggressive settlement expansion, fragmentation of the Palestinian Territories by the construction of settler bypass roads, military installations, and the establishment of new settlements, and unprecedented levels of land confiscation. Furthermore, the Israeli policy of closure over the entire Palestinian Territories has not only severely restricted the right of freedom of movement, but has dislocated families from different areas. Closure has also cut the Palestinian Territories off economically and socially, both from the rest of the world, and from the other parts of the Occupied Territories themselves. This has led to further economic deterioration and dependence on Israel. In Jerusalem, Israeli policy has been to eject Palestinian residents, through house demolitions, the imposition of Israeli domestic law over Palestinian residents of East Jerusalem, withdrawal of residency permits, harassment, and settlement activity.

House demolitions provide one example of what Palestinian families face in their encounters with Israeli occupation authorities. Homes are demolished as a form of illegal collective punishment against families of whom one member may be suspected of an offense. Alternatively, homes are demolished simply because they were built without the necessary building permit from the occupation authorities—a permit which in many cases is practically impossible to obtain. The outcome of these demolitions is to impose collective punishment and to "ethnically cleanse" the Palestinian population. Palestinian families are often given only twenty-four hours notice to remove their belongings when Israel moves to clear certain areas for settlement. These families suddenly find themselves out on the street, their home demolished in minutes before their very eyes.

Of course, I have to talk about torture. Under international law, torture is absolutely illegal, and we cannot be selective. We have to have one standard for all people, Israeli or Palestinian, regardless of race or religion. But for decades the Israeli General Security Service has been torturing Palestinian detainees with impunity. Recently, a report released by the Israeli Special Controller confirmed what we have been asserting to the world community for years—torture has been widely and systematically used by Israeli interrogators against Palestinian detainees.

After twenty years of struggle against torture, we—Palestinian and Israeli human rights organizations and lawyers—received a decision from the Israeli High Court

of Justice in September 1999, finally recognizing that torture is systematically practiced. The Court, however, went on to find that the reason torture is illegal in Israel is simply because there is no law to legalize it. The Court, scandalously, went as far as to suggest that if the government of Israel should decide that they wanted to allow the use of torture, they should pass a law to that effect.

The Palestinian people are impatient to have their state in the West Bank, Gaza, and East Jerusalem, a combined area that composes only a scant 18 percent of historical Palestine. Even so, the current Israeli government has gone even further and has clearly stated its intentions: the complete annexation of East Jerusalem, no return to the 1967 borders, no right of return for refugees, and the continuing existence of Israeli settlements.

Clearly this does not meet the minimum level of Palestinian aspirations. This has become a situation leading nowhere. Some time ago, Israel had a choice between divorce or marriage. Israel chose divorce, represented by the two-state option, in order to preserve the Jewish nature of the state of Israel. But the most basic requirement of the two-state option is that the Palestinian people have their own state. This minimal requirement has yet to be fulfilled. The one-state option (with equal rights for all citizens regardless of race or religion) was rejected by Israel. Instead all we have are fragmented Bantustans of Palestinian control, with the Israeli military occupation continuing over the Palestinian Territories as a whole.

It must be stressed that in the past six years, the Israeli occupation, in its legal and physical form, has remained a very real part of our daily lives. The world may think that peace is on the way here, but the reality on the ground is very different. I can assure you that never before has the overall human rights situation deteriorated as dramatically. The Gaza Strip has a total area of around 165 square kilometers, of which Israel continues to control around 42 percent. Twenty Israeli settlements have been established in the Gaza Strip, housing some five thousand settlers. In the remaining 58 percent of the Strip, 1.2 million Palestinians live in some of the most cramped conditions in the world.

In the year 2000, with the fall of the Berlin wall and the end of the apartheid regime in South Africa behind us, this situation cannot be tolerated. In fact, if the situation continues it will inevitably lead to a renewed cycle of bloodshed and violence. We observe with deep disappointment that the fruits on the ground of the Oslo process could not be further from the stated intention of building confidence between the parties and resolving a final agreement for a just and lasting peace in the region. We also affirm our belief that there can be no possibility of real, just, and lasting peace without respect for human rights.

The Oslo Accords were signed between the government of Israel and the PLO, the legitimate representative of the Palestinian people, expressing their aspirations and having led their legitimate resistance against the occupation. We, the Palestinian human rights community, believed from the very beginning that it was essential to both our self-respect as a people, and for the ultimate achievement of our goal of a democratic state, that the practices of the Palestinian Authority, in the very limited areas in which it was granted jurisdiction under the Oslo Accords, be closely monitored. We were, from the outset, committed to the development of a society that would respect the rule of law, democratic principles, and human rights.

We believe that the particular experiences of the Palestinian people, and the consequent development of a strong Palestinian civil society, can enable us to

develop a unique state in the region—namely, a truly democratic state. We still hope to succeed in this goal, and many Palestinians remain steadfast in working towards this end.

As local human rights organizations, we thought that the struggle for the development of this democratic society and the strengthening of Palestinian civil society would be easier than the struggle against the Israeli occupation. Now we see we were wrong; it is a deeply complex process and much more difficult than we imagined. We are deeply concerned by certain practices of the Palestinian Authority which violate human rights standards, including restrictions on the freedom of expression and assembly, undermining the independence of the judiciary, and the establishment of state security courts.

Without in any way offering this as an excuse for those practices, we nevertheless deem it necessary to express our concern at the role played by both the Israeli and American administrations in promoting these violations of human rights by the Palestinian Authority. This role is particularly perplexing since the stated strategic interest of both these parties is real and lasting peace in the region. The development of a genuinely democratic system in the Palestinian Territories not only promotes the necessary stability for such peace, but is in fact an essential prerequisite for any kind of true peace. For fifty years Israel has complained that it should not be expected to make peace with dictators. This only makes Israeli and American obstacles to the development of a genuine democratic society in the Palestinian Territories all the more perplexing, while raising serious questions as to their genuine intentions.

No one needs peace—a just peace—more than those who are oppressed. The fact that the Palestinian people have become the victims of those who were once victims themselves only shows how important it is to remember this point.

In terms of both political and human history, it is deeply saddening when the victim becomes the victimizer of people who are guilty of nothing except existing in their homeland. The Palestinian people have suffered for the past century, and for the past fifty years have been the victims of Israeli human rights violations. We must all acknowledge the lesson of history—that reconciliation cannot begin without recognition and apology.

True peace must be between people, not simply between leaders. The possibility of this materializing is severely undermined by the Israeli policy of closure, which, as well as violating the basic human rights of Palestinians, also creates a division between peoples by preventing any meaningful contact between Palestinians and Israelis.

We used to have an excellent relationship with our Israeli counterparts, human rights groups and lawyers. They used to come to us, we would go to them. They would invite us to lecture or speak at public meetings. We would work alongside each other on particular cases and causes. This created wonderful chemistry. But now, after more than five years of the closure policy, we are totally disconnected from our Israeli friends. We still cooperate, by telephone, E-mail and fax, but we are no longer able to have the human contact, because we can no longer come and go as we please.

I believe deeply in the need for peace, but my own life taught me that there can be no peace, no justice, without human rights. Witnessing massive and violent human rights violations on a daily basis makes quite a mark on a young mind and heart. In my youth I saw many people killed, arrested, or beaten before my eyes—including my brother, who was arrested, in early 1968. He was in prison for three years. As a kid, at school, I saw the army beat students for participating in demonstrations. Our daily life was really hell. My family is deeply

> "I thought: all these prisoners,
> their miserable conditions, the systematic
> torture and abuse, and nobody
> knows anything about it….I said to myself:
> I'm a lawyer, can't somebody be a
> witness to these crimes?"

rooted in this place—I'm not, by definition, one of the many refugees in Gaza. But everybody felt like strangers in our homeland. Our lives were totally controlled by the occupation. When you are as young as I was and see all this happening, it leaves a strong impression. You begin to ask: What's going on? Why is this happening? Why are these unfair things happening? Why was our neighbor's house demolished? Why was my brother imprisoned? Of course anyone who feels and begins to understand what is going on wants a better future, a better life, and you want to express it in one way or another.

For me the next stage came after my arrest and imprisonment. I saw the other side of the moon. All I had seen before did not prepare me for the hell I found myself in, even if I, as a lawyer, was treated to the "VIP" hell. When you are being subjected to torture, you want to die ten times a day. And I saw how torture was being used systematically, even on kids as young as twelve.

I thought: all these prisoners, their miserable conditions, the systematic torture and abuse, and nobody knows anything about it. And then I thought of the house demolitions, the land confiscations, the daily beatings. I said to myself: I'm a lawyer, can't somebody be a witness to these crimes? Can't we reduce the suffering even minimally, some way or another? I thought that surely it was possible, through sustained human rights work, to let the world know about the practices of the Israeli occupation, and in doing so to help these victims. So that is what I decided to do. And I've been doing it for twenty years now.

I'll never forget one time after being released from administrative detention, having been detained simply because of my human rights work, the Israeli officer said to me, "Raji, this is your last arrest, and I hope you know what that means." It was a threat, but we believed in our work, in our struggle, in human rights. I hate to speak about our own suffering as human rights activists. We

have to be strong enough to make people feel, and know, that we can defend them. We have to be strong enough to take care of the real victims.

I simply believe that human rights, democracy, and the rule of law are not luxuries. They are crucial necessities—the oxygen of meaningful life. We see the violations on a daily basis. We see the victims, we know them, we live with them. What keeps us going is the belief that you can do something, even if it is just a little something. And even if we cannot improve the situation, at least we can stop it from deteriorating further.

I believe we must continue to struggle to defend the rights of the victims, we must continue to reject all forms of human rights abuses. We must believe that it is worth it to make even small changes. For the sake of the victims of these abuses and injustices, we must carry out our work professionally. We must be vigorous in our defense of the persecuted and bold enough to never stop opposing their victimizers, no matter who they may be.

I don't believe in violence, and I don't think it is a solution. Nor do I believe that Palestinians are the only ones whose blood is sacred. All human life is sacred, no matter which nationality, race, or religion. But we cannot accept the situation as it is. We must do something.

I don't want to see more suffering. Whatever we do today may bear its fruits tomorrow. Like Martin Luther King Jr., we too have a dream—a dream and a very legitimate agenda, to get rid of the occupation, to determine our own destiny, and to have an independent state—a state where democracy, human rights and the rule of law prevail. As I have said, the obstacles we are now facing are very complicated, much more so than pre-Oslo. But we are determined to go on with the struggle—all the way.

MARTIN O'BRIEN

HUMAN RIGHTS IN THE MIDST OF CONFLICT

"The worst thing is apathy—to sit idly by in the face of injustice and to do nothing about it. There is a real responsibility to challenge things that are wrong."

As the executive director of the Committee for the Administration of Justice (CAJ), Northern Ireland's foremost human rights organization, Martin O'Brien has played an important role in bringing a cessation to the conflict which has divided Northern Ireland for decades (some would say centuries). The last thirty years of unrest, starting with the suppression of civil rights protests in the North in the late 1960s have claimed more than three thousand lives. At the heart of the conflict is the failure to assure quality justice and the rule of law for all sectors of society. A long history of religious persecution and discrimination, economic disparity enhanced by the devastating economic consequences of war, and emergency decrees which suspended civil rights, exacerbated the violence. Nongovernmental, nonpartisan, and nonsectarian, CAJ is one of the very few entities trusted by both Loyalists (loyal to British rule) and Nationalists/Republicans (advocating closer alliances with the South of Ireland) alike. Founded in 1981, CAJ offers hands-on support to victims of abuse and provides human rights lawyers with support and legal resources. As executive director of CAJ, O'Brien played a key role in drafting the strong human rights provisions in the Good Friday Peace Agreement, signed in 1998 by all parties, that set forth a timetable and a structure to end sectarianism and created a new power-sharing government in the North. CAJ is the only nongovernmental organi-

zation actively engaged in monitoring compliance with the accords. O'Brien is a pacifist, and for him, the commitment to peace requires an action agenda and a deep understanding of every point of view. The optimism and determination shown by O'Brien and those like O'Brien have prevailed over violence, and their will to resolve these conflicts will be needed in the years to come.

I started working at the Committee for the Administration of Justice in Northern Ireland in 1987. The committee has three jobs. First, it publishes and disseminates information on citizens' rights, such as how the police should behave when conducting an arrest, or how prisoners are treated. Northern Ireland is a very segregated society—so much so that it is quite possible to reach the age of eighteen without ever having met someone from a different political background. In an effort to tackle this segregation there are a range of groups that organize different activities designed to bring Protestants and Catholics together, perhaps by sponsoring activities, talking about sports, or discussing a number of uncontroversial topics. Over time, more controversial issues arise within these groups. Tension, for example, might be created within the group if someone has a family member in prison. At this point, CAJ might be invited by the group organizers

to facilitate a discussion about prisoners' rights or have a general discussion about human rights: why are rights important and where do our ideas about rights come from? CAJ publishes materials about abuses and gets that information into the press. As an extension of this, the committee acts as an informational resource for students, journalists, community groups, church people, members of the public, politicians, international delegations, and others.

Secondly, CAJ offers legal advice and assistance to people whose rights have been violated. The committee either acts as their lawyers (as in the five cases presently in the European Court of Human Rights), or helps victims and their families manage a case beyond the court proceedings. For instance, members might help the family in a miscarriage of justice case by identifying sympathetic politicians and attending meetings between the two parties. Likewise, members meet with people from Amnesty International or the Lawyer's Committee for Human Rights to enlist their support.

Lastly, the committee is involved in lobbying for changes to laws and practices that violate human rights. For example, it has worked to secure laws prohibiting racial discrimination in Northern Ireland. This has provided protection for minority groups like the Chinese and Indian communities in Northern Ireland. Another example would be our work to secure safeguards to prevent the ill-treatment of detainees. Lobbying and campaigning are critical to ensure that the government lives up to its commitment to international human rights law. Over the last few years our work centered on getting strong human rights protections written into the Good Friday Agreement. CAJ was very successful in this regard. The challenge for us now is making sure that these protections are fully implemented.

I got involved in this kind of work in 1976 when I was twelve years old. A group of people knocked on the door of our house and said, "Do you want to go on a peace march to demonstrate against the violence?" My older brother and sister went and I said I would go with them. We marched every weekend in different parts of Northern Ireland and, in doing so, formed a local group that brought together diverse people. The Peace People won the Nobel Prize in 1977. With demonstrations drawing approximately twenty to thirty thousand people, a popular movement developed. It was exciting. A number of us went to a summer camp in Norway designed to bring together Catholics and Protestants from different backgrounds and locations throughout Northern Ireland. We had discussions about politics, about religion, about violence, and life in Northern Ireland. We discussed nonviolence as well. At the summer camp, I met a Norwegian woman who came to work in Belfast after the summer camp. With the help of an American, we formed a group called Youth for Peace.

About twenty of us organized a three-day fast on the steps of city hall to highlight hunger around the world and to call for peace. We were all sitting there and fasting for peace when a bomb suddenly went off a few streets away. It was discovered that the IRA had planted it in a car. It was pouring rain and we went around to see if there was anything we could do. Nobody had been killed, but there were a lot of passers by covered with glass from the windows. Glaziers arrived and life quickly returned to normal. It was impossible to see, it was so wet, blood was dripping off the pavement, but life was proceeding as normal, and yet this dreadful thing had just happened.

I had been learning about nonviolence, hearing what Gandhi and Martin Luther King were saying. It was wrong that people should mess up the lives of others

for some political ideology, for a flag, over who should govern this particular place. That night, it became very clear to me that violence was inhumane and that we didn't have the right to use it. In my family we were brought up with a strong sense of right and wrong, that people were to be treated well and not abused. The sanctity and the preciousness of life was emphasized.

In every case, the impact of the violence is terrible. In Northern Ireland, people get categorized either as innocent victims or "other" victims. If you haven't been involved in anything, you are an "innocent" victim. On the other hand, if you are in the IRA and you are out doing something and end up getting shot, you are not categorized as innocent. In this case, there is a sense that you do not deserve any sympathy and, by extension, neither does your family. This is in spite of the fact that everyone's grief is the same.

There is a hierarchy of victimhood. If you are involved in politics, for example, you are not considered innocent. Whenever somebody is killed in Northern Ireland, media interviews with the relatives are conducted. The first thing asked is, "Was your husband involved in anything? Why would somebody have done this?" People rush to say, "He was a very quiet person. He just lived for his family. He wasn't involved." But if you are involved in public life, somehow a violent death seems to be understandable.

The worst thing is apathy—to sit idly by in the face of injustice and to do nothing about it. There is a real responsibility to challenge things that are wrong. I believe that nonviolent tactics are right and effective. Though nonviolence is a backdoor approach to combating human rights abuses, it is both morally and pragmatically right. If you believe that a greater world exists beyond this one, then it is more important from a larger standpoint to do the right thing rather than to be effective or to survive. There is a bigger frame of reference.

I have been afraid a couple of times. When I was very young and we were going on the peace marches, some of the marchers were attacked with bricks and bottles and a number of people were beaten. At those times, I remember being frightened. When Pat Finucane, a defense lawyer doing a lot of work on human rights, was killed, it became clear that he had received threats beforehand and that there was official collusion by elements within the police and army. I and other people working on human rights were frightened. And on March 15, 1999, Rosemary Nelson, a lawyer and member of the CAJ's board and a good, good friend, was killed by a bomb left under her car. That was terrible. But you don't live your life in fear and give people power over you who want to create fear. At the end of the day, it is very important that these people are not allowed to do that. It would be better to die early than to refrain from doing things because you are fearful about the consequences.

I am afraid for other people as well. I worry about the people who work with me. It is important that people know what they are getting into. If you step on somebody's toes, before you know it you are getting threatening letters or phone calls saying, "You will end up dead," or "We will get you, we know where you work, we can wait outside your office and follow you home." Mind you, it's not a regular occurrence. Of course, when you get the phone call at home, this is a bit more disconcerting.

DOAN VIET HOAT

VIETNAM

POLITICAL RIGHTS AND IMPRISONMENT

"I wanted to send a message to the people who wanted to fight for freedom that the dictators could not win by putting us in jail. I wanted to prove that you cannot, by force, silence someone who doesn't agree with you."

Doan Viet Hoat is known as the Sakharov of Vietnam for his intellectual range and outspoken role as leader of the democratic movement, even from the prison cell. Hoat protested the South Vietnamese government's suppression of Buddhists in the 1960s while still a student, and was then forced to leave the country, during which time he received a doctorate in the United States. By 1976, when North Vietnam took over South Vietnam, Hoat was back. But the new authorities embarked on mass arrests of intellectuals, and Hoat spent the next twelve years confined to a cramped cell, shared with forty others. Upon his release, Hoat began publishing an underground magazine, entitled Freedom Forum. Only months later, he was detained without trial for two years, then in March 1993, sentenced to twenty years in prison for "attempting to overthrow the people's government." Throughout his imprisonment, Hoat continued to issue statements on democracy and to offer criticism of the regime that were sent out of the prisons clandestinely. The Vietnamese government transferred Hoat from one detention center to another, in an attempt to silence him, but everywhere he went, Hoat's charismatic temperament won over fellow prisoners and guards alike, who sought his counsel and carried out his letters. Finally, Hoat was sent to the most remote prison in the country, and all prisoners were removed from the cells adjacent to his own. He spent five and a half years in solitary confinement until, in September 1998, after intense international pressure, Doan Viet Hoat was released, then exiled. He now lives in the United States.

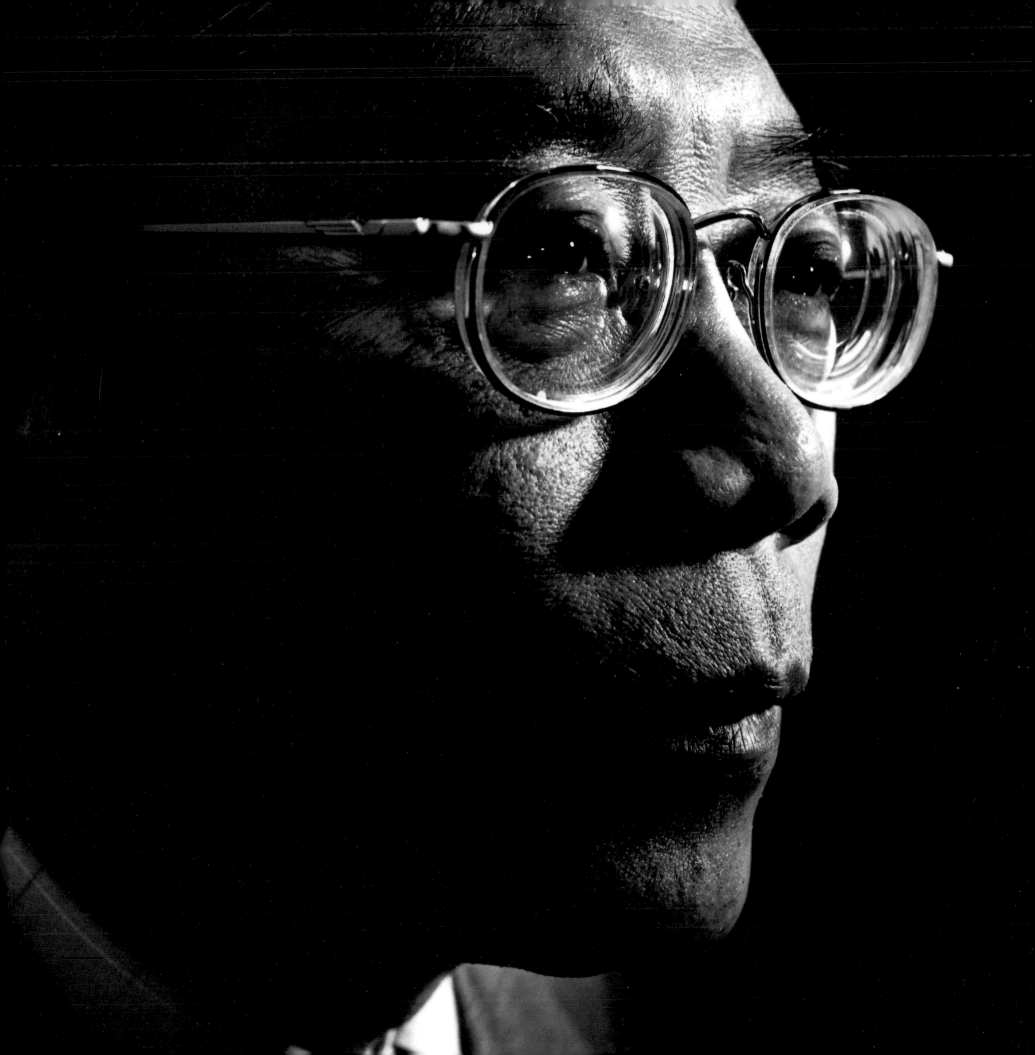

I spent twenty years in Vietnamese prisons, and was in isolation for four years. I was forbidden all pens, papers, and books. To keep my spirits up I practiced yoga and Zen meditation. I did a lot of walking. I had access to a small yard from 6 A.M. till 4 P.M., so I gardened—small cabbages mostly. I sang, I talked to myself. The guards thought I was mad, but I told them if I did not talk to myself I would go mad. I tried to take it easy, to think of my cell as home, as though I had entered a religious way of life, like a monk. My family was Buddhist and I had many good friends who were monks. I learned yoga as a student. In isolation as I had no books, I just had to use my mind. Zen meditation helped—with it you turn inside. You have to be calm, to make your mind calm, to think this was just a normal way of life. During the first one or two years this was very difficult, but I got used to it. Every day passed, like every other day. I wrote and recited a lot of poems I had learned by heart. This was a way to keep my mind alert, and helped to clarify my thoughts. As soon as I was released, one of the first things I did in America was to write down the poems from my mind that I recited in prison—now they have published a second volume of them.

The knowledge that it could have been worse in solitary confinement helped. I knew that others survived more severe treatment, and their resilience was an important source of courage. If they could persevere, so could I. Here's one ironic example. When I first came there, the first day, they asked me if I wanted to buy any necessary things, and they gave me a piece of paper to write a list. And I wrote down many things, including a fan. I had in mind a small, handmade fan. But they thought I had asked for an electric fan, unheard of in prison. So they were very angry. I didn't understand why they were angry, when I asked for just a fan. Eventually, word arrived from the minister, or the ministry officials, who had agreed to let me buy an electric fan. And one official came in and he said, "Your electric fan—made in China or Japan?" Well, I was very surprised, but knew by this incident how they were going to treat me—not so badly. But about one week later everything became clearer. One day it was terribly hot. I turned on the fan, and it did not work. I asked the official and he told me that to save energy, from now on, power would be cut off during the daytime. I observed that there was still power in the entire camp, except in my area. And every year, once or twice, they came into my cell to videotape me, sitting there, reading some newspaper, one month outdated, and with the electric fan always vividly behind me.

The common criminals clandestinely listened to illegal radio broadcasts from abroad on the BBC, or RFI (Radio France International) about me and about my cause fighting for human rights. Prison conditions were unbearable, They were

"I spent twenty years in Vietnamese prisons, and was in isolation for four years. I was forbidden all pens, papers, and books. To keep my spirits up I practiced yoga and Zen meditation. I did a lot of walking. I had access to a small yard from 6 A.M. till 4 P.M., so I gardened—small cabbages mostly. I sang, I talked to myself."

beaten almost every day. So they asked for my help. I secretly wrote a report about the conditions at the camp, and the other prisoners smuggled it out to my family in Saigon. The officials found out about that because my friend sent a letter back to me in a piece of pork, and the officials (who check everything very carefully) found the letter. They knew therefore that I had written about the camp, so they quickly sent the letter to the minister of interior affairs, who in turn sent inspectors to the camp—and finally life improved. They stopped beating the prisoners, they removed the officials who liked beating prisoners, they improved meals, and now they even have musical groups who sing every day to make the camp very lively! I realized that our voice had been heard by the international community. I felt more inspired.

I had been writing other essays criticizing the regime, and fellow prisoners in all the camps I had gone through got them out for me. After I wrote the reports the officials increased their efforts to isolate me. They removed prisoners from the cells all around me. They blocked up the window of my cell so that no one could get in touch with me. It became unbearably hot because no air could circulate. I developed high blood pressure. They put in a new door so I couldn't see out and for the two last years it was very bad for me.

Still, I felt that if I kept silent in jail, then the dictators had won. And I wanted to send a message to the people who wanted to fight for freedom that the dictators could not win by putting us in jail. I wanted to prove that you cannot, by force, silence someone who doesn't agree with you. That's why the prisoners, both political and criminal, tried to circulate my writings. Without their help I could not have sent my messages out. We united to continue our fight for freedom and democracy, even from within the prison walls.

My dream for the future is a dream of Vietnam. Our country has a long history of people who fought against aggression and injustice. Our highest calling is love of country, as has been demonstrated by many Vietnamese patriots in the past. I, too, have been moved by the love of my country and also by the greatness of my country's future and the world's future. I believe in a very bright future for Vietnam and for the whole region of Southeast Asia. Time has passed too slowly for my country and my people, and left a long history of suffering. So these thoughts make me unable to keep silent—my knowledge, vision, and love of country urge me to speak. And I always believe that truth, justice, and compassion will prevail, no matter how strong the dictators are, no matter how bad the situation might be.

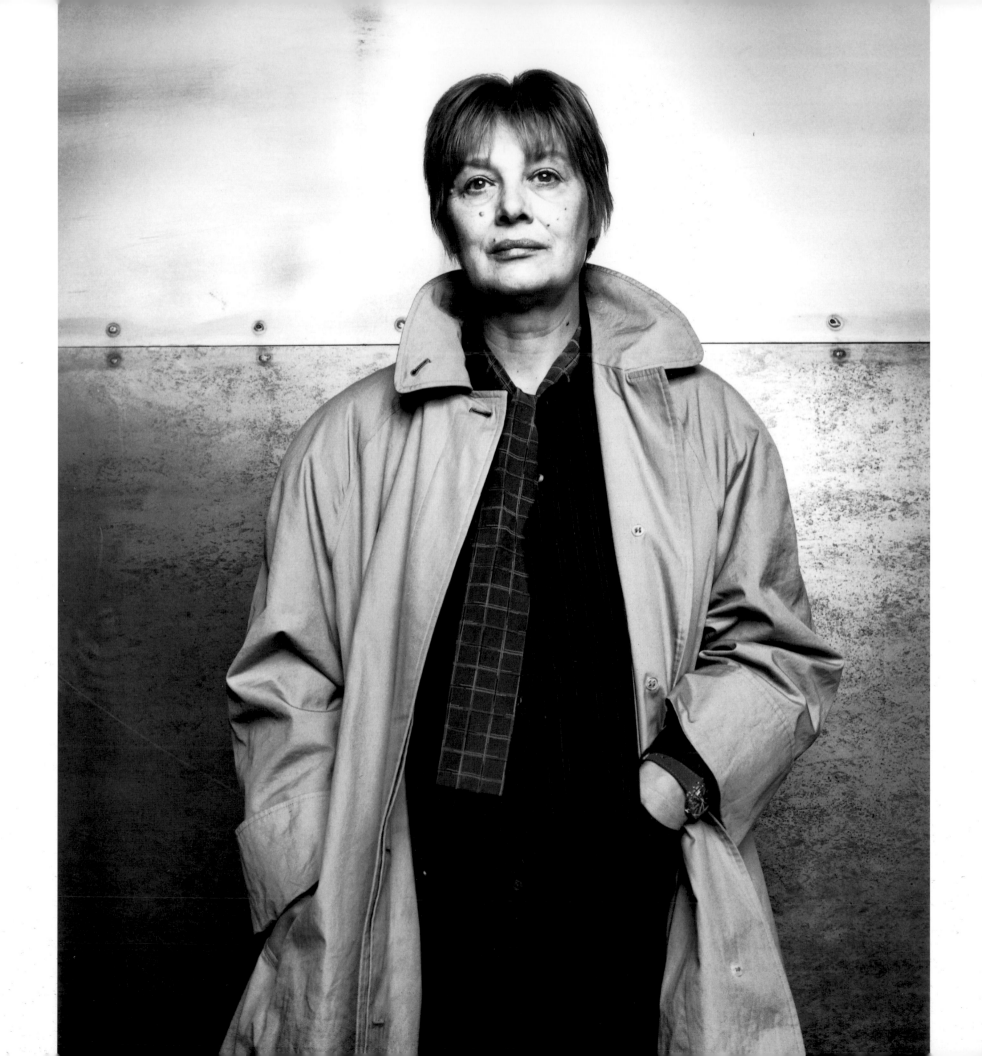

NATASA KANDIC

SERBIA

HUMAN RIGHTS IN TIME OF WAR

"In 1991, many of my friends decided to leave the
country, but I felt I had to stay and fight the policies of war itself."

In 1991 the cessation of Slovenia triggered the disintegration of the former Yugoslavia into the republics of Serbia, Croatia, Bosnia and Herzegovenia, Montenegro, Macedonia, and Kosovo. Led by the Croatian dictator Tudjman and the Serbian Milosevic with their policies of ethnic cleansing, efforts to consolidate territory along ethnic lines were systematized and enforced, using concentration camps, rape camps, and other gross violations of human rights. With the NATO bombings of Bosnia and later of Kosovo, the armed conflict ground to a halt. Physical bravery is rare on the battlefield; rarer still is the bravery it takes to stand up against one's own government, or against one's own community, including family, friends, and professional colleagues, all in the pursuit of justice. Natasa Kandic is among a small minority of Serbs who have dared this, as she investigated wrongs committed by her own and other ethnic groups. Serbs, Croats, Muslims, Kosovar Albanians, and Romas have, in turn, labeled her a traitor for her unbiased and unrelenting struggle for human rights. Born in 1946, and first working in housing issues for the Trade Union Organization, in 1992 Kandic formed the Humanitarian Law Center, Yugoslavia's premier human rights organization. Known for meticulous investigative work despite the extreme danger, HLC has been relied on by the War Crimes Tribunal to research human rights abuses in wartime. HLC also represents victims before tribunals, and is a legal pioneer in bringing claims against the Serbian and Montenegran governments. HLC provides legal assistance to refugees for land claims, citizenship, right of return, pension payments, and property ownership rights, among others. Kandic also has used her own considerable organizing skills to mount popular support for peace, initiating the Candles for Peace campaign in 1991, where citizens stood with flames alight outside the Serbian presidential building nightly for sixteen months, reading the names of those killed during the war. Kandic also organized a thousand volunteers to collect 78,000 signatures protesting forced conscription of Serbians into the war in Croatia. In 1992, the Black Ribbon March saw 150,000 Belgraders demonstrate against the suffering of civilians in Sarajevo. That same year, Kandic's weekly column (wherein eighty intellectuals called for peace) appeared in Borba, Belgrade's first independent daily newspaper. Natasa Kandic has consistently spoken out against repression and bigotry in all its forms, and her work for peace and tolerance in the former Yugoslavia will be remembered long after the last guns sound there.

Before the war years I was involved in political actions in the former Yugoslavia without any knowledge about existing international powers for the protection of human rights. And when the war started in 1991, many of my friends decided to leave the country. I understood their choice, but I felt I had to stay and fight the policies of war itself. I began to travel throughout Yugoslavia, in the beginning to

the region of Croatia. I investigated human rights abuses and tried to protect activists, including intellectuals and political parties. When the war later began in Bosnia I focused on minorities and Muslims and their position in Serbia.

In 1992 I decided to formally establish an organization to gather information about the violations of humanitarian law. The idea was to gather evidence, to investigate cases, and to speak out about abuses based on the testimonies we had heard. First we developed a methodology, then established a database. We wanted to be absolutely sure that every allegation was true.

We succeeded in documenting the abuses, but of course we failed to stop the war, or to establish peace. When I documented abuses against the Croats, the regime called me a traitor. When I documented abuses against the Muslims, the regime called me a traitor. When I documented abuses against the Serbs in Croatia, the regime said—nothing. I documented crimes against the Albanians, and of course the regime said that I was a traitor. Lastly, I documented abuses against the Serbs and minorities, much of it against the Roma after the Kosovo war, and the government continued to call me a traitor.

So you see, I don't agree with human rights activists who claim that human rights issues are not political issues. They are crucially important political issues, with serious implications for the future of society. Without respect for human rights and implementation of human rights standards, there won't be democratic changes. Human rights is, in fact, the ultimate political question.

To describe what the last nine years have been in the former Yugoslavia would take days, weeks, months. So let me tell you one or two stories from the recent past. In 1999, I went to an international meeting in Paris and returned on the last flight to Belgrade, just before NATO started to bomb. Three days into the bombing, I decided to go to Kosovo. The war was on; there were certainly no buses there. So I got in a cab and asked the driver to take me to a town about a hundred kilometers from the border between Serbia and Kosovo, and he agreed. When

we finally got there, I asked if he would drive me further, all the way to Pristina. Well, at first he was so afraid. A Serb, he thought the Kosovo Liberation Army was there, that he might be killed. And I then explained to him that only the Serbian police and the Yugoslav army were there. So he decided to do it.

Our first impression of Pristina was really awful. The only people on the streets were the police and military, only men brandishing weapons, no women at all. I tried to find my office and staff to see what to do. It was so dangerous that we decided to collect everyone and go to Macedonia. But when people heard that I was in Pristina and that I planned to go to Macedonia, there was a big panic. The word spread like a fire and thousands and thousands of cars followed us to the border. Within ten minutes caravans of cars were all around us. But by the time we got to the border it was closed. We told the soldiers that some of us in the cars were Serbs and some Albanians; they were taken aback to see mixed company. But one young soldier warned us to go no further, "Because very strange police are here." We were very afraid, and I thought we'd better return immediately to Pristina.

We traveled through empty roads without cars or civilians. Everything was abandoned: the fields, the houses, the villages. Police were hiding because NATO was targeting police forces and military forces. It was very dangerous to travel. But for me it was very important to go out. Based on my experience in Croatia and Bosnia, I know that every effort made in a difficult time will bring some hope. Again, whatever police were there were surprised to see us. Our taxi driver was brilliant. The police checked his identity cards and he began to speak about the situation with the police, always calling them "my brother." The police suspected nothing. This driver was just an ordinary man, without links to human rights organizations or anything. But he courageously just kept driving us through this war zone, never asking why we were there or what we were doing. He knew I was a Serb and he saw that we were sleeping in Albanian houses shared by Albanians and Serbs. He was confused, but he thought that's okay for Albanians and Serbs to be together. And he wanted to

"Without respect for human rights and implementation of human rights standards, there won't be democratic changes. Human rights is, in fact, the ultimate political question."

understand, asking my lawyers. "What's happening? What is her job, anyway? Why are you going to Macedonia? What's happened to the Albanians?" And this incredible driver, whom I didn't know before, felt he was safe with me. He said, "I will travel always with you because you are so sure of what you are doing, I don't believe we will ever have trouble."

But I wasn't sure—not really. But I knew it was important to go to Kosovo just to be with the people. I saw their fear and I cannot describe it. They were sitting in their houses without moving. Only a few women had the courage, the strength to go out to buy food. All the men were shut in their apartments, scared of the police, in terror of the paramilitaries, horrified by what might happen to them tomorrow.

I couldn't afford to feel fear because I saw their fear. They kept asking me, "When will you return?" They were completely isolated and I was virtually their only contact with the outside world. I couldn't share my fear because I had an obligation. I spent nights with them, talking about the situation, what to do. I tried hard to convince them to stay, because after war they would need to have a house, to have property, to have their computers, their books. And I think a majority of the people in Pristina who decided to stay did so because of the ten days I was there, talking to people in their houses. It was very important to them that somebody from Belgrade visited, because they knew the danger that effort represented. They knew someone cared, that they were not alone.

After my trip, I returned to Belgrade. I was so surprised to see that people weren't even talking about what was happening in Kosovo. They saw the refugees on CNN, on BBC, but it was unreal to them—nobody even asked me about Kosovo. The level of denial was high.

Then, on March 26, 1999, civil police and military forces had expelled all Albanians from the city of Peje and the refugees fled to Montenegro. So I continued on to Montenegro with my staff to open a temporary office there. I asked my good friends who were Albanian lawyers in Montenegro to work in the office, to begin to interview these expelled Albanians about the expulsions and what happened in Peje, and they accepted.

One stayed to investigate abuses, and two continued on to Albania. And I was happy to see them working in the office, instead of a refugee camp without books, without food, in awful conditions. I left again for Pristina, saying to myself, "Don't think about the police, everything will be all right." I always traveled with the same incredible driver and each time the police stopped us he said, "We are going to Kosovo to pick up some children from our family. How is the situation?" We tried to convince the police that we were Serbians just like them. And they let us go. I was always traveling: Kosovo, Montenegro, Belgrade, and back again, always the same circle.

We talked with people all day and all night, and thousands came to our office, because all of them, as Albanians in Kosovo, were listening to the radio station, Free Europe, which talked about us and the work we were doing. Free Europe was a famous station among Albanians, because they could get objective information from it about events in the former Yugoslavia. When I was in Belgrade, Free Europe always called me about the situation in Kosovo, which was very important, because nobody had any information about what was really happening there. The first time they interviewed me, they prefaced it by asking, "Are you afraid to talk?" I said, "No, I am not afraid. Because I am a fighter. And every step is important."

And you know, after the NATO military intervention, when the troops began to reach the villages, people recognized my voice, not my face, from those broadcasts. Once that saved me in a terrible situation. I was with my Albanian lawyers in a village where sixty people from one family got killed. When all these people came up to us I said "Good afternoon," in Serbo, and people were first shocked, and then very, very angry. It was—menacing. Suddenly, one of them said, "Wait, I recognize your voice. You're the one from the radio." And then all of them came over to me and began to speak of what they had seen and what they suffered.

FAUZIYA KASSINDJA

TOGO/ UNITED STATES

FEMALE GENITAL MUTILATION AND IMMIGRATION ABUSE

"On Thursday they said I'd be married. On Friday they told
me they'd cut me. At midnight I escaped."

Fauziya Kassindja narrowly escaped female genital mutilation by fleeing from her remote village in Togo under cover of night and making her way to the United States where, in December 1994, she sought political asylum. Instead of receiving this seventeen-year-old orphan with understanding and humanity, U.S. officials proceeded to strip her naked, put her in chains, imprison her, and send her through the Kafkaesque nightmare known as the U.S. immigration system. After extensive advocacy by a law student at American University and an appearance on the front page of The New York Times, *Kassindja became the first person to receive political asylum from the United States based on the threat of female genital mutilation. Up to 130 million women worldwide, the vast majority concentrated in twenty-six African nations, have been subjected to female genital mutilation, and 2 million annually confront it. The procedure involves cutting off the clitoris. No anesthesia is used. Often other parts of the external genitals are also excised, and the entrance to the vagina is commonly sewn almost completely shut. Infection, scarring, infertility, excruciating intercourse, complex childbirth, and almost unbearable pain are common side effects. Many women die in the aftermath of the procedure, which is performed with razor blades, sharp rocks, knives, and in some instances, scalpels. Despite the trauma she suffered, Kassindja has spoken actively against the practice and about the difficulties she faced in the U.S. immigration system.*

I have four sisters and two brothers; I was the sixth child, the last girl. I was a mischievous one, very close with my father—he was my best friend. All my sisters were encouraged by him to do whatever we wanted with our lives. Our parents didn't decide for us. They always said, "It's your decision. If it's a positive one we're going to help you make it come true. If it's negative, we're going to advise you not to do it, but if you think that's what you want, go ahead. Later on you have yourself to blame. You can't say your parents forced you." My father sent all of us to school, so that we could learn English and help with his business. This was unusual for girls in Togo.

When I was sixteen my father died and everything changed. My aunt and my uncle, my father's siblings, hated my mom right from the beginning because Mom was from Benin and they thought she didn't fit in—she's not from their tribe. They tried to force my father to divorce her, but he didn't listen. They said my mother was behind all of us going to school. They thought she poisoned my father's mind.

After Father's death, Aunt moved into our house. She told us that my mother had decided to go live with her family in Benin, which was untrue. She and my uncle made my mother leave, and my aunt became my new guardian. I was allowed to go to school until the end of that year. When I turned seventeen she

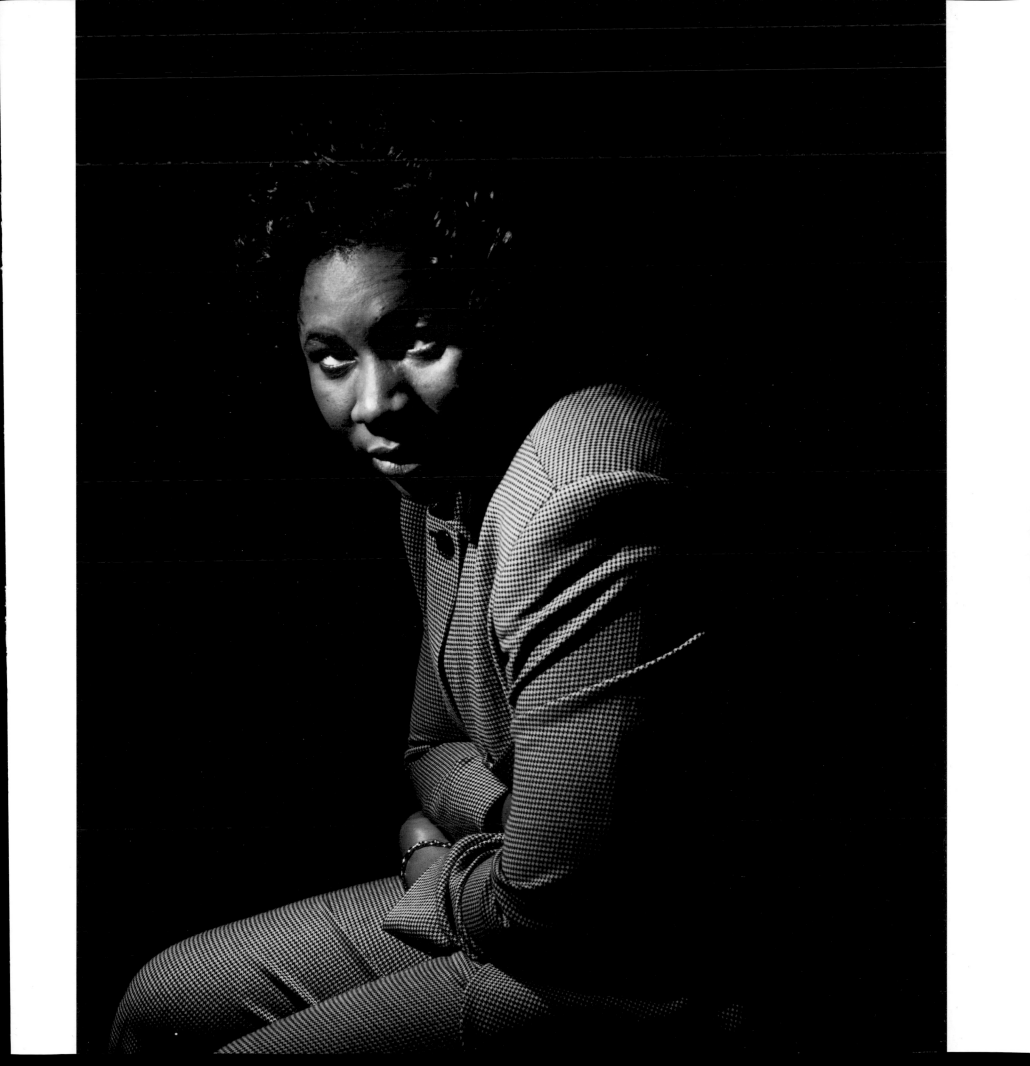

told me that I wasn't going back to school because there was no need to waste money and time, and besides, all my sisters had gone to school and had just ended up married. I had lost my father, I had lost my mom, and now school. I thought, "Oh my God, what is going to happen next?"

Shortly after a gentleman started coming to the house. I thought maybe my aunt wanted to get remarried, so whenever he left I said, "Oh I think he's a great guy." She kept going on, praising him, how rich he was, how famous, how nice he can be. I thought she was in love. I didn't know that she was really saying that to get me interested. She didn't tell me that she wanted me to marry him until one time she mentioned, "I told him that you weren't going back to school." I was surprised. "Why would you have to tell him I'm not going back?" So she said, "Remember how you always say he's a nice person? He wants to marry you."

I thought she was kidding. She told me that he was forty-five years old. I said, "Forty-five!!!" And she kept going, "Don't worry. He has three wives and they will help take care of you." I said, "I don't want to do this." So after that it was a huge fight in the house all the time. Then one day she said, "I know you don't love him now but once you get kakiya [genital mutilation], you will learn to love him."

Soon after I woke up and she called me into her room and I saw all this beautiful clothing on the bed—dresses, jewelry, shoes—and she said, "This is all from your husband. He wants you today. So tomorrow will be the day of kakiya." I said, "What! I am going to get married today?" I had no idea what to do. The marriage proceeded and, after, they gave me the marriage license to sign, but I refused. My older sisters and brothers came, and we talked about it. They apologized for not doing anything to prevent things so far. My older sister was so upset. She told me not to cry—everything would be okay. She would make sure that nobody would do kakiya to me. But I didn't believe her because there was nothing that she could do. I was somebody else's wife now. She says, "Don't worry. Amaray and I will disguise you." Amaray is what we call my mom; it means "bright."

She told me not to sign the marriage license, told me not to worry. Everything would be fine. She came back in the middle of the night and we left the house and crossed the border to Ghana. The next available plane was to Germany. My sister gave me three thousand dollars, all the money she had. I got on the plane from Germany to the United States by purchasing a passport. When the immigration officer at Newark Airport said, "Do you have any money?" I showed her the little money I had left and then told her that I wanted asylum. She said go sit over there, and she would be with me shortly. So I sat waiting until she

> "I felt just like the criminals
> I had seen in movies. I started
> crying. I said, 'Please,
> don't take me to prison.'"

checked everybody and came to me. She said, "Okay, tell me what you want from the United States." I told her I wanted asylum. She told me I had to tell her what is the problem. So I told her everything. Well, not everything, because it is so embarrassing. How could she understand? I didn't know the words even to say it in English. I didn't know what it was called. I told her my father was dead and my mother had vanished, and my aunt wanted me to marry somebody I don't want to marry and that I wanted to go back to school. That basically summarized everything—I didn't mention *kakiya* because I knew she probably couldn't understand and she would also think I was crazy. Whether I got asylum was up to the judge, she said, so I would go to prison, then see the consular official from my country, and then I could go home and be with my family.

I started crying and screaming—telling her that I was only seventeen, and I didn't do anything wrong, I didn't want to go to prison. Then they brought the cops to the waiting area where I was sitting. Her supervisor said if I didn't want to stay, then I either had to go back to Togo or to Germany. I didn't know anyone in Germany, and Togo was the last place I wanted to go. They took my fingerprints and everything. A woman in uniform called me into her room, where she asked me to take off my clothes. I said, "Please, I am menstruating, can I keep my underwear on?" And she said to take it off. It was the most humiliating moment in my life. I took

it off and just wished I could disappear into the wall. She gave me back my pants and my sweater and then she started putting the handcuffs on me. I felt just like the criminals I had seen in movies. I started crying. I said, "Please, don't take me to prison." She ignored me and she put the chain around my waist. I couldn't walk very fast with the chains, but she kept pushing my back, saying, "Let's go. Let's go." So I was taken to this detention center in Elizabeth, New Jersey.

That's where the nightmares really began. I was strip-searched again, and left in this huge cold room and this man came in and stared at me, as I was standing there naked. Then I was taken to this prison in Hackensack where I was sexually harassed by an inmate. I think she was a drug addict. They put me in the maximum security part, with a cellmate convicted for I don't know what. She smoked, and I had terrible asthma. I told the doctor that I couldn't stay in that room and he just said, "I am sorry, ma'am, I can't help you." I started coughing and throwing up blood. But I was denied any medicine because of my immigration status.

Then I had to go to Lehigh County Prison in Pennsylvania. A girl from Tanzania and I were handcuffed together. During all this process of transferring from one prison to another, we were chained, like criminals. First they sent us for a medical evaluation, where they thought I had tuberculosis. As a result, I was

put in isolation. They kept me in this room for eighteen days, and I lost thirty pounds. Before I could talk to anybody I had to put on a face mask, like the one doctors use for operations. When I needed something I had to stand in the other corner of the room, turn to the wall, and yell for a guard. The door had this small window in the middle where they passed my food. I couldn't come near the door. They treated me like an animal. I needed soap. I needed a toothbrush. I called and called—most of the time, nobody would come.

I met Cecelia Jeffrey, another prisoner, in a detention center in New Jersey. She treated me like a daughter. When I'd go to bed, she would come and tuck me in. She has always been there for me ever since we met. When I started feeling sick again—stomach, heartburn—they ignored me and wouldn't give me any medicine. So I thought, "If I'm going to die, why don't I go back." I wrote the request form to the INS [Immigration and Naturalization Service], and wrote Cecelia a letter, telling her how much I really appreciated the way she took care of me and that I would never forget her.

She got really upset, because she knew about my situation back home. She got furious. She wrote to the counselor that I was her daughter and that they should please transfer me to minimum security, because she could persuade me not to go back.

They were so overcrowded they put a bunch of us in the maximum security part of the prison. The prison guards asked me, "Is Cecelia your mom?" and I said, "Yes." So I was transferred to minimum security, where she was, and she was so upset with me. She said, "Are you crazy? Do you know what you're going back for?" And I said, "I just can't take it anymore." Next day she was in the shower and called, "Sweetheart, come here." (She always called me sweetheart.) I went to the bathroom and she was standing in there, and she opened her legs apart and said, "Look. Is this what you want to go back to?" I didn't know what I was seeing.

It was so scary—terrible—I didn't know how to explain it. I just saw it and ran away from the bathroom. And she screamed, "Come back here! You want to be stupid? Come back here! Come and look!" So I went back and she said, "Do you know what this is?" I didn't know. It didn't look anything like female genitalia. Nothing. It was just like a really plain thing like the palm of my hand. And the only thing you could see was a scar, like a stitch. And just a little hole. That's it, no lips, nothing. I said, "You live with this?" And she said, "All my life. I cry all the time when I see it. I cry inside. I feel weak, I feel defeated all the time."

I look at her and I see the strongest woman on earth. Outside you can't really tell that she's suffering or in pain. I know she's not happy, but you couldn't tell

"If I hadn't been through
all these things, the case wouldn't have
reached the many people that it has today.
This is the work of God."

from her appearance or the way she treated others. She's the most loving person I've ever met. After she said, "Well, if you want to go back, I'll help you write the request form. It's your stupidity. Fine." I introduced her to Karen [Masalo], my lawyer, and together they made me stay.

At my first hearing, the judge was so rude, so mean to both Layli and me. Layli Miller Bashir was a law student from American University Law Clinic who had taken my case. Layli asked me a question and before I could answer the judge said, "It's not necessary, the court doesn't want to know this." And he asked me a question and before I answered, he answered for me. I couldn't talk at all in the courtroom. He didn't believe that my mother couldn't protect me from the genital mutilation. And he didn't believe that my father protected my other four sisters, but not me. It was so scary. He yelled a lot and he said my name and my country's name wrong and when I corrected him, he got so upset. And he said something, and I spoke out, "No, that's not what I said." And he yelled, "This will be the last time you interrupt the court." From the way the hearing was going, I knew he wasn't going to grant my asylum. Even before he came into the court, he had made up his mind not to grant it. Layli told me that I shouldn't worry, that no matter what happened, she would make sure that justice was done. She begged me not to go back.

I was in prison when I met with the reporter from *The New York Times*. At first I didn't want to do the interview. I had already done several, but none helped me get out of prison. So I said, "What's the use? I feel like I'm exposing my family. And who knows, I might be sent back to my country and that is going to be really terrible for me." They sent a list of the congressmen who signed a petition to the district attorney to have me paroled—it was denied. If twenty-five congressmen couldn't get me out of prison, could an interview help?

But I finally agreed to talk to the *Times,* and to our surprise the story appeared on the front page. It was the eleventh and I got out the twenty-fourth. They said that the media was very powerful here in this country. More powerful than the Congress? It was scary, and I couldn't understand it.

Everything happens for a purpose and whatever happens is destined. So I got out because it is God that made this possible. At that time I was going through all this suffering, I couldn't see it that way. I thought, "Why me, why doesn't it happen to somebody else?" But now when I look back I know that if I hadn't been through all these things, the case wouldn't have reached the many people that it has today. This is the work of God. And it is truly unbelievable.

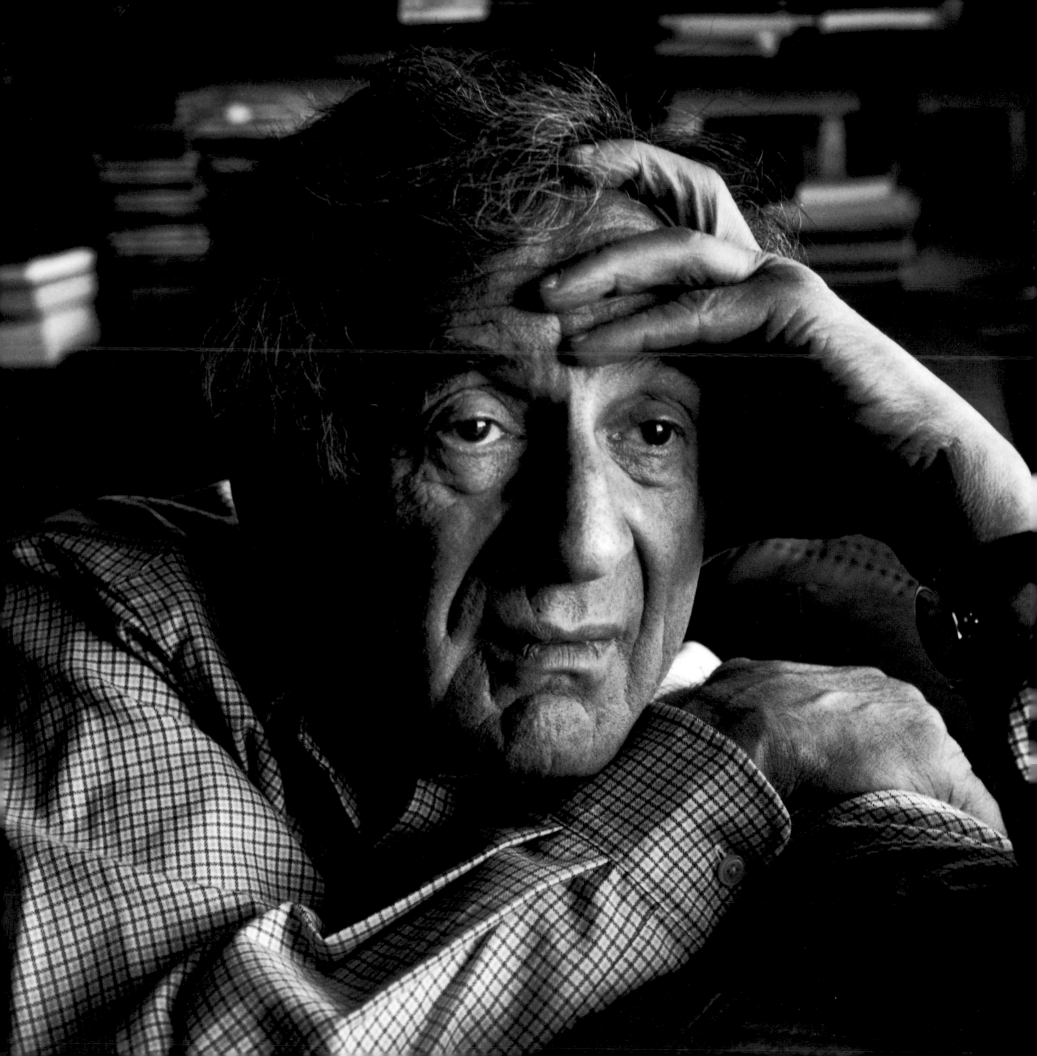

ELIE WIESEL

ROMANIA / UNITED STATES

THE POWERLESS

"What I want, what I've hoped for all my life, is that my past should not become your children's future."

Elie Wiesel was brought up in a closely knit Jewish community in Sighet, Transylvania (Romania). When he was fifteen years old, his family was herded aboard a train and deported by Nazis to the Auschwitz death camp. Wiesel's mother and younger sister died at Auschwitz—two older sisters survived. Wiesel and his father were then taken to Buchenwald, where his father also perished. In his autobiography, Wiesel writes: "Never shall I forget that night, the first night in camp, which has turned my life into one long night, seven times cursed and seven times sealed. Never shall I forget the little faces of the children, whose bodies I saw turned into wreathes of smoke beneath a silent blue sky. Never shall I forget those flames which consumed my faith forever. Never shall I forget that nocturnal silence which deprived me, for all eternity, of the desire to live. Never shall I forget these things, even if I am condemned to live as long as God himself. Never." Wiesel has devoted his life to ensuring that the world does not forget the atrocities of the Nazis, and that they are not repeated. After the war, Wiesel became a journalist in Paris, ending his silence about his experiences during the Holocaust with the publication of Night *in 1958. Translated into twenty-five languages, with millions of copies in print around the world,* Night *was a searing account of the Nazi death camps. Wiesel has written over forty books, and won numerous awards for his writing and advocacy. He served as the chairman of the President's Commission on the Holocaust, and was the founding chairman of the U.S. Holocaust Memorial Council. In 1986 he won the Nobel Peace Prize. Wiesel teaches at Boston University and travels the globe advocating for human rights and the discussion of ethical issues.*

KERRY KENNEDY CUOMO Why don't you give in to futility, the sense that there's nothing one person can do in the face of the world's ills? What keeps you going?

DR. WIESEL When you think of the other you realize that something must be done. If I think of myself, I probably wouldn't have done many of these things. But what else can they do to me that they haven't done already? I think of the children today who need our voices, possibly our presence, possibly all our help, but at least our emotions. I think of the minorities—social minorities, ethnic minorities, religious minorities, or health minorities, the victims of AIDS or the victims of Alzheimer's. Then you have no right to say: "Since I cannot do anything. I shouldn't do anything." Camus said in one of his essays (and it's a marvelous thing), that one must imagine Sisyphus happy. Well, I don't imagine Sisyphus was happy, but I imagine the other is unhappy. And because the other is unhappy, I have no right not to diminish his or her unhappiness.

KKC How did you, as a child, survive after your father died?

DR. WIESEL A few months after his death came the liberation. In those months, I could have died any day, any moment. There was no will to live. And even if I were to say today I wanted to live to testify, it wouldn't be true.

KKC Do you believe God gave you a special gift to bear witness to the atrocities, or was your survival arbitrary?

DR. WIESEL It was arbitrary. I don't want to call it a miracle because it would mean that God performed a miracle for me alone. It means he could have performed more miracles for others who were worthier than I, probably, or at least not worse than I. I don't think so. It was sheer luck. I happened to be there, and there were people standing ahead of me. And just as they left, the gate closed. Every single day I was there and at the last moment, the quota was filled. If I had been five rows ahead, I wouldn't be here.

KKC Do you think there's a Divine plan?

DR. WIESEL No, I don't believe it. I don't know how to react to that. I don't accept it. I go on questioning God all my life.

KKC Could you talk about the relationship between courage and love in your experience? From where do you derive your sense of hope?

DR. WIESEL It's very simple. Only another person can give me hope, because only another person can take hope away from me. It's not God. It's a person, a human being. Ultimately all this, our relationship with others affects our own destiny, and surely our own moral attitude and destiny (call it love, call it friendship, call it conviction), is related to the other. Whatever it means, this relationship with someone else doesn't mean my relationship with God. All the laws, morality, are about human relations. In my tradition, my life, there was no animosity, no resentment, no fear in my family. It was a source of strength, of faith, with both my mother and father. Maybe I was too young when I left them.

KKC Fifteen?

DR. WIESEL Yes. Maybe if I had lived longer with them I would have developed the same problems that children today have with their parents. I don't know. Maybe.

KKC How about your own son?

DR. WIESEL He is the center of my life. The center of my center. He's now twenty-six. I am a crazy father. But he doesn't like me to speak about him.

KKC You wrote that you were inspired by the Jews' courage and determination to remain committed to their faith, even in the face of evil and absolute powerlessness against it. Talk about your sympathy for the powerless.

DR. WIESEL The powerless, for me, are the most important, the weak and small. For me, that's why in every book of mine, in every novel, there's always a child, always an old man, always a madman. Because they are so neglected by the government and by society. So I give them a shelter. And therefore in my childhood, I liked these Jewish people—and do to this day. Years and years ago, I used to go and spend the whole afternoon with old Yiddish writers, whom nobody read because they were marginalized, to make them feel that somebody reads them.

KKC It's important to reach out to people who are marginalized—

DR. WIESEL Yes, to those who feel nothing is worth it, who feel that one is forgotten. And in fact, with human rights abuse, with prisoners, nothing is worse for a prisoner than to feel that he or she is forgotten. Usually the tormentor, the torturer uses that argument to break the prisoner, saying, you know, nobody cares. Nobody cares. This is why, for instance, at a conference in Washington on the

looted artwork and monies, I asked, "Why so late? Why the pressure now?" The main thing is we forget that most of the victims were not rich. The enemy stole our poverty and nobody speaks about it. They speak only about the fortunes and the galleries of those who were rich. But what about the poverty of the poor? At times, when I speak, people listen, but they don't hear.

I owe something to these people who were left behind. We who are so life-oriented, who celebrate youth, who celebrate strength—it's enough to see the commercials on television of only beautiful girls, healthy young men to know that somehow it is a kind of rejection of those who are not young, who are not healthy, who are not rich. Therefore I feel I owe them something. That's also why I write. That's what I write. I've written more than forty books, but very few deal with the war. Why is that? Because I believe in sharing. I learn so I have to share that learning. I have a great passion for learning and for teaching. So many of my books are about learning—from the Bible, from the prophets, from mysticism.

KKC How do people become cruel, talk about hate?

DR. WIESEL At least we are in a situation where we realize the consequences. What a hater doesn't understand is that in hating one group, actually he or she hates all groups. Hate is contagious, like a cancer. It goes from one cell to another, one root to another, one person to another, one group to another. If it's not stopped, it can invade the a whole country, the whole world. A hater doesn't understand, therefore, that actually, in destroying others, he then destroys himself. Show the outcome, show the ugliness. There is no glory in killing people, and there's no glory in degrading people. There is no glory in persecuting. That's a very important lesson.

KKC One taught over and over again. Is there a point in repeating it?

DR. WIESEL I know what you're saying. Of course there is. But to come back to what I said earlier, I know I don't manage to persuade people to change, but I do it anyway. A story: a just man decided he must save humanity. So he chose a city, the most sinful of all cities. Let's say it is Sodom. So he studied. He learned all the art of moving people, changing minds, changing hearts. He came to a man and woman and said, "Don't forget that murder is not good, it is wrong." In the beginning, people gathered around him. It was so strange, somewhat like a circus. They gathered and they listened. He went on and on and on. Days passed. Weeks passed. They stopped listening. After many years, a child stopped him and said, "What are you doing? Don't you see nobody is listening? Then why do you continue shouting and shouting? Why?" And the man answered the child, "I'll tell you why. In the beginning, I was convinced that if I were to shout loud enough, they would change. Now I know they won't change. But if I shout even louder, it's because I don't want them to change *me*."

KKC After all that shouting, do you think you have made a difference?

DR. WIESEL Here and there, maybe. I get letters, at least a hundred a month from children who read my books. I answer every one of them. My first book came out forty-two years ago. I know that some are moved. I know they are.

KKC Is it possible to have courage, the determination to make a difference in other people's lives, without suffering yourself?

DR. WIESEL Of course, by studying the suffering of others. And you can do it in an elegant way, a discrete way. If a person suffers, you cannot reduce his or her suffering, but one thing you can attain is that the suffering should not become a source of human nature.

KKC What does courage mean to you?

DR. WIESEL You know, for me, courage is the way you define it. I don't even make U-turns. I remain a refugee at heart. I'm afraid of the police. So if I do run into them, I stop and move away. I let my wife handle it. I'm afraid of uniforms. Generals frighten me. It wasn't courageous for me to tell Ronald Reagan not to go to Bitburg, it was just natural. For me, prophets were courageous because they had no constituents, nobody protected them.

KKC Wasn't there one very powerful guy watching out for them?

DR. WIESEL Prove it. Do you have a paper identity card, saying, I, the God of the universe, appointed you? It's only the prophet who said, "God sent me." Go and prove it. And nevertheless, because of the personality, because of the words, he spoke through God. And that is courage to speak the truth. Power may be that of a president or a king. Power may be a destroyer of the individual. And power may be something you must address with courage, which is the truth. The problem is how do you find it? . . . What I want, what I've hoped for all my life, is that my past should not become your children's future.

SAMUEL KOFI WOODS

LIBERIA

POLITICAL RIGHTS

"I saw a society yearning to be convinced about the essence
of conviction. I saw a society where there was a vacuum.
I saw a society that required more sacrifice and understanding.
There is a universal contest betweengood and evil.
And I believe that eventually good will triumph over evil.
But good cannot triumph over evil by retreating from
evil—good must confront evil."

Founding director of the foremost human rights organization in Liberia, the Catholic Justice and Peace Commission, Sam Woods managed on a shoestring budget to write and distribute to the international community reliable reports of abuses in the midst of a brutal civil war. His work led to the liberation of more than fifty inmates at the Central Prison in Monrovia, many of whom were held without charges after arbitrary arrests. The human rights radio program he established broadcasts reports of arrests and extrajudicial executions, and educated tens of thousands of Liberians about their rights. Woods, his family, and his staff were under threat from government authorities, and he was forced into hiding and exile on several occasions. Though many of his colleagues were murdered, Woods returned again and again to his work for justice and peace. Woods's lifelong commitment to human rights began with student activism leading to his first arrest in 1981. In 1986, as a member of the National Student Union, he was forced into hiding, then banned from employment and travel. He later became director of the YMCA, where he organized citizens. After civil war broke out in 1989, he fled to Ghana, but returned to work with the Catholic Church and in 1991, with the support of the courageous Archbishop Michael Francis, he founded the Justice and Peace Commission. At the height of the war in 1996, Woods was evacuated by the U.S. embassy, only to return to Liberia a few months later. In 1998, he was declared an antigovernment activist and was threatened with sedition for exposing forced child labor in the country. Today Samuel Kofi Woods continues to fight for justice in the face of terror.

I was born in a zinc shack in a suburb of Monrovia; a place called Bushrod Island. It is a place of squalor as a result of migrants from the rural areas coming to seek job opportunities. I was one of twenty or so children of my father—that alone created difficulties—no educational opportunities, no housing. And those conditions imposed upon me a perception of the world—the perpetual conflict between good and evil as expressed through political, social, and economic systems.

Liberia comes from the word "Liberty." Our capital city is Monrovia, named after one of the American presidents, James Monroe. Our first president was Joseph Jenkins Roberts. I am told he has a monument in Virginia. There is a deep link between the United States and our country. We have always been an American protégé. Back in 1821, a group of freed slaves entered Liberia's shores and settled on a place called Providence Island. Most of those people were mulattos, products of relationships between slave masters and slaves of the households sent back to Liberia by a group called the American Colonization Society, a philanthropic organization in the abolitionist movement. Our constitution, our laws, our way of life, everything that we attempted was modeled after American society. The hope of these freed slaves was to create a paradise in Africa for all people seeking freedom and liberty. As a result, we've had a number of different settlers in Liberia, which in fact is part of the problem. Those from North America were considered skilled politicians, because they were related to the slave master and had the opportunity to be close to the family. Those from South America were basically

unskilled plantation workers. There were those from the West Indies, from the Congo, and others recaptured by the British warships and American ships when the abolitionist movement was very strong. Within that group there were contests for power while at the same time erecting a political and social system that marginalized the vast majority, who were indigenous. Add this to the racial crisis: if you had lighter skin you were considered superior to those of darker skin, which was reflected in the social relationships and in the political relations.

Not until the 1870s did the first dark-skinned black president emerge in Liberia. His name was Edwin James Roye. After a few years he was overthrown and allegedly murdered. The Liberian crisis has roots in the problem of identity, of those who came into the country, those whom they met in the country, and those who felt marginalized by the legal, political, and social processes. Legitimacy was an issue and the government tried to assert its authority in the rural areas by imposing rule by force. In that process, a lot of violations occurred: a lot of internecine wars where so-called indigenous people were killed. This division grew over the next century.

In 1980 there was a coup in which the president was killed, and a leadership of the so-called indigenous came to power. Those who carried out the coup were from the army. The military in our country was generally illiterate, and for ten brutal years Liberia submerged into violence, chaos, and anarchy.

When the coup occurred I was still in high school, agitating for change. We thought it had finally come. Within a year, we students called for the government to estab-

lish a timetable to return the country to democratic elections—we became the enemy. In time, student leaders were arrested. A campaign of intimidation, harassment, and arrests followed that period. We also began a campaign for academic freedom and social justice. I personally participated in a number of demonstrations between 1981 and 1985, until I was elected student president of the university, and a leader of the national student organization in 1986. I was hunted on many occasions for my position on national issues. I went into hiding many times for my life. In November 1995, the first military invasion of Liberia occurred. It was brutally crushed by the late Samuel K. Doe. An orgy of killings and disappearances ensued. He used the opportunity to pursue his perceived enemies. A group of armed men stormed my home in search of me. I miraculously escaped. When I completed my university degree in economics and management, I was arrested two days after graduation. The government unofficially banned me from employment and travel. I couldn't find a job. I was denied the right to travel. I was virtually a noncitizen. It was difficult to get jobs from the private organizations, because they were all afraid. My documents from the university were censured. I remained in Liberia in spite of repeated calls to leave the country for exile. I totally rejected this idea.

I decided to take the government to court. I felt that my situation should be pursued in the court of law. I consulted many law firms. No one wanted to represent me. Everyone was afraid. I was compelled to enroll at the law school with the intent to defend those who would face a similar predicament in the future. In March of 1986, I got arrested and went to prison. That experience opened my eyes to the horrible situation in the prison. I encountered people who were detained illegally, without charge, without due process, without the right to

lawyers, with nobody to represent them. I was seriously motivated. When I got out, I went right to law school. By 1989, we had a civil war on our hands, and I was continuously harassed to join one of the many factions because I was a student activist. I refused to believe that violence was the solution.

In November 1991, I met Mike Posner of the Lawyers' Committee for Human Rights. He had just had a discussion with the archbishop, Michael Francis, who is a very committed man, about trying to institutionalize the idea of respect for human rights. He asked me to start the Justice and Peace Office of the archdiocese. I had no road map, no training, just a desk and a typewriter. It was a difficult situation. Liberia was experiencing war, and the concept of human rights was new to the population in general.

Upon reflection, after seven years, I am proud to say that ours has become one of the strongest Catholic Justice and Peace Commissions in Africa and probably internationally. We have been able to provide free legal service to indigents—people who cannot afford legal fees for their defense. We represented journalists and political prisoners. We represented factional leaders who were detained illegally, people who were killed or reported missing. We ran radio programs on human rights and reconciliation. We have now been able to conduct training for journalists on conflict resolution, human rights, and peace building. We have been able to do it for youth, for women's organizations, the police, and the law enforcement institutions. And more than that, we have served as a central link in civil society. Because of that I have suffered a lot of attempts on my life.

In April 1996 during street battles among factions for the city, I was pursued by some of them. My hideout was ransacked twice one night. By God's guidance, I was not in. The American marines subsequently evacuated me from Liberia. A month later, after fighting subsided, I returned—much to the astonishment of many. I had been warned by friends and relatives not to return. For the past ten years, I have slept in a different place every night, for security reasons. I have been moving from place to place, often sleeping only two hours at a time for well over a decade.

It doesn't feel good because it doesn't make you a normal person. But you are propelled because you are doing a good deed. You are trying to sacrifice so that other people can survive, so they see hope and meaning in living. In June 1998, last year, the Liberian Information Ministry declared me an antigovernment agent while on a visit to Europe and I was told by my European friends not to go home. I went back. And strangely enough, when I arrived at the airport, there were citizens waiting for me to work on their cases and to stop any attempt to have me arrested. It was said that the government intended to charge me with sedition for statements that I have made against forced child labor in the southeastern parts of our country. The purported charge was never effected.

In September, government troops reportedly killed some people while attempting to arrest a former warlord. I condemned it and called for an investigation. The statement was issued on October 9, 1998. I had to travel for a three-day meeting in Brussels. While I was away, the police impounded my office vehicle and the driver was flogged. It was reported that I would be

123

arrested for treason upon my return based on official allegations levied against me by some officials of government. Everyone advised me not to return again. I said I would return and plead my case if there was any. And I went back to Liberia after about a month. When I went home, my mother (my father died a few years ago) was shocked to see me. She couldn't believe I was in the country—she had written me a letter saying not to return, that even if she died, I should not return for her funeral. My office, the entire leadership, wrote me a letter too, also urging me not to return to Liberia. My colleagues, my friends, everyone wrote to advise of the potential danger of my return.

But I saw a society yearning to be convinced about the essence of conviction. I saw a society where there was a vacuum. I saw a society that required more sacrifice and understanding of my conviction. I wasn't frightened because I believe that life means nothing if the pursuit of the truth cannot be achieved. We don't want to be heroes or to be foolish. We want to be normal people. And to be normal people is to pursue the truth, though it's very difficult. There is always a universal contest between good and evil. And I believe that eventually good will triumph over evil. But good cannot triumph over evil by retreating from evil—good must confront evil.

At some point in your life you are confronted with the fear of death. You walk into the corridor of death and you know this moment might be your last. And everything about life leaves your body—yet you survive. It takes time but then life returns and you see how meaningless you are as a human being—how much you can gain by sacrificing for others. I went through this.

I went to prison one time and while in prison one of the guards came to me and threatened my life. He pulled out his gun and put it in my mouth. And he said to me, "Who do you think you are?" It was late and this guy was drunk. I didn't have

clothes on. I was powerless. The gun was already in my mouth. I could have died and each time I reflect on it, it's like—I was gone, gone. My life has always been, at every moment of the day, every moment, a surprise. I walk to different places and people hold my hands and can't believe that I am still living. Because all that was heard about me was that I would be killed in a moment. Society needs people who can help by their sacrifice, by their conviction. Because when you confront evil you provide a moral alternative for society. When a nation is so consumed in evil, it's difficult to see alternatives, unless people of conviction stand up! Sometimes you can even convince other people to join the struggle. You can even convert those of evil heart to good. I have seen that happen.

In July 1997, Charles Taylor was elected president. In November, a former ally who had broken away from him (along with his wife, his cousin, and his bodyguard) was killed on the highway. Everyone was afraid. It happened on a Friday when he disappeared. This man had been one of the most serious critics of the Justice and Peace Commission, of my work, and of the archbishop. And his family could go nowhere else but to me. His children were afraid to say that he was arrested and subsequently killed by agents of the government. They needed a voice. And I became their voice. We filed a case against the government to produce the bodies. We provided evidence that it was the security forces that arrested this man. We launched a sustained international campaign. We insisted on investigation. We went to court. I personally led the defense until President Taylor was forced to admit that the man was actually killed at the hands of the security forces. In this man's death, he was confronted with the truth: in his grave he was confronted with a reality that we have no malice against anyone.

We also sent a signal that we will stand up for anyone's right to due process. And this is what motivated us. This is what keeps us going. We do it with a clear conscience. President Taylor didn't understand why I would take the gov-

ernment to court. I told him, "Mr. President, I am doing this because I want you and many others to know that human rights are universal. Everyone is entitled to them, no matter how high or low she or he is. And we must be here to ensure that those guarantees exist. So even you, Mr. President, if you are arrested in this country, we will defend you." Taylor couldn't understand it. He offered me a job on the National Human Rights Commission set up by the government. In some cases, I was offered money. I said no. I have said to many people that he has been able to defeat a lot of people because they have sold their souls, they have compromised their convictions.

I became Catholic in 1992. But I have never been a good churchgoing Catholic. I have seen religion as my relationship with God and my fellow man—for me this is religion. And I believe that the divine mystery is how I have been delivered many times. How I have decided to sleep in one place one night, and I stayed until about midnight and decided to change all of a sudden. And then that very night it was attacked. There's no answer. I don't have any special powers that lead me to understand how I survive these things without arms, without violence, without security protection. But I have a deep and abiding confidence and faith in God.

My life has a toll in terms of keeping the family going. At some moments you almost feel that you are sacrificing them in pursuit of your conviction. Sometimes it appears as if you are being very selfish, for these young children have not developed enough to have convictions of their own. The instability in their lives, the movement from one country to another: they were in Ghana and they went back to Liberia and now they are in The Hague. They had to leave Liberia, using different travel documents. My daughter had to deny that she was my daughter. A young girl of about eleven had to say, "I don't know that man." How painful it is for children to

go through this! And you call your son on the phone and he says, "Don't come home, the police are looking for you." My fiancée has been with me for a long time. She suffered a similar fate. She has been a driving force in trying to propel me in what I have to do. She is convinced that it is right. She has motivated me in that direction. She has been helping me to understand where the children are involved. They are growing in understanding and are helping me, too. They have been so molded by this experience that, rightly or wrongly, they too have been consumed by this conviction. There were times that we were not able to be so close because I was always on the run, always away from them. But we have become very close and even closer now. My friends, coworkers, relatives, Liberian people, and the international community have been of great inspiration, too.

You are not motivated because you are a decent person, no. Sometimes it is a calling. And when there is a calling, there is no explanation for what motivates you. There is no explanation for your action, or what propels you. It has to be a vocation. Every one of us has been born into this world with a mission. It has to be fulfilled. Whether I like it or not God intended to use me in society in this way. I hold no malice against anyone. I believe hatred blurs the human sensibilities and diminishes the spirit. Those who hate me, criticize me, and vilify me, purify my conviction and strengthen my courage.

We all live in different societies. We all have to face our different circumstances and challenges. But we must find our common ground. We must work together. And I think we can all make this world a better place. When I attend funeral ceremonies and have to say something, this is my favorite quote by Etienne de Grellet: "I know I shall pass this way but once. And if there is anything I can do, any kindness I show, any good thing I can do, let me do it now, for I shall not pass this way again."

BALTASAR GARZÓN

INTERNATIONAL LAW

"The world's problems seem to be only problems that you watch
on TV, then you go on having dinner, and then you go to sleep …
We cannot say that 'I only take account of what happens in my country,
and whatever is not happening in my country, what happens
beyond the borders does not affect me.'"

Judge Baltasar Garzón has made an illustrious career taking on powerful enemies, specializing in cases against government corruption, organized crime, terrorists, state antiterrorism units, and drug lords. In 1973 Augusto Pinochet led a bloody military coup against democratically elected socialist President Salvador Allende of Chile. Pinochet's seventeen-year reign of terror was characterized by human rights violations on a truly massive scale, including widespread disappearances and extra-judicial killings. In October 1998, Garzón made history when he seized the opportunity to indict Pinochet in Europe, when the general visited London. Garzón carefully and boldly pursued the general legally, despite furious pressures both abroad and at home. While Pinochet was eventually released to Chile because of failing health, following the decision of U.K. Home Secretary, Jack Straw, Garzón's campaign for justice had set a precedent that heads of state may now be tried for crimes such as torture and genocide, that no person is above the law, and that sovereign immunity does not extend to crimes against humanity. Other countries quickly followed Garzón's lead, and there are currently extradition requests against Pinochet with other countries (Belgium, France, and Switzerland also submitted extradition requests) while the former dictator of Chad is now being held for trial in Senegal. Dictators across the globe have canceled trips abroad for fear of the long arm of justice. Garzón's work has given hope to thousands of victims of Pinochet's regime, and of the military juntas in Argentina (1976–1983), and, indeed, to all oth-

ers who suffered at the hands of dictators around the world. Most importantly, it reminds us that when a government persecutes its own people, that betrayal is of universal concern. With the Pinochet case pending, Judge Garzón is conducting enquiries against military officials in Argentina and others have taken his lead, bringing charges against former General Rios Montt in Guatemala. The world will never again be quite so safe for dictators.

The combination of the responsibility I was taught in the seminary, which was a responsibility learned through discipline, and the work I was taught at home, through freedom, was a wonderful combination. My family is Catholic, and they thought I was too naughty to be a priest. But I was stubborn and went to the seminary anyway from eleven to seventeen. I wanted to be a missionary, and to work for social justice, for the benefit of other people, but after a time, I realized that I might not be able to cope with all the restrictions of being a priest. So I opted to study law instead. Although my family was a well-to-do middle-class family and I didn't have to work to study, I thought I should work as well so that all my brothers and sisters could study, too. So I worked in construction, waited tables, and pumped gas. My father was diabetic and also worked at the gas station. I would work nights so he could go home—he had already had one diabetic attack. I studied at night and in the morning I would go to the law uni-

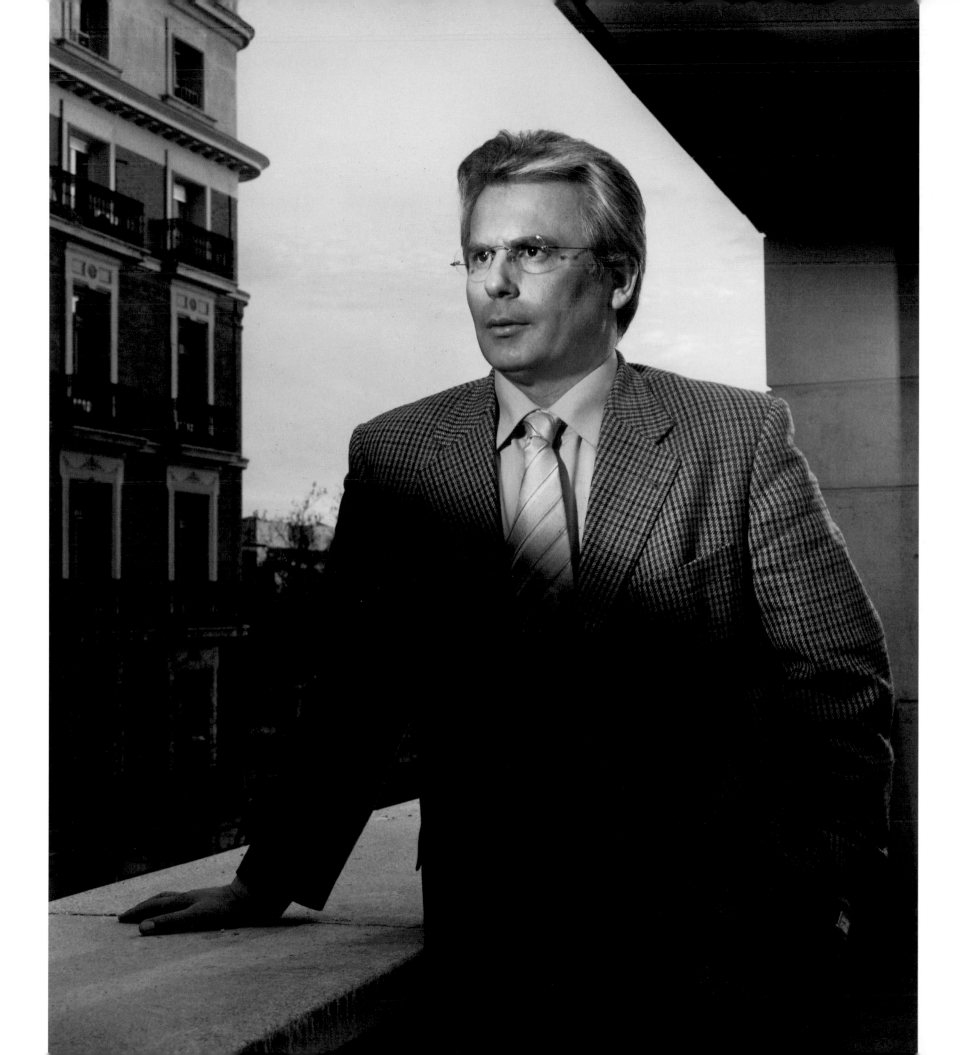

versity, and in the afternoon I would sleep a bit. Of course, working was also for me a way for seeing my girlfriend. (The girlfriend I had at that time is the woman I'm married to now.) I wasn't sleeping much. Actually I do not sleep much now either (three hours a day), so I have time to do more things.

To become a judge in Spain, you have to study five years of law. And then you have to take a special examination, where you're tested on 438 topics, followed by judge's school. On December 1, 1980, just after my twenty-fourth birthday, I became a judge. I've been in the national court for twelve years now. I deal with organized crime, terrorism, drug trafficking, extraditions, counterfeiting, corruption, crimes committed outside Spain, but where the Spanish are competent to try them—such as genocide and torture, as in the cases of Argentina and Chile—crimes committed against international organisms and national organisms such as the king or the government. I was also a politician for a year, in 1993, and I served as a head of The National Program Against Illicit Drug Trade.

My work is dangerous mostly in matters of terrorism, and also counterterrorism, meaning state terrorism, or death squads, against organized terrorism. I've had to order the vice minister of the Interior taken into custody, along with the heads of the antiterrorist police. I've also prosecuted cases against the leaders of the antidrug police, of the civil police, because there were many cases of bribery. My work regarding Spanish problems is mostly dedicated to cases of terrorism, political terrorism, pro-independence terrorist acts, Islamic terrorism. But mostly, ETA terrorism, which is the Basque organization from northern Spain.

I have received many death threats, but you get used to it. Threats have never changed my mind. Threats mainly come when I investigate cases of drug trafficking, from Colombia or Turkey, with heroin. One time when I felt a great deal of pressure was when I opened up the cases of counterterrorism, death squads. People broke into my house and left a banana peel on top of my bed. At the time, accusations appeared charging me with misuse of government funds. They had all these receipts, some real, others bogus. Luckily I was able to prove the accusations were false. (Ever since then I keep meticulous records of every single thing I purchase.) But such accusations continued until I went to the attorney general and asked that he investigate me, so everything would be clear. That's when the banana appeared. The banana peel was a sign to me that they could do whatever they wanted with my family; a Mafia-style warning. If they had access to the most intimate room in my home, my bedroom, that meant they could go anywhere undetected. On that Saturday, our family was out of the house, but our home is under surveillance by television cameras and a policeman twenty-four hours a day. A week later, a journalist phoned me. Since nothing had happened, nor had I said anything, or denounced anything, somebody had phoned this journalist and told the journalist the story that somebody broke into our home and left a banana peel on the bed. So the journalist phones me and says, "Did you see a banana peel on top of your bed a week ago?" I answered, "No, what are you talking about? I haven't seen anything." That evening, while having dinner with my wife and kids, I said to my wife, "It's such nonsense, this journalist pretends a week ago there was a banana peel on our bed." And my wife became pale. I said, "What's wrong, aren't you feeling well?" And she said that on that same Saturday, when she and her sister came

"Politicians keep writing international conventions. But then when the time comes to apply one of those laws that have been ratified, they say 'the problem is, economic stability, or political stability, could be threatened by the application of this rule.' So what's the point?"

back from shopping, they found this banana peel on the bed. But they didn't give any importance to it, because they thought one of the kids had left it. They threw it in the garbage and thought that was it. So we realized it was true, that they had broken in, they had broken the key lock of the house, the cameras were broken, they were not working, and yes, we were frightened.

Despite the pressures, it is very clear to me that I have a job to do. The rest is peripheral. I can't allow these things to change my life. I am voluntarily where I am. These problems are included in the job description. I'm not cavalier. I take precautions. I'm aware there's a risk. I do my best to stay at home as much as possible. I don't go to public places very often. When I go with one of my kids to the cinema, I never follow the same route. So I have a measures that are almost ingrained after twelve years and I do my best so that this does not affect me. I'm lucky because my wife has always supported me. And even when I have had doubts about myself, it has been my wife who has stopped me and said, "You can't have doubts about anything, you can't be weak, you must go on." We have both talked a lot to the kids about this commitment that we feel, that our life is this way, and that there are risks, but we have to take them. When I abandoned politics as an independent deputy, to return to being a judge, my eldest daughter came and embraced me, saying, "Daddy, I support you and I like you more as a judge." One of the things we've made clear to our children—as I was taught as a kid in my family—is that this is a job, that somebody has to do this job, and that I have decided to take this job with total freedom and absolute responsibility. I explain that I could earn much more somewhere else, but money isn't everything. This job is something that society needs, and I have to do it. For me, social commitment is very important, almost vital.

All my education stressed that in good times or in bad times you always have to face problems, not run away from them. Sometimes you can be wrong, you can make mistakes. But I accept the responsibilities of my actions. Because what you cannot do is what many people do, you cannot pretend that these problems are not your problems. I believe that a judge must live in society, must deal with the problems in society, and must deal directly with the problems of society, must face them. We have good, strong laws both domestic and international. Yet nobody seems to apply them. They say, "Well, this is something that is maybe different from what I'm used to." The world's problems seem to be only problems that you watch on TV, then you keep on having dinner, and then you go to sleep. This does not mean that I feel I am Mother Teresa—I wish I were! But it does mean that if a case comes to me, I must apply all the laws and extend the application of law to benefit the case. We cannot say that, "I only take account of what happens in my country, and what happens beyond the borders does not affect me." That would be a nineteenth-century approach. The key issue is that the victims, those massacred as a result of those crimes against humanity, need protection.

Argentina and Chile are situations where international laws that have been ratified by Spain are being applied. These are cases like those of Guatemala, Rwanda, Yugoslavia, where the fact that those crimes happened inside those countries does not mean they can only be judged inside those countries. Mass violation of international human rights must be universally persecuted. International human rights have universal jurisdiction. The issue is whether you want to apply international law or not—you can either apply the law or shy away from it.

It has always amazed me that politicians keep writing international conventions. But then when the time comes to apply one of those laws that have been ratified, they say "the problem is, economic stability, or political stability, could be threatened by the application of this rule." So what's the point? Do we ratify the laws in order to apply them or not? What is amazing is that there are no inconveniences when we're talking about violating human rights. Yet, there are many incoveniences when we talk about judges, or taking people to trial who have committed human rights violations. We must respect the law and the autonomy of judges and politicians who complain that judicial action will affect the stability of a country, but who do not respect the rule of the law. If those in political power would support transparency, then democracy, political systems, and also the economy would be fortified. But they are fearful of being called into court, so they do not want an international judiciary with real power. That's why the United States, for example, will not ratify the International Criminal Court. World leaders should have no fear of accepting jurisdiction for a court which will only prosecute crimes against humanity or other international crimes. They have no problem accepting economic globalization, or the free circulation of people among European states. Europe has no problem in accepting a common law restriction to immigration. They acknowledge some crimes are transnational and that they affect humanity in general. So what is the problem with judging these crimes? We laud ourselves for setting up norms and structures and then we claim these laws do not apply to us. Since Nuremberg we have gone out of our way not to apply the laws. In Cambodia they were not applied because of China. In South America they were not applied because of the United States, and in South Africa they were not applied because the United Kingdom. Now, finally, a new consciousness is being created in the wake of awful atrocities in Bosnia and Rwanda. The denunciations and activities of non-

governmental organizations like Amnesty International and Human Rights Watch have contributed to this consciousness. So when cases dealing with these issues have come before people like me, we have thought we have the means, why not use them? An independent judiciary can take advantage of the legal instruments, and develop them, and thereby help society.

International principles must be applied. It is possible to hold perpetrators of mass human rights violations accountable. The president of Chad has been detained in Senegal for torture. Italy was opening investigations for the crimes committed when the attempt to murder Bernardo Leighton occurred in Rome. There have been spectacular advances, like the decision of the House of Lords that Pinochet is not immune from prosecution. The international community has now accepted, thanks to this case in England, that the principle of universal jurisdiction is valid. Four years ago, when I started these cases, jurisdiction was a formidable obstacle. We were actually creating that path. Now in universities and international forums people recognize that we can use all these laws that had been passed but never used before. Now we know we can use them. When interpreting a law, a judge can develop the law or be conservative about it. We have been able to open up progressive interpretations of the law. When you face one of these problems what you must do is see beyond the end of your nose. You must determine who the victims are and how international law can be used to hold the perpetrators responsible, and protect the victims efficiently.

When this is all in the history books, the way such cases were conducted will be standard practice for applying the principle of universal justice and prosecuting crimes of genocide, terrorism, torture, or forced disappearances. It will simply be an issue of victims, perpetrators, and application of the law. Today

"Political leaders claim to be concerned with upholding the law and meanwhile they insist on compromise when it comes to human rights."

some people say that it is a political and economic problem and that relationships between one country and another may be harmed. But in very few years everybody will say what this is; it is evident that it was only an issue of law.

Political leaders claim to be concerned with upholding the law and meanwhile they insist on compromise when it comes to human rights. So it seems it's always the crazy mothers of the Plaza de Mayo, or the crazy students of Tiananmen, or women in Morocco or in Jordan who ask for equal rights with men, or women in Iran who don't want their faces covered, who are responsible for advancing human rights. The leaders forget their own responsibilities very quickly, along with the victims.

Being a judge is not a calling; its something much simpler. The only thing is that you just have to do your job right, that's it. If a case comes to you, you can ask some simple questions and apply the law—and you are doing legally what a judge must do. But of course you know that if you start asking more questions, then the case gets complicated. So you will not be able to go home early. You will have to stay late. But I believe that's actually the difference: you must ask more questions until you get to all single points in a case, and not only to the minimum legal points of the case, which is another way of seeing this job.

Courage means to be honest with yourself and to be able to overcome the fear that you have. When you're doing this work, you have so many responsibilities it is hard for outsiders to understand how you can manage with such a weak infrastructure. You have so many things to do that actually you have no time to think of courage. You just have to do those things. Perhaps the biggest fear is the fear of making mistakes. Or of damaging people. But that is part of the job of a judge and you have to make decisions. And sometimes decisions

are very, very hard to make. I always suffer when I have to send anybody to prison because I am always aware that I can be mistaken.

Some people may think that I am a very tough person but I am actually not. Sometimes it is very hard to continue when you are convinced that somebody is guilty but the legal system has not been able to prove guilt, thus he is innocent. It is most difficult to maintain this stance when one of your colleagues is murdered. The next day you have to go to the office and keep on working. And then you have to have the author of the murder in front of you. And if there are not enough legal proofs to sentence him, you have to accepted it, and release him. But then, with the same rigor, when the legal proof exists, you have to condemn him.

There was a Sicilian judge, Giovanni Falcone, who for me was the personification of judicial independence. He was assassinated in 1992 for his commitment to justice. It was then that the Italian government realized that they had to fight the Mafia. When you see people of such courage, you understand how important the rule of law is. You have to give something to society in exchange for that which society gives to you. This is a way of thinking, a life philosophy. It is very demanding and difficult, too.

Before dying, my father said, "Son, you must have broad shoulders." Our family has broad shoulders. You always have space to bear a bit more load. But you have to make sure that other people don't notice it. What does this mean? You always have to have your tie on. You have to go into the office smiling and then if you want to cry, you have to wait until you go home. That's what you have to do. Sometimes, it is difficult to bear.

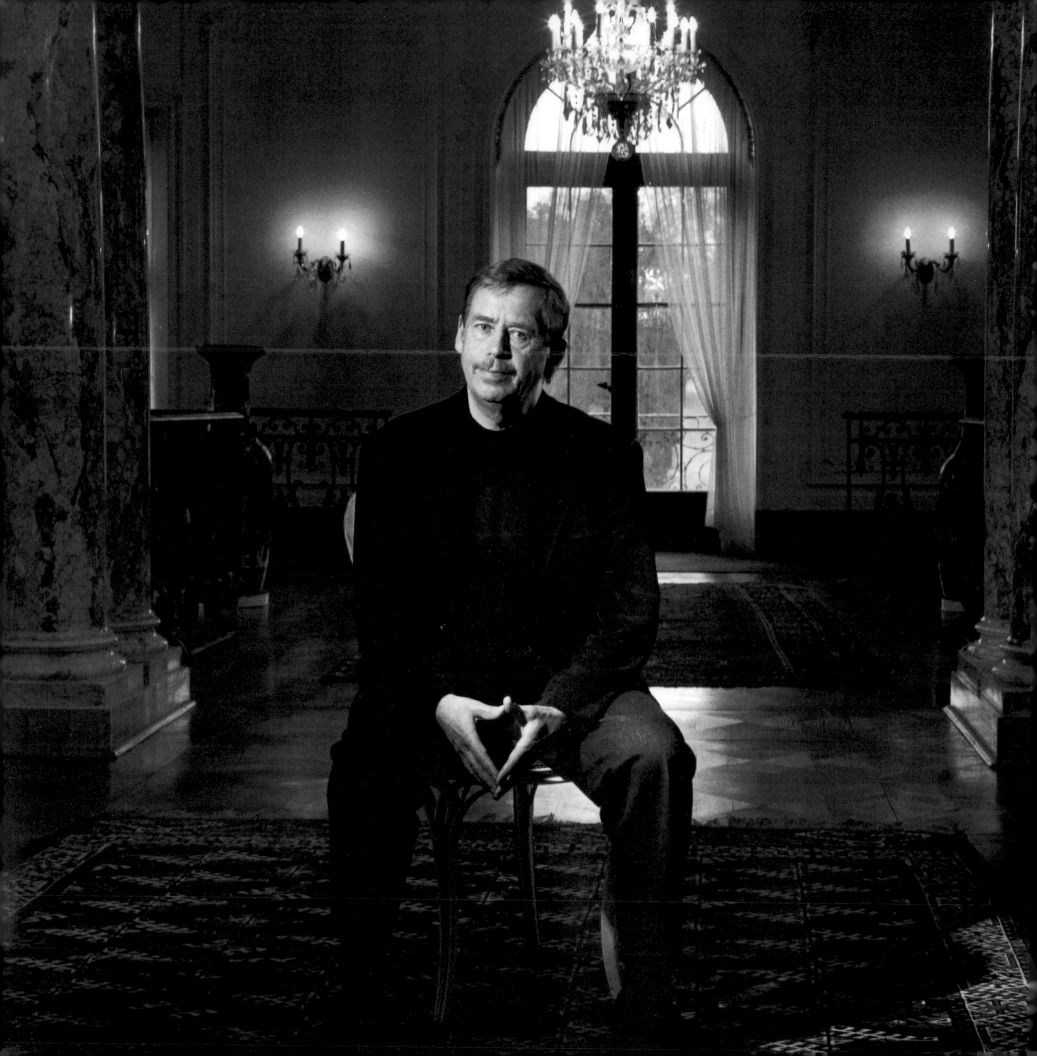

VACLAV HAVEL

CZECH REPUBLIC

FREE EXPRESSION

"You don't want to become involved with the dirt that is around you and one day, all of a sudden you wake up and realize that you are a dissident, that you are a human rights activist."

Vaclav Havel is one of democracy's most principled voices. Armed with a moral compass that points true north, and an eloquence unsurpassed in the political arena, Havel speaks with the honesty of a dissident from the halls of the presidential palace in Prague. Czechoslovakia's leading playwright and a perennial victim of state repression under Communist rule, he is celebrated for his absurdist plays including The Garden Party, The Increased Difficulty of Concentration, The Memorandum, Largo Desolato, *and* Temptation. *Havel, who was born in 1936, was a founder of Charter 77, a human rights and democracy organization that challenged the Soviet takeover. He wrote compelling texts on repression and dissent, and his 1978 work,* The Power of the Powerless, *is one of the best political essays ever written. In 1979, in retaliation for his human rights activism, Havel was sentenced to four and a half years at hard labor, during which he wrote* Letters to Olga. *As chief spokesperson of Civic Forum, which he cofounded in 1989, Havel's leadership, political savvy, and moral persuasion helped bring Communism to its knees, and enabled him to negotiate a peaceful transition to democracy. Out of the ashes of Soviet control emerged a new state, based on free expression, political participation, civil society, and commitment to the rule of law. In 1989, Havel was elected the first non-Communist president of Czechoslovakia in over forty years.*

ON LEADERSHIP AND COURAGE

The crisis of authority is one of the causes for all the atrocities that we are seeing in the world today. The post-Communist world presented a chance for new moral leaders, because at that time of transition in these countries there were no professional or career politicians. This gave intellectuals an opportunity to enter into poli-

tics, and, by entering, to introduce a new spirit into the political process. But gradually people were suppressed—the mill ground them down—and much of that opportunity was lost. There are certain leaders that one can respect, and I do certainly respect, leaders like the Dalai Lama. I appreciate the fact that, although very often they have no hope, not even a glimpse of success on the horizon, they are still ready to sacrifice their lives, to sacrifice their freedom. They are ready to assume responsibility for the world, or at least for the part of the world they live in. I have always respected these people and appreciated what they do. Courage in the public sphere means that one is to go against majority opinion (at the same time risking losing one's position) in the name of the truth. And I have always strongly admired historic personalities who have been capable of doing exactly this.

ON BECOMING A DISSIDENT AND THE DIVINE

Becoming a dissident is not something that happens overnight. You do not simply decide to become one. It is a long chain of steps and acts. And very often during this process, you do not really reflect upon what is happening. You just know that you want to avoid any debt that would put a stain on your life. You don't want to become involved with the dirt that is around you and one day, all of a sudden you wake up and realize that you are a dissident, that you are a human rights activist. With me the story was rather similar. It was only much later, while I was in prison, that I started reflecting on the process and why I had done what I had done. There must be some, call it "transcendental," source of energy that helps you overcome all these sacrifices. Now some people may disagree with this idea of a transcendental source, but I feel it. While I was in prison, I often thought about why a man decides to remain decent, a man of integrity, even in situations when he or she is on his own, when nobody knows your actions and thoughts—except you yourself. Even in these situations, a man can feel bad, can have a bad conscience, can feel remorse. Why is this? How is it possible? And my answer to this is that there must be another eye looking on—that it's not just the people surrounding you that make the difference. I have no evidence of the existence of such an eye, but am drawing on the archetypal certainty of such an existence.

ON FEAR

I have experienced, and still experience, a whole spectrum of fears. Some of my fears have had greater intensity than the fears of the others. But my efforts to overcome these fears have also been perhaps more intense. The major fear is

> "There must be some, call it 'transcendental,' source of energy that helps you overcome all these sacrifices. Now some people may disagree with this idea of a transcendental source, but I feel it."

imagining I might fail somebody, that I might let somebody down and then have a very bad conscience about it. For example, when I am thrown into an unknown Latin American country, I could be asked to speak, to address the parliament. I give a talk, I try to be flowery, impressive. I deliver. But once this is over, I always turn to somebody and say, "What was it like? Was it good? Did I deliver?" I have always felt this uncertainty; I have always been a person suffering from stage fright, from fear. Fear is with me, but I act in spite of it.

ON HUMOR

When a man or woman is ready to sacrifice everything for very serious matters, what happens in the end is that such a person takes himself or herself extremely seriously. His or her face then becomes very rigid, almost inhuman, and such a person becomes a monument. And as you know, monuments are made of stone or of plaster and it is very difficult for monuments to move. Their movements are clumsy. If one wishes to retain humanity, to stay human, it is important that you keep a certain distance. To keep this distance you need to be able to see that there is a certain element of absurdity, even ridicule, in one's deeds.

ON HOPE

Often people confuse hope with prognostics. Prognostics is the science of studying whatever happens around you in the world. With it either you will make a positive prognosis (because you are an optimist) or a negative prognosis (which would have a pessimistic impact on the people around you). But it is very important to differentiate. Hope is not prognosis. Hope is something that I see as the state of the spirit. If life had no sense, then there would be no hope, because the very sense of life, the meaning of life, is closely linked with hope.

ON FREEDOM AND RESPONSIBILITY

Freedom without responsibility is perhaps something that is a dream of almost everybody to do whatever you want to do and yet not to assume any responsibility for what you did. But of course, that would be a utopian life. And also, life without any responsibility would not make sense. So I think the value of freedom is linked with responsibility. And if freedom has no such responsibility associated with it, then it loses content, it loses sense, and it also loses weight.

JOSÉ ZALAQUETT

POLITICAL RIGHTS, TRUTH, AND RECONCILIATION

"I no longer took notice of fear, much in the way
a surgeon becomes accustomed to the sight of blood."

José Zalaquett began his career as a founder of the modern human rights movement worldwide, campaigning while a law student for Salvador Allende. Upon Allende's election as president of Chile in 1970, Zalaquett served a two-year term as cabinet minister, which he left for a post at the university. Shortly thereafter in 1973, General Augusto Pinochet launched a bloody coup which forcibly ousted the elected government. Thousands were arrested, imprisoned, tortured, and killed. Many more went into exile. In the aftermath, the Catholic Church, one of the only entities remaining with a degree of political space, approached Zalaquett to create a Committee for Peace to help the victims of the coup. Under Zalaquett's leadership, the committee, later known as the Vicaría de la Solidaridad, was the foremost human rights organization operating in Chile throughout the dictatorship, from 1973 to 1990. The Vicaría defended hundreds of detainees and helped family members of the disappeared file habeas corpus documents demanding the whereabouts of their loved ones. In retaliation for his work, Zalaquett was imprisoned in 1975 and 1976, and expelled in 1976. In exile he continued his human rights work at Amnesty International, serving as chair of its executive committee. Ten years later, he returned to Chile. In 1990 Zalaquett was named as a member of the National Commission on Truth and Reconciliation, and with his nine colleagues wrote a report on the fate of the victims of the Pinochet regime. As such, he became an internationally respected authority on truth and reconciliation, and has since advised similar commissions on three continents.

In the 1970s, I was an official in the Allende government. After a couple of years, I left politics and went back to the university, serving as deputy vice president for academic affairs. Then the coup occurred. The Palace of Government, a symbol of our freedom, was bombed. It was a devastating blow, a strategic move to take power and to paralyze the opposition.

The military immediately began to round up people. Because the prisons were not large enough to accommodate the many thousands taken prisoner, they were put into a soccer stadium. Congress was dissolved and the military burned the electoral rolls, forbade political parties and trade unions, and established a curfew, which lasted for twelve years.

There was nothing left in this barren institutional land in 1973 except for the government and the churches. Those who knew that I was a lawyer approached me and asked for my help in finding their imprisoned or disappeared relatives. Learning that the churches were organizing to provide some relief, I joined them. When I say "churches," I am referring to the Catholic Church (the largest in any Latin country), five Protestant denominations, and the rabbi of the Jewish community in Chile.

They organized the Committee for Peace that would later be transformed into the Vicariate of Solidarity, a human rights organization which became interna-

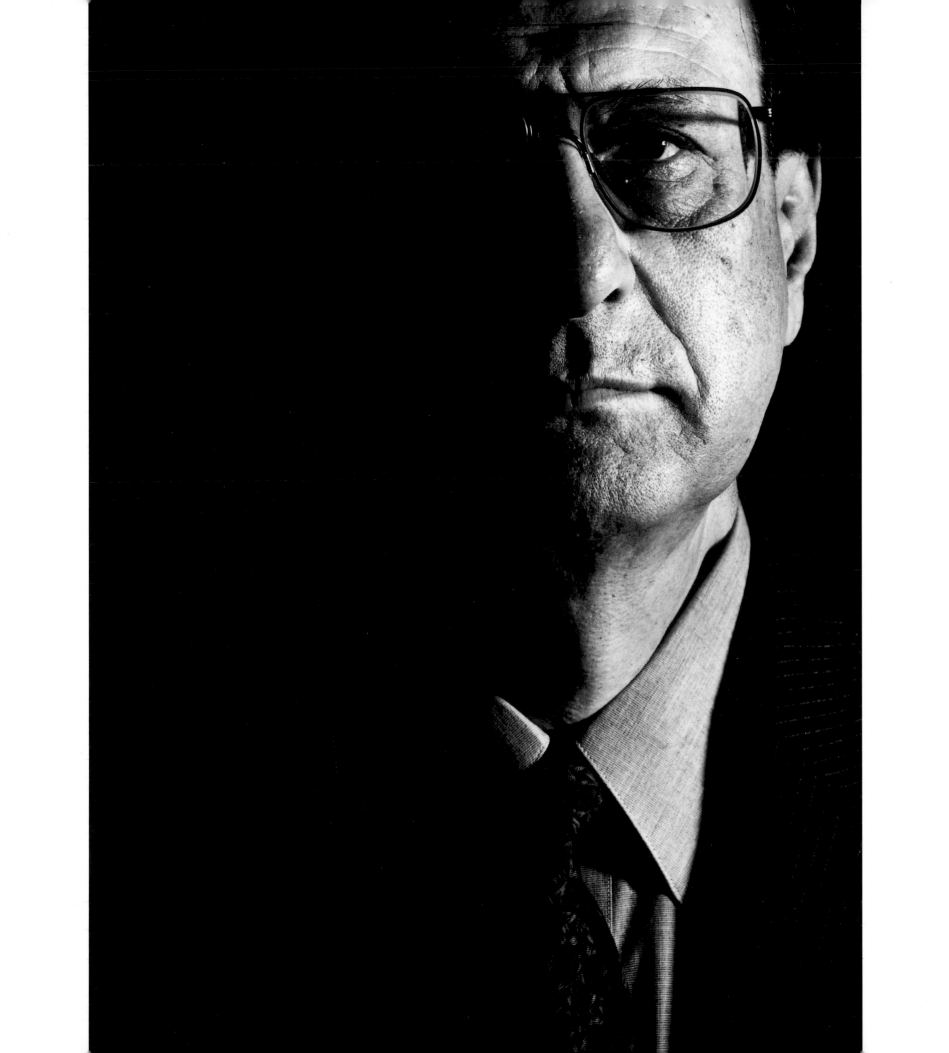

tionally famous. My first task was to go around the country—a country as long as the U.S. is wide—checking out the situation, visiting prisoners, and trying to establish branches of the nascent committee.

At that time, the Catholic Church was well respected by the military because Chile is a Catholic country. I carried credentials issued by Cardinal Silva, from Santiago. This opened many doors. Local bishops would receive me and put me in contact with the local military commander. Because of this, I was able to visit several prisons and camps.

When I returned to Santiago, I was asked to form a proper legal department to defend the prisoners. We soon had a staff of more than seventy people and began to establish legal strategies, mainly habeas corpus writs. Although we lost virtually every case, we knew that we had to continue. The process itself was important.

Under normal circumstances, a case can be won if the law is on your side and the lawyer is competent enough. This was not the case in Chile. The Supreme Court proved itself to be fearful of, and subservient to, the military junta from the outset. The junta kept it in place, to be able to claim that it was respecting the independence of the judiciary. Yet it was obvious that legal proceedings were merely cosmetic: the courts would invariably rule in favor of the government.

Despite this, we could still use such legal proceedings to help people and to denounce what was going on. For the families of victims it was important to have a lawyer by their side. Also, through the legal process we could second-guess the secret police's intentions. If they told the courts they had never arrested the person in question, we knew they probably intended to make him dissapear and we had to mobilize all the national and international pressure we could muster to try to stop that. The legal ritual also helped build a historical record. Since we kept copies of all transcripts, we had thousands of official files which we photocopied and sent to the United Nations, the OAS, or Amnesty International. Foreign correspondents from *The New York Times*, *The Washington Post*, or *Le Monde* could examine them. In addition, we had recorded eyewitness accounts that proved to have tremendous documentary value. Seventeen years later, this information served as the cornerstone of the Truth Commission's work.

However, our work did not go unnoticed by the military junta. By the end of the seventeen-year period, more than fifty of us had spent time in prison. One committee worker was killed and many more were exiled.

Yet compared to the fate suffered by others, we faced lesser risks. The secret police followed a certain rationale. Those who posed the greatest threat to the regime were the well-trained and ideologically conscientious left-wing militants; they were marked for death or torture. Their lawyers, instead, could be subject to imprisonment or exile. Had I been at greater risk, I don't know if I would have proceeded as I did. I had a commitment to justice but I do not claim to have innate bravery. Rather, I'm very normal and try to shun danger when possible. In the end, whatever courage I displayed was an exercise in learning how to live with fears. After a while, I no longer took notice of the fear, much in the way a surgeon becomes accustomed to the sight of blood. The important thing

"The important thing is not to let your heart grow cold while keeping your head cool. If you let your head become as impassioned as your heart, you run unnecessary risks and do not serve people well."

is not to let your heart grow cold while keeping your head cool. If you let your head become as impassioned as your heart, you run unnecessary risks and do not serve people well. Finding this balance requires a good deal of time.

The authorities arrested several of us in 1975, although they never charged us. The junta then asked Cardinal Raúl Silva Henríquez to disband the Peace Committee, and when the cardinal complied, those of us who had been arrested were released. Then Cardinal Silva reorganized our group under the Vicariate of Solidarity. I went back to work in this new office and was arrested again. I was taken directly from prison to the airport where the guards even buckled my seat belt and sent me into exile.

Where did my impulse for this come from, you ask. Since I can remember, I have rebelled against the misuse of power, as have others in my family. Although my father and mother were both loving and just people, in their time they did not have to wrestle with situations of political emergency. However, all four of my sisters have. One was in Lebanon serving as a war nurse, two married Nicaraguans and fought against Somoza, and the youngest was part of the Chilean underground working to oppose Pinochet. After her husband was killed, this sister spent a year in prison. I hold in the highest moral regard those who do not conform to arbitrary power and are always humane and never cruel. Mean-spirited people are obsequious with power and are tough with the meek.

Of the seventeen years of military rule, I spent ten in exile. In 1986, the ban was lifted and I was allowed to return to Chile. Before this time, my passport bore

the letter "L," indicating that I was to be arrested if caught trying to reenter the country and sent back to the place from where I had come.

When I returned to Chile, I continued to work on questions of political transitions and past human rights violations. I had started addressing these issues in 1984, when I visited Argentina on behalf of Amnesty International. I talked to President Alfonsín and his government, and met with the mothers of the disappeared and with the Truth Commission that President Alfonsín had set up to account for their fate. I was in Uruguay the following year, to talk to President Sanguinetti, lawyers, judges, and relatives of the victims. In 1987, I went to Uganda and in 1988 to the Philippines. When, in 1990, there was a change of government in Chile, President Aylwin asked for my advice. He established a Truth Commission and I became a member of it. The commission produced a voluminous report in 1991, accounting for nearly three thousand people killed and disappeared. I have continued to work in this field, writing, teaching, and advising human rights organizations or governments on questions of political transition and human rights.

We call democratic transition a process by which the country attempts to build a just political system after a period of civil war or dictatorship which has left a legacy of war crimes, human rights violations, and deep divisions in society. Every step of this transitional process takes on symbolic value and has lasting effects. Truth is important. Justice is important. Forgiveness is, too—but not blanket impunity.

I believe that there are two levels of forgiveness. On the individual level, a person may forgive his offender. This is a very intimate process in which govern-

mental policies can not intervene. Personal reconciliation or forgiveness is a heart-to-heart matter. Community clemency, which refers to laws of amnesty or pardons, is altogether different.

Community forgiveness is legitimate when it contributes to reaffirm the community laws and values which have been broken or violated. This is the rationale behind the doctrine of forgiveness in all major religions—Christian, Jewish, Islamic. They place a higher value on pardon than on punishment. But community pardon requires that some steps be taken. In the Christian tradition, absolution is not granted unless there is an admission of wrongdoing. The individual must atone for sins that have been committed and make reparations. In this manner, it is as if the sinner is putting back the brick he took from the moral building. This reaffirms the community values and the process of moral reconstruction and the culprit may be forgiven. But if the individual refuses to acknowledge his guilt, then punishment is necessary to subdue his stubborness. On the contrary, a blanket measure of amnesty, without acknowledgment, only serves to validate human rights abuses. There is no truth, no repentance—just cynicism.

South Africa helps to demonstrate this point. After several decades of apartheid, involving countless politicians, judges, or policemen, tens of thousands of people were potentially liable for prosecution. Prosecution of this magnitude was impossible and it could jeopardize the goal of the democratic transition, that is, to achieve a united, reconciled society. However, if nothing was done, the transition would have condoned the past and insulted the memory of all who suffered for so long. Given this situation, South Africa chose to grant amnesty to those who disclosed the truth about the crimes and their involvement in them.

Concerning the acknowledgment of misdeeds, it's not possible to peer into the hearts of people and discover whether their contrition is genuine or whether it is calculated. This does not really matter. Acknowledgment is not a subjective question, but rather a civic ritual. The important thing is the external, solemn manifestation of acknowledgment. A record is thus established which is left in the annals of the nation to enlighten future generations. This is the meaning of forgiveness at the social level. At the personal level, of course, it is a very intimate affair.

As a member of the Truth Commission, I went throughout the country interviewing thousands of people. Although I rarely heard a call for sheer, absolute vengeance, many people demanded that their violators suffer the full weight of the law. This was fair enough. The commission consistently heard that Chile should never again allow these abuses against humanity to happen. Many people said that they didn't want revenge or to create a situation in which more children would be orphaned. Most wanted to know who to forgive. Anonymous forgiveness, you see, is not very human. The victim needs to know who committed the crime so that he or she may forgive and live in peace.

For me, courage signifies the determination to act according to your values. It is a daily exercise in addressing the natural trepidation that we have to confront and to learn how to live with fear. In the Peace Committee we had shared a

sense of togetherness, we supported and encouraged each other. Heroism is something different. I reserve this word for those who brave any danger in the pursuit of their ideals, even without the support of others.

I cannot claim to have suffered inordinately in prison. Rather, I suffered mostly while in exile because I was only able to see my two daughters twice a year. My daughters understood that despite my circumstances, they remained the most important part of my life. At one point or another, both have told me they are very proud of me. This is very important for me. However, at times I wished that I would have done things differently, knowing what I now do about the reality and consequences of being exiled. I am still torn apart and wish that I could have been more a part of their early lives. Sometimes I feel I should have spared myself for them rather than run the risks I faced. But then again, I could not have done otherwise. This has been an emotionally wrenching question for me, one that has been a constant until this very moment.

After returning to democracy, Chile had to face the question of moral reconstruction. Although transition was difficult, the country did not have to build democracy from scratch. Rather, it could rely on traditions of justice and the rule of law that had been established in the past.

The Truth Commission was able to accomplish a great deal. By accounting for the disappearances and deaths of nearly three thousand people, it exposed the Chilean system of human rights abuse and established a global truth. It is no longer possible to deny that these people were unjustly killed. This is very important. Justice has been done in a number of cases involving key people. Compensation was provided and society acknowledged the truth.

Yet there are some unfinished tasks. They are now being addressed by a government-sponsored series of roundtable discussions involving eighteen people. Participants include high-level military officials, human rights lawyers, religious leaders, and community leaders. The debates have been highly publicized in the press and have been closely followed by civil society as a whole. This initiative was made possible after the arrest of Pinochet in London. Two main issues are being dealt with: how to find the remains or account for the fate of nearly one thousand disappeared prisoners; and how to get the armed forces to publicly acknowledge the wrongdoings of the military regime, so as to prevent the abuses from ever happening again.

Chile has yet to complete its transition to democracy. Nonetheless, the country has learned something in the process, namely that everybody is endowed with fundamental human rights which override all differences. Politics remain contentious. However, the sharp polarization that characterized the old system has dissipated. There is no longer a sense that individuals, whether they be suspected subversives or members of the bourgeois class, can be eliminated to serve a greater purpose or ideal. It has taken Chile many years to come to this consensus. The memories of human rights abuse are still vivid and it often seems that old hatreds will be reignited, but a fundamental degree of political and social tolerance has begun, at least, to prevail.

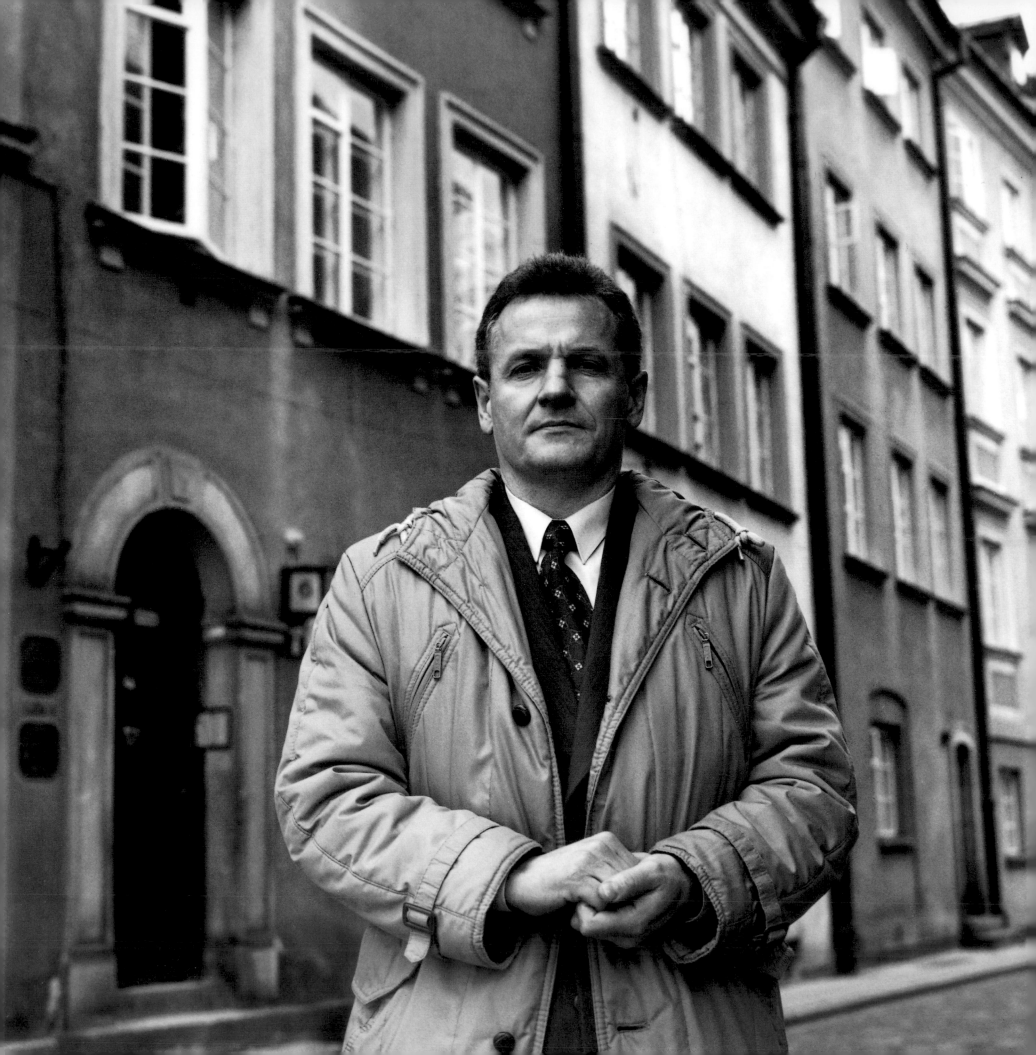

ZBIGNIEW BUJAK

POLAND

POLITICAL PARTICIPATION AND LIFE UNDERGROUND

"'Let's not get caught' was our slogan."

Zbigniew Bujak (b.1954), currently a cabinet minister in Poland, led the Solidarity underground in the Warsaw region from the imposition of martial law in 1981 until his arrest in 1986. Trained as an electrical technician and soldier, Bujak became active in the opposition in 1978 while he was working at the Ursus tractor factory. After organizing a strike in 1980, Bujak became the leader of the Warsaw (Mazowsze) region of Solidarity in 1981. Escaping capture in Gdansk on the night martial law was declared, Bujak traveled underground back to Warsaw where he set up one of the most elaborate and effective underground operations ever known. After his release from prison in a general amnesty, Bujak continued to lead Solidarity for the Mazowsze region until 1989. He was one of Solidarity's leading negotiators in the "Round Table Negotiations," during which he and his colleagues negotiated a peaceful compromise with the communists and set the stage for the rise of democratic governance in Poland. The wave of democracy that started in Poland inspired change in Hungary, East Germany, Czechoslovakia, and eventually throughout the entire region. Bujak decided not to run for office in this electoral contest, instead choosing, like Lech Walesa, to stay focused on the trade union movement. He also worked on the political arena, and helped to found the Citizens' Movement-Democratic Alternative, later the Democratic Social Movement, and the Union of Labor. Elected to Parliament in 1991, he served until 1997. There he spoke eloquently on behalf of women's rights and against anti-Semitism, incurring the wrath of many who were once his ardent supporters. He currently serves as Minister of Customs, one of the most important posts in the Polish government.

In the Solidarity Movement, though we didn't realize the army would be used on such a scale, we knew there would be some sort of martial law introduced. We prepared—hiding the money, all the machines, the files—we hid it all. On December 12, 1981, on the very day when the Solidarity Trade Union held a national meeting at Gdansk shipyard, news was coming in that ZOMO, a special unit of military police used in street fighting, was mobilizing. We thought, "This is it. Even if there is very little we can do at this point, we just have to go. We have to finish the meeting of the national committee."

This particular meeting was being very closely monitored by the secret service. Entering the Gdansk shipyard and arresting us there could have been dangerous because it was a big factory, with a lot of people around and it could have turned into a direct confrontation—with consequences. It was clear from the very beginning that General Jaruzelski was trying to avoid that. He used a tremendous number of police and army units to intimidate us. He wanted to paralyze us with this massive force. Tactically speaking, he did it all very well. They decided to wait and arrest us in our hotels, which was much easier to do. We could see the Monopol Hotel being surrounded, and people being taken away. When we got there, the receptionist told us that Janusz Onyskiewicz, the Solidarity spokesperson, had been arrested. The moment had come. Zbyszek Janus, another activist, and I went directly from the shipyard to the railway station. From there Zbyszek went to his friends in Gdansk, and I stayed that first night in a monastery; then, the next day, I moved to a private apartment. From the windows I could see the tanks, one after another, entering the shipyard. We managed to get in touch with the people of the strike committee inside to figure out whether we should join them, but they suggested that we should stay out,

that all the leadership should scatter to different hiding places. I got an engineer's uniform and rode the train back to Warsaw.

In Warsaw, the most important problem was figuring out who was in hiding, and how to get in touch with them. I had a very clear-cut strategy. I went to my friend's family and asked them to ask their neighbors to go to a very trustworthy priest named Father Nowak to ask for help in contacting others in the underground. Nowak already knew where my deputy, Wiktor Kulerski, was hiding in a private house. I met Kulerski the same day. Another priest from a neighboring parish helped us out. Wiktor then got in touch with Ewa Kulik and Helena Luczywo, and now we knew that our problems had been solved. With those two women, we would be able to build the entire underground network.

We organized three separate structures. The editorial committees published and distributed underground newspapers and leaflets—our most important function. A separate structure existed for all these people who organized Pularski's, Janus's, Zbigniew Tomaszewski's, and my activities. Every single one of us had to have a separate crew of people who organized safe houses for us where we could live, have meetings, and work. The others didn't know where we lived or which people were organizing for us. So if somebody got caught by the secret service, that person would know as little as possible—just one cell would be disrupted. Every month we had to change apartments and our appearance. The way the secret police did their surveillance was by compiling details about the kind of hat, coat, bag you carried. If you switched what you wore, you could easily lose the police. At one point I remember having this

jacket that was very light on one side and very dark on the other, so I could turn it inside out and unbutton it and it would look like a coat.

In one place, where we were for a month, we had about sixteen different apartments at our disposal to move to at any time, apartments of complete strangers. We avoided both our own families and those of other activists. We avoided our friends. That meant we had to completely put our trust in strangers. At the beginning we had this fear that these people would sell us out. The reward for doing that was huge: twenty thousand dollars and a permanent exit visa to leave the country. But only once was someone betrayed.

"Let's not get caught" was our slogan. The general belief in Poland was that the secret police were omnipotent. The whole system was based on the myth of their "terrible efficiency." When people were shown that a year had passed and the opposition was still not captured, was flourishing underground, the myth of efficiency began to show cracks. This was our conviction—that remaining free would compromise the system. And we were right. Today we still get calls from former secret police agents who say, "You know, you son of a bitch, if we had caught you then…" and you can see they are still angry.

There are two kinds of courage. I have a deep conviction that military struggle (though this is certainly a paradox) does not require that much courage. I myself was in the army and know it's easier to just point, shoot, and run. When I read about the dissidents in Russia, I realized "civilian's courage" is much harder. I don't know how to prove this, but when you have to make a decision—whether to sign a petition, or whether to participate in a demonstration—when

you know you can be put into jail, sentenced, or sent to Siberia for years, the way that the Russians have been, this is real courage. When you read about Mandela in South Africa, you can see that it requires a different courage to be ready for this type of activity.

In politics, you can call it courage to express your true opinions. It may turn out that you lose friends—that somebody in the family turns from you. I experienced it. I know I stopped being a hero to all Poles when I expressed my opinions aloud. A lot of people said, "You have disappointed us, you betrayed us. We thought you would be with us, the Nationalists, you would be leading us." And a lot of anti-Semites said, "We thought you would be a true Pole, and that we would deal with those Jews and Communists." Or all those people involved with the antiabortion movement, when I said I believed that it's the woman's decision to choose, turned me into enemy number one.

Look, I believe all of my dreams are coming true. I was afraid that my wife and I would be childless. Then we had a son and we are happy beyond belief. If he hadn't been born I think I would have been a frustrated, bitter person, thinking I'd wasted my family life for something abstract. But he came. And I have this feeling that what I am leaving for my son is the best Poland I could possibly have helped create. You know what we are doing now is going to become the stuff of legends, the same way as it was for us when we talked about our parents' lives. I have the sense of participating in a huge victory: the end of martial law, and later the roundtable, and then Tadeusz Mazowiecki's success. Our idea has won, in the sense of helping fulfill a big political vision, and I was part of it.

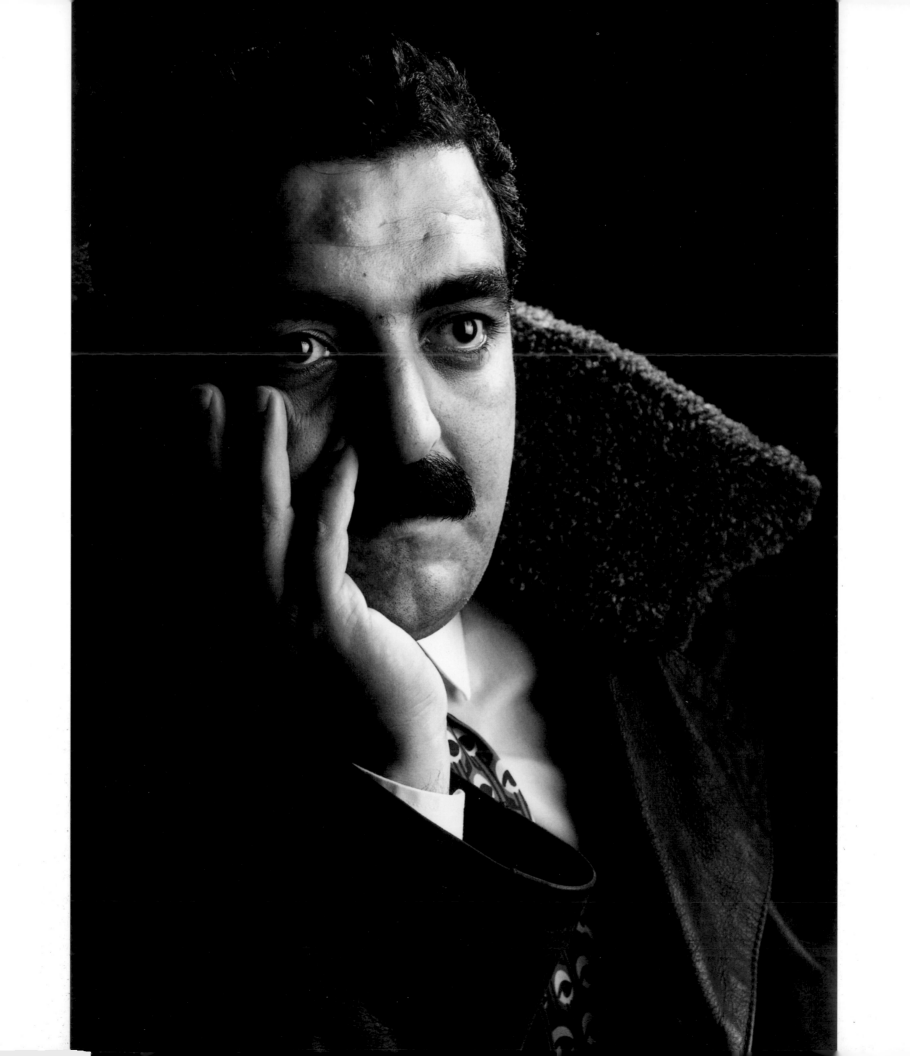

SEZGIN TANRIKULU

TURKEY

KURDS AND SELF-DETERMINATION

"When I am in court, eye to eye with people that I am
accusing of torture, be it soldiers or policemen, when they look
into my eyes and I don't look away, when I am not the first to
flinch, I feel that I have more courage than they do. In their eyes you
can see the hatred they have, their hatred of you, that they
want to kill you for what you are doing."

Sezgin Tanrikulu is the leading human rights attorney in Turkish Kurdistan, a strong advocate of legal reform and strengthening civil society. Co-founder of the Diyarbakir Human Rights Association, the Secretary of the Bar Association in Diyarbakir, and the regional representative of the Human Rights Foundation of Turkey, his work has taken him where few dared to go. For over a decade, the Kurdish region has been under a state of siege, including food blockades and curfews. Fighting between Turkish troops and the Workers Party of Kurdistan has caught civilians in the cross fire. Turkish forces have engaged in a systemic practice of targeting civilians, destroying villages, and forcibly evicting noncombatants. More than twenty-six thousand people have been killed and two million displaced since 1992. Extrajudicial killings, disappearances, arbitrary detention, and torture in police custody are commonplace. Freedom of expression is severely curtailed: until recently, Turkish law forbade the Kurdish language, Kurdish dance, Kurdish songs, and even the use of Kurdish names.

Throughout Turkey and particularly in the southeast region, lawyers avoid defending politically unpopular clients. In this climate, lawyers become victims of persecution themselves, and are routinely identified by prosecutors, police, and security agents as "terrorist lawyers." In Diyarbakir alone, more than thirty lawyers have faced criminal charges apparently based solely on their defense of clients in the courts. Even submitting complaints to the European Court of Human Rights or passing information to international human rights groups has been considered evidence of terrorist support and has resulted in prosecutions and prison terms. Tanrikulu has been indicted several times for his activities as a lawyer and in 1994 was charged with "insulting the judiciary" for appealing a decision to convict on the basis of a statement ruled inadmissible by another court because it was extracted by torture. Tanrikulu's commitment to stay and defend human rights in the face of state persecution reflects his tenacity and devotion to the rule of law.

SEZGIN TANRIKULU

When I graduated from law school in Istanbul in 1984, I returned to my native city, Diyarbakir, and started my practical training. The government had imposed emergency rule and there were at least three thousand political prisoners in jail, so tension was high in the city. It was very difficult to be indifferent to such a situation. The mayor of the city, Dr. Megdi Zana, who is the husband of Layla Zana, the Kurds' most famous political prisoner, was charged with separatism. He needed the energetic work of a young lawyer to help him full-time, so I started defending him. Once I got involved, I became a specialist in human rights. The scale of terror increased in the region, the war became bloodier, and it was impossible for me to take cases other than those involving human rights abuses.

Megdi Zana was an independent mayor, without any party affiliations. After the military takeover in 1980, he was alleged to be a member of a terrorist organization and had to spend from 1980 to 1991 in jail. He was dedicated to the Kurdish cause. In the 1980s the Turkish government banned the Kurdish language. However, every time he was in court defending himself against their charges, Megdi Zana spoke Kurdish to the judges. Because of his efforts the law was abrogated in 1991, and the Kurdish language was accepted by the Turkish central government.

Six of my friends, all of them lawyers of Turkish origin, were killed between 1990 and 1995, a time I call the nightmare period. They were killed for nothing else than their courage in defending human rights, killed because the authorities wanted to send a signal to people like us working for human rights. They were just the victims of our situation. We suspected they were politically planned assassinations involving military intelligence. Our suspicions were corroborated when an information officer asserted that one of the lawyers was assassinated by an agency linked to the military. This information officer was later murdered.

From 1992 to 1995 the situation in Diyarbakir was especially acute. At least two or three people were killed in Diyarbakir every day in extrajudicial political assassinations. It was a very tense period. I was followed from the moment I stepped foot outside my door every morning. There was nothing to do but find humor in the situation. Most of the time when people were killed they were assassinated with one bullet from behind. We joked at the notion of placing mirrors on our shoulders so we could see who was creeping up!

In 1988, with five of my colleagues, we decided to establish the Human Rights Association of Diyarbakir. By 1997, the Human Rights Association had six hundred members. But on May 22 that year, the government closed down the HRA after they allegedly found forbidden publications in the archives of the association. We weren't alone. Two other cities, Mardin and Urfa in southeast Turkey, also had human rights associations closed for the same reason.

I was detained for short periods of time. On my way back to Diyarbakir from Europe, the authorities stopped me at the airport and told me that I was on their list of suspects. I knew that if they took me to the police station bad things could have happened. But in Diyarbakir there are also some very honest judges

"Once you work for people, once they call you at two o'clock in the morning, once they come to your office and you see the suffering in their faces, you don't think about representing a case, you're representing people. Your job becomes a very human one."

and prosecutors, and one prosecutor who heard about my case immediately called and insisted that they had to interrogate me in court. He saved me.

In another instance, a state prosecutor who really believed me once he heard me—that I was not guilty on the charges of separatism and membership in a terrorist organization—said: "Why don't you just write up your defense and I will just sign it as if I had written it?" That was amazing—but it happens. That's why I have to say that although the picture is very bleak, there are pockets of hope.

My conscience is clear because I haven't done anything illegal; I am not in contact with any terrorist organization. Everything I do is on the record. I have no reason to fear security forces or state authorities. I would have no problem in court defending my case. All my fear is based on the fact that there are circles within the state that are beyond state control. These people can really be dangerous and that's why our job involves a certain risk.

There were times I was really concerned about my family but my wife says she's the one who is always scared. Something that I'm particularly afraid of is car bombing, because once you switch on the engine it's too late. A friend's car, a lawyer in Diyarbakir, was bombed like this.

The struggle for human rights is as old as human beings themselves. And I believe that if we do not stand up against injustice, nobody can help us. It's only people themselves who can change situations. To live under conditions in which there is no justice is worse than dying. So I do what I do in order to ensure a better future. On the other hand,

our region is a very backward one. The literacy rate is very low and there is a war going on. So for people who are ignorant but who are still suffering abuses of human rights, we are seen as people who can save them. We lawyers are considered demigods, which carries a lot of moral responsibility. Since there are so few lawyers in Diyarbakir, we really have to work hard to deserve the people's trust. That's why we feel, in our region particularly, that we have a special task. Once you work for people, once they call you at two o'clock in the morning, once they come to your office and you see the suffering in their faces, you don't think about representing a case, you're representing people. Your job becomes a very human one.

Let me offer a very narrow personal definition of what I think courage is. If I can represent someone who was tortured, if I can stand up to the police force, to the system that has tortured this person, this is courage. And this is my way of fighting. There are different ways of getting to the same end but representing people who have suffered is my way. When I am in court, eye to eye with people that I am accusing of torture, be it soldiers or policemen, when they look into my eyes and I don't look away, am not the first to flinch, I feel that I have more courage than they do. In their eyes you can see the hatred they have, their hatred of you, that they want to kill you for what you are doing. And as someone who is fighting for justice, you should not be ashamed of what you are doing. I have friends who keep telling me, "Why are you fighting so hard against the system? Why are you putting so much at risk?" But I think I am doing what I must do. I do something that someone has to do. And I have no second thoughts, no doubts about the rightness of what I am doing. If everybody was responsible in what they were doing, there would be no problems in this world.

MARIA TERESA TULA

THE DISAPPEARED

"We held a press conference telling the public about the work. . . .
As a result, a death threat appeared in the newspaper
threatening all members of Co-Madres that if people did not obey
they would be disappeared or decapitated one by one."

Maria Teresa Tula is a leader of the Co-Madres (Mothers of the Disappeared) of El Salvador, a group of impoverished, mostly illiterate women whose husbands or children were kidnapped or killed by death squads and government security forces during El Salvador's bloody civil war. The 1980s conflict pitted leftist organizations and campesino farmer-based guerrillas against an entrenched alliance of landowners and the military, with each side aided by different Cold War backers. In 1992, when a peace accord was signed by the government and the Farabundo Martí Liberation Front, the reign of terror that had ruled in El Salvador for over a decade finally ended. After Tula was threatened, abducted, and tortured, she returned to Co-Madres to continue her work for justice and for women's empowerment. A self-described feminist, Tula escaped to the United States, crossing the border as an illegal alien. She spent the next several years running the Co-Madres office in Washington, D.C., and fighting deportation for herself and all Salvadorans. She now lives in the U.S., fulfilling her dream of providing her children with a safe environment and a good education.

I was born on April 23, 1951, in the village of Izalco, in the Department of Sonsonate in El Salvador. My father was a bus dispatcher and my mother worked in a factory in Santa Ana nearby. I had eight brothers and sisters. Like most people in the village, we were poor. I received only a first-grade education. After that I began helping my mother in the house until the day I was married. My husband, José Rafael Canales Guevarra, was killed by the Salvadoran military in June 1980.

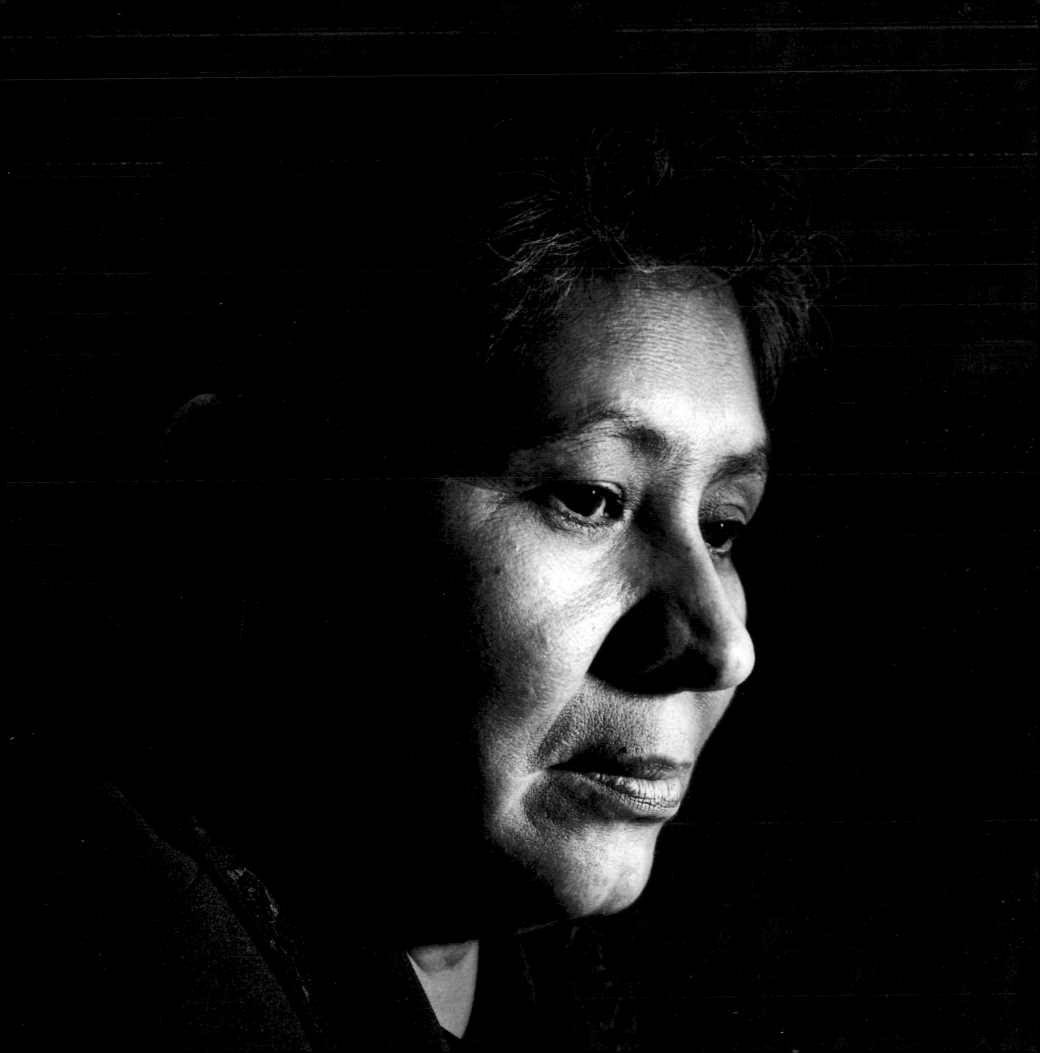

We had five children together. I also have a sixth child, Oscar Feliciano Tula, born on July 5, 1986, while I was being held in prison without charges.

Until 1978 I was never involved in politics in any way. My husband was working in the Central Azucarrero de Izalco (Izalco Sugar Company), owned by one of the richest families in El Salvador—and I was taking care of our children and taking in washing and ironing. Conditions at the company were very bad. There was no job safety, wages were low, and there were no health benefits. The seventeen hundred workers decided to go on strike and refused to leave the plantation. Some stayed inside the processing plant. Others guarded the gates of the hacienda to make sure no trucks could get in.

My husband was very active in the strike. On the second day I went to bring him medicine and food at 10:00 A.M., just as the security forces arrived and arrested everyone. Many ran into the sugar cane fields to escape. The police beat those who were caught, tied their hands behind their backs and told them to lie face down. All of us family members were there watching and waiting to see what they were going to do with our husbands and sons. They separated twenty-two people and let the rest go. My husband was one of those they kept. He was taken to the National Guard headquarters in San Salvador and held incommunicado for three days. On the fourth day, a military tribunal sentenced him to six months in prison. The only witnesses were Guard members. At first they wouldn't even tell me where he was, but I finally found out and visited him in Santa Tecla Prison. He told me how he had been tortured—beaten in the testicles, then hung from the ceiling and beaten all over, a torture described as "the airplane."

Then I started working with the Co-Madres—an organization of women formed in 1977 to fight for the release of husbands and other family members jailed or disappeared or assassinated and to demand that the government respect human rights. In June 1978, my husband was released from prison. We decided to move to Santa Ana, since it would have been dangerous for us to remain in Izalco. Once a person has been in prison they are in even greater danger of being assassinated or disappeared by the security forces or death squads.

In Santa Ana my husband got work as a bricklayer. He was not involved in politics. He worked and spent time at home with our children. I kept doing my work washing and ironing clothes, and kept working with Co-Madres, pressuring the government to respect human rights. During this time there were continual assassinations and disappearances. On the highway from Santa Ana to San Salvador you could see fifteen corpses in different places on any given day: students, workers, peasants, old people, women.

The Co-Madres would call press conferences when people were disappeared, or place ads in the newspaper announcing that someone was being charged and tried. I worked mostly with governmental organizations, international officials, and institutions and churches. I also distributed food to people who visited the office, visited political prisoners in jail and brought them supplies, and solicited food and other donations from international and domestic organizations.

Like other independent human rights organizations, we came under attack from the right wing. In October 1979 I was in San Salvador with a group when we learned that the body of one of these mothers' sons had been found on the streets; he had been disappeared. It was 7 P.M. and we were returning with the body in a minibus, when we were stopped by the police. They accused us of carrying arms and made all ten of us, including a child, lie face down with our arms stretched above our heads. The six policemen walked in single file around us, beating us on our backs with rifle butts and stepping on us. We were lying about three hours, while more police arrived, including a commander. Meanwhile it kept getting closer to the curfew time—midnight—when everyone had to be off the street. If anyone was on the street after midnight they could be machine-gunned. So they were detained until then—many people died this way.

Around 11:40 P.M. they started to let us go. Six women were released, but four of us—including me—they kept. They asked us questions—where were we from, our names, the names of our parents, what were we doing. Meanwhile, they kept on saying we were carrying arms, a complete lie, and joking that the boy whose corpse we were carrying had died of mosquito bites. Finally, at ten minutes to twelve, they told us to put our hands behind our head and start walking. Then they told us to stop, turn around with closed eyes, and then keep walking,

then stop again, and turn around. They kept doing this until at one moment we all felt rifles against our stomachs. They asked us if we wanted to die. We were silent. I felt complete terror and thought they were surely going to kill me. Finally, they told us we could leave. It was two minutes to twelve, which meant we had only two minutes to get off the street. They brought back the chauffeur, who had been taken a short distance away; he had been badly beaten. We all got into the bus with the corpse. Fortunately there was a funeral home nearby and we arrived there before the curfew began. This was my first personal experience of torture and the kind of tactics used by the security forces. I had heard many stories but this was the first time I had experienced it myself.

In 1980 I moved with my family to Sonsonate, where my husband had gotten a job building big houses. Barely a month later he was assassinated. On June 19 four men in civilian clothes, heavily armed, came to our house. They asked for my husband and said they were taking him to the municipal police station because he had been witness to a robbery. When he didn't return I inquired at the police station, but he wasn't registered there. The following day the newspaper had a picture of him saying he was a guerrilla who died in a confrontation with the armed forces in a clandestine house full of arms. This was a complete lie since he hadn't been involved with anything since the strike. When I went to get my husband's body, the judge who had identified it told me that it was the armed forces who had killed my husband, that his hands and feet had been bound and there was a bullet hole through his head. At the cemetery in Sonsonate, I saw his tied hands and feet and the bullet hole through his head.

My neighbors warned me that my house was "militarizado," with soldiers surrounding it and going through all our things. Once they kill one member of a family, they often kill others. So I never went back. Instead I went to San Salvador. I was pregnant at the time with my fifth child.

I continued to be very active with Co-Madres, which was under intense pressure from the right-wing death squads and security forces. In 1980 the Co-Madres office, which we shared with the nongovernmental Human Rights Commission (CDH), was bombed twice. The first bombing took place on March 13, 1980. Afterward the National Guard came, supposedly to investi-

gate, but did nothing. The second bombing occurred in September 1980, and several unknown decapitated bodies were left at the front of the office, as a further warning of what would happen to us. Several members of the Human Rights Commission were also assassinated during this period.

In the beginning of 1982, Archbishop Rivera y Damas recognized the work that we at Co-Madres were doing and he gave us office space along with the Human Rights Commission, Socorro Juridico, and Tutela Legal—the Archdiocese's own human rights and legal offices. To announce our move, we held a press conference, telling the public about the work we were doing and where they should come for help. As a result, a death threat from the death squad leader Maximiliano Hernandez appeared in the newspaper threatening all members of Co-Madres that if people did not obey they would be disappeared or decapitated one by one.

Fifteen days after this, a member of Co-Madres, Ophelia, was captured by members of the security forces dressed as civilians, and then taken to the National Police Station. We started paid advertising to get her released and to force a tribunal to investigate why she had been captured. The police confirmed that she was being held, "for investigation." We later learned that during those days she had been tortured and raped, and eighteen days after she had been captured, she was dumped near the Santa Ana–San Salvador Highway, about fifty kilometers outside of San Salvador, early in the morning. Some workers called us to say a woman had been found. Her hands were still tied behind her and her mouth was gagged. She was so disfigured that we didn't even recognize her. Her whole face was inflamed; she couldn't talk because her teeth had been broken inside her mouth, and she had cigarette burns on her arms and body. When we asked her who she was, and she managed to say "Ophelia," we couldn't believe it. We took her to a doctor, and after she had recovered she testified about what had happened to her. She said there were photos of all of us at the National Police Station, but they were asking her about a few people in particular. I was one of the people they were asking about.

It was shortly after this that men dressed as civilians started coming to my house, asking questions. Others were constantly watching the house and whenever I left they would come and talk to the children. The children were

nervous about what would happen to me. Around this time in the street the army and the security forces were also stepping up their street searches. They would make people get off buses and show their registration and they would physically search you and everything you were carrying, including diapers.

The terrorization of Co-Madres continued. In 1982, Elena Gonzalez was shot and killed by death squads in her home in Cuzcatancingo. Three Co-Madres mothers, Haydee Moran, Blanca Alvarado, and Carmen Sorto Ruano and her nineteen-year-old daughter, were taken one by one by National Police to the famous body dump, "Puerta del Diablo," where they laid their heads on a stone and told them their heads would be cut off with a machete if they didn't talk about Co-Madres. Haydee and Blanca were released; Carmen and her daughter were imprisoned until 1983.

It was clear to me that my life was in danger. I decided to flee El Salvador for Mexico. I left on August 4, 1982, taking four of my children, and leaving the eldest in San Salvador with my mother. I stayed in Mexico until 1984, and worked there with the Co-Madres office. Then my visa expired so I was afraid of being deported back. The United Nations Committee on Refugees recognized me as a refugee and they gave me papers to apply for political asylum in Mexico, and though I had a number of interviews I never received any response. This made me even more nervous since I knew other Salvadorans whose applications were granted; I might be on some kind of blacklist.

In 1984, after the Co-Madres received the Robert F. Kennedy Human Rights Award I decided to return to El Salvador as I believed that with international attention and recognition for our work, I would now be safer. Also, Napoleon Duarte had recently been elected president after a campaign in which he promised to respect human rights and initiate investigations into disappearances and assassinations. But when the four of us applied for our visas to travel to the United States for the RFK award, they were denied. An article appeared in *La Prensa Grafica* quoting a U.S. State Department declaration saying they were denied since we had Communist connections. To have our names printed in the newspaper linked to Communists was very dangerous. It was like giving permission for the death squads to come in and assassinate us.

A few days after, the U.S. Embassy told the public, the Kennedy Memorial, and a human rights delegation that the visas were denied because we were dangerous and terrorists and we had direct connections to guerrillas. We asked for an audience with the ambassador so he could provide proof, but he wouldn't see us. A visiting U.S. delegation also asked for proof, but nothing was forthcoming. From that moment we noticed an increase in surveillance, but luckily, around this same time, three of the four of us were invited for a European tour. We left on January 20, 1985, and spent three months touring Spain, Holland, Switzerland, England, Greece, West Germany, France, Italy, Norway, and Sweden. We met with Mrs. Mitterand, Mrs. Papandreou, and other prominent women; also with Willy Brandt in West Germany and with United Nations representatives in Geneva. We hoped this kind of international exposure would give us more protection, and on our return on April 20, 1985, we were accompanied by European parliamentarians.

Meanwhile, the assassinated body of a Co-Madres member, Isabel, who had disappeared some eleven months earlier, was found in her home. Only a few months later, Maria Ester Grande was detained by the Treasury Police and threatened; they picked up her son and tortured and interrogated him for fifteen days to get information about his mother and where she lived. (During this time, those of us who were active in Co-Madres never lived in one place. We moved around for fear of being picked up by the death squads or security forces). Finally, he told them and the Treasury Police went and picked her up; then they returned four times to her house, treated her children brutally and threatened to kill their mother and brother if they didn't tell where arms were hidden. They never found any arms. But they presented her with her son tied up and beaten, and said if she wanted her son to live she would have to go back to Co-Madres and get the names of all who worked there and their addresses. Then she was dropped off at our office. Instead of cooperating with them, she told us what happened. We immediately went to the Red Cross and finally her son was transferred to Mariona Prison until 1987.

Shortly after this, there was a break-in of the Co-Madres office and everything was taken—documents, testimony, tapes, photos, and money. As a result they had those lists of everyone involved with Co-Madres. From this

point on, there was constant surveillance and repression. In November 1985, Joaquin Antonio Caceres, of the Human Rights Commission, with whom we worked closely, was captured and held for forty-five days and later brought to prison and accused of being a guerrilla. Around the same time, Co-Madres was awarded the Bruno Krisky Human Rights Award. I traveled to Austria to receive it, visiting other European countries as well. I was away until March, and when I returned, all my movements were monitored by the police. I lived in constant fear.

On May 6, 1986, I was grabbed suddenly by a man at a bus stop, a pistol was pressed in my side and I was told to walk and not make any noise. Then I was pushed into a white car that was waiting with its doors open. They forced me to lie on the floor with my head down, so that I couldn't see outside, and then the car drove around in circles so I wouldn't know where I was being taken. Finally I was taken to a house with the three men who captured me. They blindfolded me and put me in a chair with my hands tied behind my back, and they started interrogating me about who I was, what was I doing in the neighborhood, and whether I knew people from Co-Madres. I was held for three days, during which time I was beaten and raped by the three men, all while blindfolded. I was seven months pregnant at the time. There was no way for me to know if it was day or night. They gave me no food and only a little water. Later they started carving my belly with a knife. They didn't make deep wounds but scrapes which left blood. They questioned me about Co-Madres and when I continued to tell them I knew nothing, they told me I would die. Then they left me for the night, blindfolded, with my hands tied to the chair.

The next day they asked me the same questions and again wounded me with the sharp object, but this time the wounds were deeper—I still have scars. Finally, they blindfolded me again, put me in a car, and told me not to look where we were going or they would shoot me in the head. Then they dropped me in the Cucatlan Park. It was nine in the morning. I was bleeding, disoriented, and my clothes were torn since they had sliced them with the sharp, pointed object. I was holding my wound to stop the bleeding. I had no money; they had taken everything from me. I asked a woman at a bus stop to help me, telling her that I had been robbed. She gave me some money. I didn't know if I should go first to the hospital, my home, or the office. I decided the office and told them everything that had happened. Several days later we published a "denuncia" (an accusation).

The security forces' arrests of people connected with human rights organizations intensified. And on Friday, May 26, I was arrested again. They were dressed as civilians, heavily armed, but I later learned that they were members of the Treasury Police. I was tortured for four days, beaten all over, on my head, my back. At one point a towel was put over my head and one of my torturers sat on my head and neck. Ten days later I was visited by the International Red Cross and the Human Rights Commission who told me that I was accused of being a terrorist. Though I was never tried or sentenced, I was held in Ilopango Women's Prison until late 1986. I was able to find homes for four of my children. But my six-year-old daughter stayed with me in prison, along with my son, who was born there.

On September 22, I was ordered released by President Duarte, in a public ceremony. At that ceremony I pointed to a man there who had been one of my torturers. Following my release I was terrified to go to the Co-Madres office, I was scared at bus stops, and if any vehicle stopped, I was afraid someone would jump out and grab me. I was frightened that I would be machine-gunned on the street. My house continued under surveillance and attacks against the Human Rights Commission also continued. I knew that there was no way I could remain in El Salvador. I began planning my escape.

I learned that I was being invited to the United States in January to talk to members of Congress and other groups: this would be a good opportunity to find temporary safety. I was no longer safe in El Salvador or Mexico, which was no longer accepting Salvadorans for asylum. I was forced to leave three of my children in Mexico, living with different families. My two youngest children came with me.

There is another story to tell about my efforts to get asylum in the United States in the 1980s, when many in the U.S. government were supporting the regime in power, but that is for another time. I rejoice that peace has come to my country at last and that the human rights we fought for during those dark years now seem within our reach, not just in our dreams.

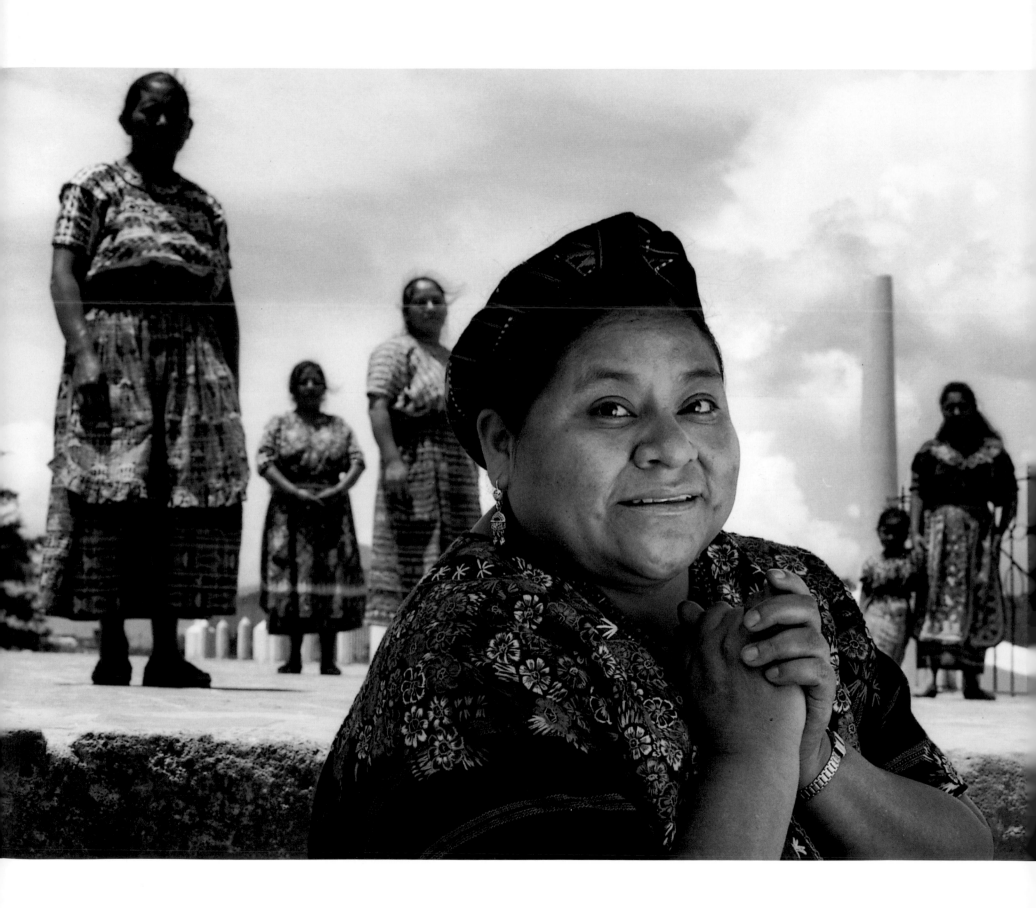

RIGOBERTA MENCHÚ TUM

GUATEMALA

INDIGENOUS PEOPLES' RIGHTS

"I was a militant woman in the cause of justice.
And for twelve years I did not have a home of my own or a family."

Rigoberta Menchú Tum is a heroine to Mayan Indians in Guatemala and indigenous peoples throughout the world. Born into an impoverished family in 1959, this daughter of an active member of the CUC (Committee of Campesinos [Agricultural Workers]), she joined the union in 1979, despite the fact that several members of her family had been persecuted for their membership. In the early 1980s, the Guatemalan military launched a "scorched earth campaign," burning over four hundred Mayan villages to the ground, massacring hundreds of children, women, and the infirm; and brutally torturing and murdering anyone suspected of dissenting from the policy of repression. The military killed up to two hundred thousand people, mostly Mayan Indians, and forced one million people into exile. Menchú's mother and brother were kidnapped and killed, and her father burned alive. While the Guatemalan army marched against its people, the rest of the world remained almost completely silent. In 1983, Menchú published her autobiography, an account of the Guatemalan conflict. I, Rigoberta Menchú was translated into twelve languages, and was an influential factor in changing world opinion about support for the military. Fifteen years later, discrepancies were found about certain details of the work, but there is no dispute regarding its essential truth and the massive suffering of Guatemala's indigenous peoples at the hands of the hemisphere's most brutal military government. In 1992, Rigoberta Menchú Tum won the Nobel Peace Prize for her work. Menchú has been forced into exile three times for her advocacy within Guatemala, and despite the threats, continues her work today on human rights, indigenous rights, women's rights, and development.

Struggles for the rights of poor people, for dignity, for human life, seem to be very, very dark tunnels, but one should always try, in that struggle, to find some light and some hope. The most important thing to have is a great quantity of positive feelings and thoughts. Even though one can easily be pessimistic, I always attempt to look for the highest values that human beings could possibly have. We have to invent hope all over again. One day, sadly, I said to myself with great conviction: the death of my parents can never be recuperated. Their lives cannot be brought back. And what can also never, never be recuperated is the violation of their dignity as human beings. Nothing will ever convince me that anything could happen to pay back that debt.

Now, I don't think this realization is a personal matter; rather, it is a social question. It's a question of a society, of history, of all memory. Those of us who are victims are the ones to decide what pardons are going to take place and under what sort of conditions. We, who have survived the crimes, are the ones who should have the last words, not those observing. I respect the opinions of those who say that a decree or an accord or a religious philosophy is enough to pardon others, but I really would like, much more than that, to hear the voice of the victims. And at this moment, the victims are really not listened to.

An amnesty is invented by two actors in a war. It's hardly the idea of the victims, or of the society. Two armed groups who have been combating each other decide that it is best for each to pardon the other. This is the whole vulgar reality that the struggle for human rights has to go through at this moment.

An agreement with real dialogue would bring war to an end as soon as possible. But I never could accept that two sides that have committed horrendous atrocities could simply pardon themselves. What the amnesties do is simply forget and obliterate, with one simple signature, all the violations of human rights that have taken place. Many of these abuses continue in the lives of the victims, in the orphans of that conflict. So even though there are amnesties in countries such as Argentina, Chile, El Salvador, and Guatemala, I can see that people do not forget the human rights violations that they have suffered, and they continue to live them. These are things that are not going to be forgotten.

A real reconciliation has to be based on the search for truth. We who are the victims of these abuses have a right to the truth. Finding the truth is not enough. What we also have to find is justice. And the ways, the processes, and the means by which this justice can be accomplished are through law and through the courts, through procedures that are legal.

This is why I now have a legal case in Guatemala against the military. We have a lot of corrupt judges, we know about bribery and threats. The military does not want to set a precedent for real justice, so they bribe the entire legal system. One of these days that system will become more fair. But we have to give time to the system of justice to improve.

Living in a country of such violence, of such a history of blood, no one, no one would want to bring a child into this world. I was a militant woman in the cause of justice. And for twelve years I did not have a home of my own or a family. I lived in refugee camps when I could. I lived in the homes of nuns in Mexico. I left behind many, many bags in many different countries, in many different buildings. Under those circumstances, what would I have done with a child? I was involved in all kinds of risks, and thought that maybe I would have to sacrifice my life for my people. When one says that, you understand, it is not just a slogan, but a real-life experience. I exposed myself to the most difficult kinds of situations.

I met my husband in 1992. When I met him, I really didn't think that it was going to be a longstanding relationship. How could it, when I was always going from one place to another, almost like a vagabond? My husband's family, in particular, helped me a great deal in stabilizing my life. It only happened because my future in-laws were really very persistent and just insisted—all the time—that we get married, even if it was only a civil wedding. They were worried about what the family, what the society, what the community, what everybody else would think, if we weren't married. For me, it didn't have any particular importance.

For me stability began with another wish: it was very important to find, once again, my sister Ana. She was the youngest of the family. She had decided that she was going to live with me, but I didn't have a home where she could live. I began to actually have the desire to have a home, a desire that coincided with the time when I was awarded the Nobel Peace Prize. Many friends, people who gave me counseling thought that it would be better for me, too. After all, you can't have a Nobel Prize winner wandering around the world semiclandestinely!

"It's not true that it is only pain that motivates people to continue struggling to make their convictions a reality. The love of many other people, the support that one has from other people, and above all, the understanding of other people, has a lot to do with it."

I give thanks to Mexico—to the people of Mexico, and at that time, to the authorities, the officials of Mexico City—who offered me that sense of stability in a very short period of time. The office of the mayor gave me a house, and in that house we were able to construct for ourselves, once again, a very normal life. We were once again a family. I'd left Guatemala in 1981, but though I'd returned in 1988, I was detained, so I was forced to leave again. After that I would come and go in and out of Guatemala, but I could never stay for very long. Finally, in 1994, we went back, officially.

Home is important to me for another reason. I have two children now—one who I lost. It just changes around your life completely when you have a child, doesn't it? You can't be just moving around the world in any way that you want anymore. So you live life according to the circumstances that you are in. I can't say, though, that I ever had the intention of living my life, or any part of my life, quite the way in which I lived it! Things just happened. Suddenly I was caught up in the situation. And I tried to overcome it, with a lot of good will and not a whole lot of introspection. Now my son lives with my family, with my sister and my nephews; there are seven children in the house. There are two twins, two years old, a daughter of my sister-in-law, and four children who don't have a father. But we live in a large family, and that gives my son a great deal of satisfaction. He has a community every day.

My youngest son, whose name was Tzunun, which means hummingbird, was part of a very, very difficult pregnancy. It was risky from the very first day. It required a tremendous desire to be a mother, to carry it through, and I had decided to have this child. All my work, all my activities had to be stopped. Still, so sadly, he lived only three days. But when he died I thought that he had lived with me for many, many years. I talked to him, I understood him, we thought he could perceive things around him.

During this time, I was always thinking about the world and listening to the news and trying to find out what was going on. And when you really listen it has a very, very big impact on you. Because when you are going around to conferences and talking to people and people are applauding you, you really don't fully realize what a terrible situation that women and children are in. But being at home, in your own four walls, and knowing what is happening in the world, you really feel very limited in what you are doing and what you can do. My child gave me time to sit back and to think about the condition of women, and children, and children who don't have parents, and children who are abused by their parents. My situation, my condition as a mother is a great, great privilege: not just some kind of decree, or law, or desire, but something that, fundamentally, has transformed my life.

There have been a lot of successes in my life. And when you have success, it helps you to want to continue the struggle. You are not alone, for it's not true that it is only pain that motivates people to continue struggling to make their convictions a reality. The love of many other people, the support that one has from other people, and above all, the understanding of other people, has a lot to do with it. It's when one realizes that there are a lot of other people in the world that think the way you do, that you feel you are engaged in a larger undertaking. Every night when I go to sleep, I say a prayer that more people, more allies will support the world's struggles. That's the most important thing. That would be so good.

JOSÉ RAMOS-HORTA

NATIONAL SOVEREIGNTY

"More courage is required to forgive than is required to take up arms."

José Ramos-Horta received the Nobel Peace Prize in 1996 for his uncompromising and indefatigable work on behalf of the people of East Timor, brutally invaded by Indonesia in 1975. Muslim West Timor became part of Indonesia in 1946, while East Timor, settled in 1520 by the Portugese with different language, religion, and customs, remained a colony until Portugal's withdrawal in 1975. Twenty-five-year-old José Ramos-Horta was named foreign minister of the newly formed government in November 1975, but only a month later, Indonesian troops massed around the capital city, Dili, and, as Ramos-Horta's plane touched down in Portugal, he was told that Indonesia had taken control of his country. In the years following the invasion, one-third of the population was to lose their lives to massacres, starvation, epidemics, and terror. Throughout the next two decades, Ramos-Horta traveled the globe speaking out against abuses, and, in 1992, he put forth a peace plan which called for a phased withdrawal of Indonesian troops culminating in a referendum in which the people of East Timor would vote for independence, integration into Indonesia, or free association with Portugal. When the September 1999 vote showed that 80 percent of Timorese had voted for independence, Indonesian armed forces and their militia allies went on a rampage. They massacred hundreds, burned to the ground 70 percent of the standing structures in the country, set fire to crops, killed thousands of farm animals, and destroyed major sewer systems and electric lines. Hundreds of thousands were forced into exile at gun-point. Ramos-Horta led the international charge against the slaughter, and, because of his appeals, the United Nations sent in troops to stop the violence. In December 1999, after twenty-four years in exile, José Ramos-Horta finally went home again to a free and independent East Timor.

I was born into a mixed family, with a Portuguese father who had opposed the Salazar fascist regime in Portugal, and therefore was exiled to East Timor in the thirties, and a mother from East Timor. We grew up in remote villages without electricity, running water, roads, or cars. Tetum, the main native language, was spoken in our home. I only learned Portuguese at the Catholic Mission school. We had very little: I remember getting my first shoes when I was a teenager and since I didn't want to ruin the shoes, I saved them to wear at Christmas. By the following Christmas they no longer fit me—I was so upset.

The Catholic Mission was also very poor. For almost ten years we had corn for breakfast, lunch, and dinner. They'd throw it in a drum, boil it, and then put it on your plate. It was old and hard and I have a tooth ruined because of that corn. We'd have meat maybe, oh, once a month. And the Catholic school was very conservative. You had to pray fifty times a day, and confess constantly because the priest used to tell us that even if you were young you could die at any moment, and if you died with sin, you'd go straight to hell. So I thought